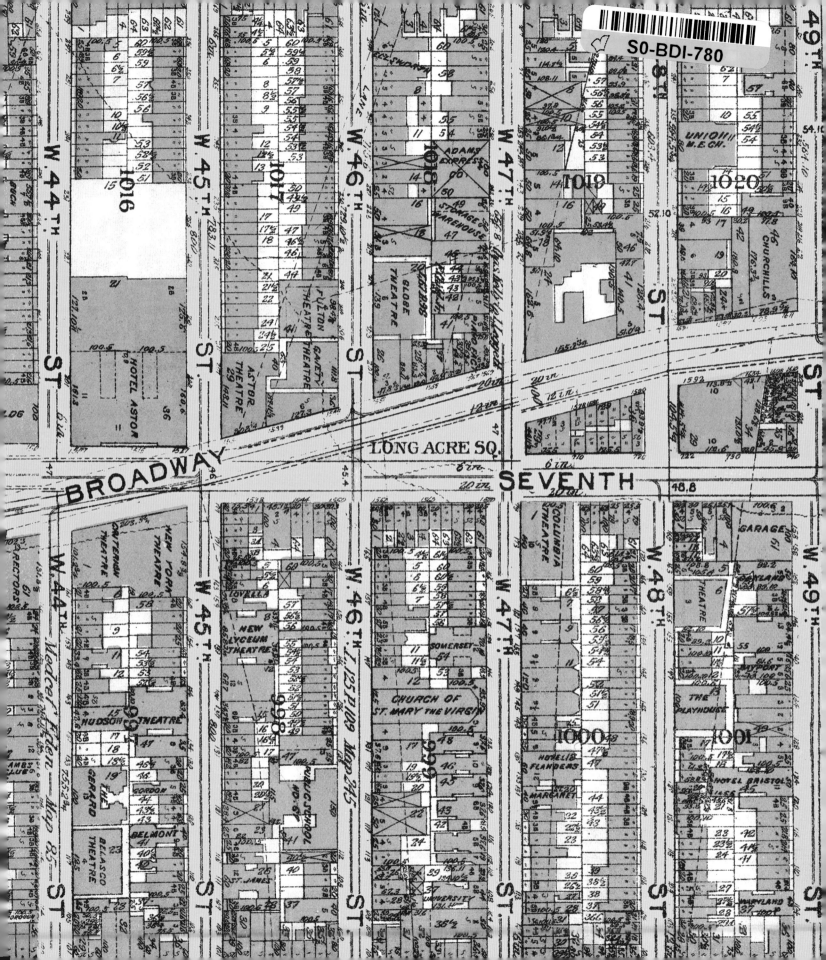

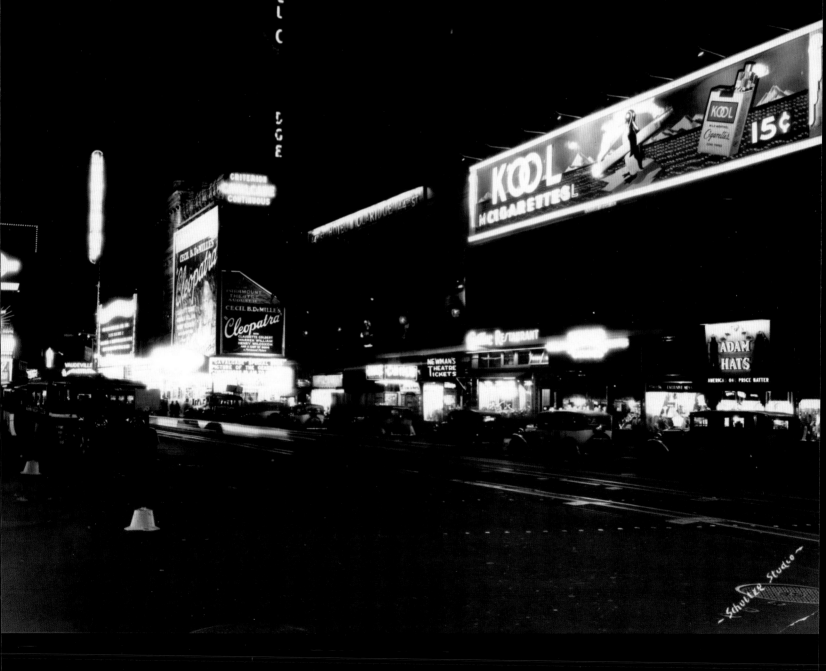

TIMES
SQUARE
Spectacular

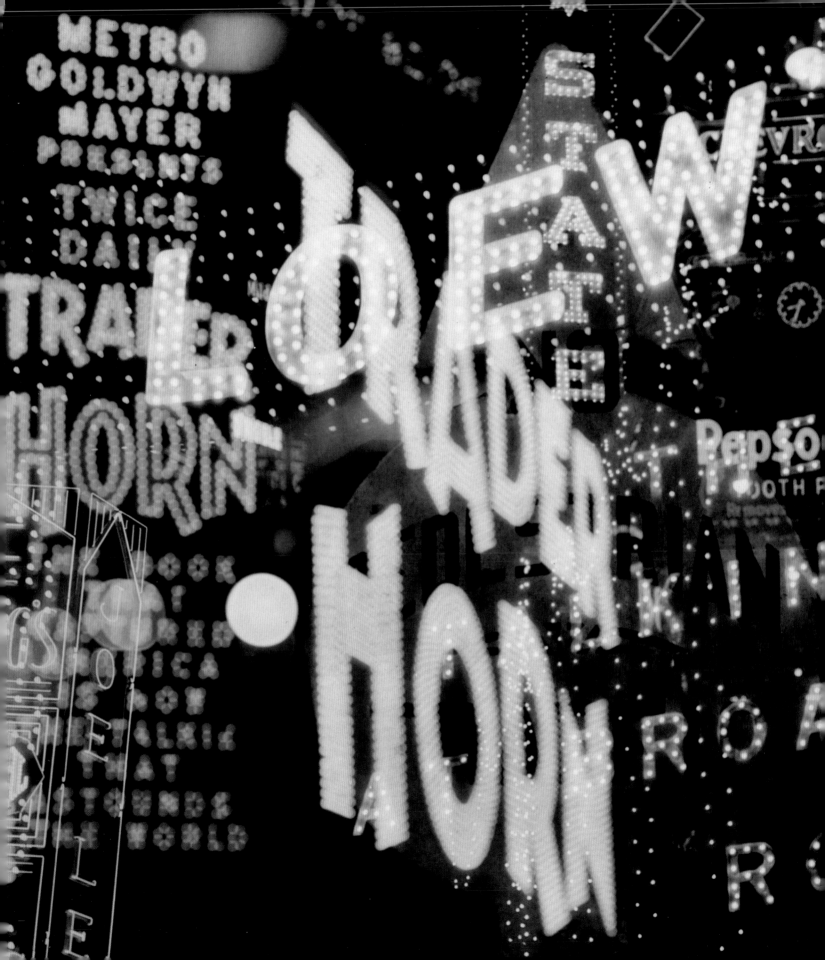

TIMES SQUARE

Spectacular

LIGHTING •
UP BROADWA

Darcy Tell

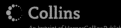

Smithsonian Books

Collins
An Imprint of HarperCollins Publishers

HarperCollins books may be purchased for educational, business, or
sales promotional use. For information please write: Special Markets
Department, HarperCollins Publishers, 10 East 53rd Street, New York,
NY 10022.

Published in 2007 in the United States of America by Smithsonian Books
in association with HarperCollins Publishers.

FIRST EDITION

BOOK DESIGN BY SHUBHANI SARKAR

Printed in China

978-0-06-088433-8
ISBN-10: 0-06-088433-9

07 08 09 10 ID/TOP 10 9 8 7 6 5 4 3 2 1

CONTENTS

Foreword *by Alison Lurie* vii

Introduction ix

ONE Both Sides of Broadway 1

TWO The Great White Way 25

THREE Boomtown 61

FOUR White Way to Midway 81

FIVE Outdoor Theater 103

SIX Raze or Revive? 133

Afterword
 Lighting Up New York 165

Chronology 173

A Note on Sources 179

Acknowledgments 183

Credits 185

Index 189

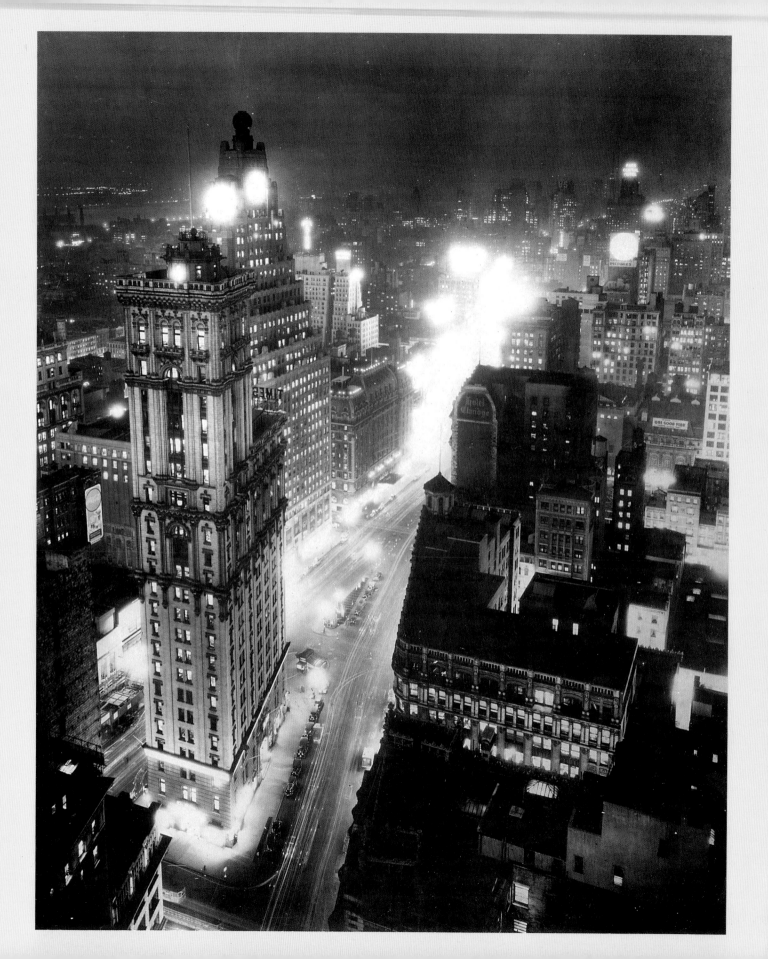

When my sister and I were children living near New York City, we felt very lucky that our father's office was on Times Square, at the corner of Seventh Avenue and Forty-seventh Street. Every year, from the windows of his building, we watched the bright, bulging balloons of Mickey Mouse and his friends in the Macy's parade on Thanksgiving Day. If we were in the city after dark, Times Square was even more exciting: a magical show of color and light. The animated signs gave us the same sort of awe and pleasure as fireworks, and called forth similar sighs of admiration from the crowds in the street. I loved the giant colored waterfalls and fountains, the jerky comic movements of Felix the Cat against a background of a thousand lightbulbs, the plumes of steam rising from an illuminated coffee cup two stories tall, and the giant floating smoke rings blown out over the street by a huge painted soldier or sailor.

When the end of World War II was celebrated in Times Square, my family was on Forty-seventh Street at the edge of the crowd. But as we stood there a sudden surge of sailors and girls separated me from my parents and my sister, and I was shoved onto Broadway and surrounded by shouting, cheering strangers. This was thrilling, but also frightening; almost at once I was dizzy and bruised and had lost one of my new red leather sandals. My father, always calm in a crisis, pushed his way into the mob and retrieved both it and me.

Later, just out of college, I marveled at the Times Square version of the ideal man and woman: the fifty-foot-tall, almost naked three-dimensional figures on either side of the huge Bond clothing store sign. (At the time they looked faultless, though by today's standards the man should have spent some time at the gym, and the woman needed to lose a little weight and do something about her hair.) On New Year's Eve with friends, I watched the ball descend at midnight, twice in person and many times on television.

There is a reason that the celebration of the New Year always takes place in Times Square. For many Americans over the past century, these few blocks, though they contain no official buildings, have been the unofficial center not only of New York City, but of the whole United States. Though, unlike the Mall in Washington, D.C., it has no official political significance, Times Square is one of our most famous national gathering places—a secular center for semiofficial events: parades, holidays, theater and film openings, birthday parties, and award ceremonies. It is where Americans and visitors go to find excitement and fun

Times Square from above at night, late 1920s or early 1930s.

and spectacle, and it is also where for more than a hundred years big business and blockbuster shows have celebrated themselves through giant displays of light and color.

In her expertly researched and brilliantly illustrated book, Darcy Tell records the history of Times Square as a hub of pleasure and profit and spectacle—of society frolics, popular tourism, and sometimes of crime. She portrays its early years as a high-class entertainment center, crowded with carriages and limos and night clubs, theaters and luxurious rooftop restaurants. She traces its later decline into a middle-class and finally a working-class tourist destination, full of cheap souvenir shops and dance halls and picture palaces and fly-by-night con artists.

Ms. Tell is especially good on the effects on Times Square of three historical crises: Prohibition, the Depression, and the blackout of World War II, when many legitimate theaters closed or moved to side streets. She describes the dangerous 1920s and 1930s, when Broadway was dominated by the gamblers and mobsters immortalized by Damon Runyon and by the musical based on his books, *Guys and Dolls*. She covers Times Square's low period in the 1970s and 1980s when nude shows, porn movies, video arcades, and petty crooks dominated Broadway. She also describes the recovery of the 1990s, the cleanup of Forty-second Street, and the gradual, not yet totally complete, reclamation of Times Square for middle-class and working-class tourists and office workers.

Darcy Tell is not only a good writer, she is a remarkable picture historian. This book is full of unusual illustrations: sheet music covers, ads, programs, menus, and also many wonderful photographs—some by the author. They document the growth and apotheosis of the square as a showcase for some of the most famous spectacles in the history of advertising. Ms. Tell is one of the first writers to recognize the Times Square electric display as a form of art. She has also tracked down the biographies of the two eccentric artists who were most responsible for its development. One is Oscar J. Gude, who created, among many other famous displays, the exploding and frothing Canadian Club ginger ale bottle, which, as Ms. Tell suggests, had what she politely calls "a bawdy association." The other, Douglas Leigh, introduced animated cartoons and designed the famous Camel sign that blew smoke rings over an appreciative crowd that hadn't yet heard what cigarettes could do to you.

As a child, I found the lights of Broadway dazzling. Later, however, I became critical: I complained that Times Square, as Darcy Tell points out, was not really a square but two long triangles, which meet in the shape of a stretched-out hourglass. I adopted the snobbish attitude of friends who deplored the brilliant display as commercial, and told me how much more attractive they had found the cities of Japan, where they could not read the names of the products. It has taken this book, with its admirable research, entertaining presentation, and many wonderful illustrations, to correct my mistake and make me want to go back and take another, now better-informed, look at Times Square.

The words *Times Square* conjure up a nearly universal set of images—of the roar as the ball drops on New Year's Eve, of the electric news zip's running headlines, of the blur of speeding cars, of giant neon advertising signs, their colored lights brightening the night. The signs of Times Square are particularly evocative, calling up big national ideas: America, New York, Broadway, the movies, World War II. The signs suggest, too, the big city (in its good and bad incarnations), gangsters, sailors kissing nurses, chorus girls, Busby Berkeley, film-noir mysteries, television crime shows, carnivals, amusement parks, and, of course, sex. These associations may be as insubstantial as air, but they are key to the surprising longevity of Times Square as an iconic image.

Located in the approximate middle of Manhattan and serving as the center of its transportation system, Times Square is known as the "Crossroads of the World." Like many clichés, the term succinctly and precisely describes the reality of this city space where Broadway and Seventh Avenue intersect between Forty-third and Forty-seventh Streets. Millions of people have passed through Times Square each year for the last hundred years, and from this fact has followed everything else that made Times Square famous.

The district's electric signs are the most original and memorable part of its streetscape and define it as surely as architecture has defined other public spaces. Because electricity is an evocative medium that in the blink of an eye suggests excitement and mystery, from its beginning in the 1880s it has been tied (often by marketers) to the sacred or miraculous role given to light. The lights of Times Square have thus automatically been infused with a sense of almost religious transcendence. Such an idea may appear a little unseemly applied to the center of American commerce, but most people's half-conscious perception of the miraculous quality of light is another inescapable part of the enduring appeal of the brilliant signs of Times Square.

After a century, Times Square's electric signscape has remained as fresh and as famous as ever. But how did the signs become so celebrated? The origin of the square's wider fame can be traced to the flowering of local nightlife after 1904, when the city's subway opened. With a raft of new theaters in the Forty-second Street–Times Square area, and a brash new restaurant scene that followed, the neighborhood attracted world attention. Electric advertising signs, which began to move into Times Square at the same time, quickly gave the area an exciting

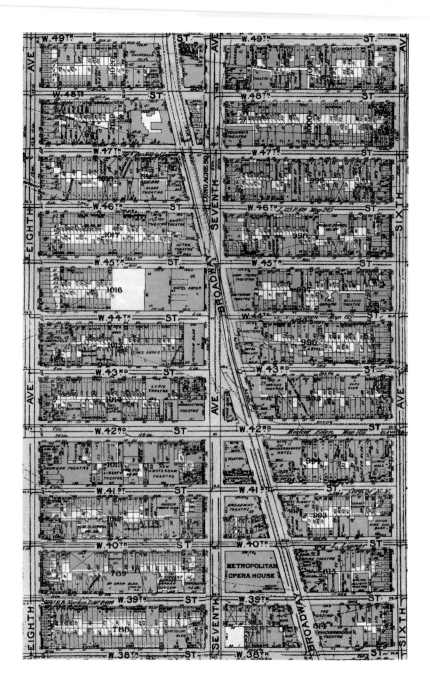

visual identity that symbolized its high-profile night-life.

 After the turn of the century, spectacular signs, as admen and signmakers called them, were a thrilling new international medium. Disposed over the open, elegant space of Times Square, electric signs were breathtaking. The dynamic lines of Broadway and Seventh Avenue were in part responsible. Spreading out and receding above Forty-fifth Street, they set off to perfection the oversized electric "pictures" on roofs and facades. Times Square, marketers and editors discovered, was made to be photographed.

 At first, media attention, the most important engine of long-term fascination with Times Square,

focused on the crowds, the theaters, and the flamboyant nightspots. The over-the-top nightlife—stylish, racy, and full of celebrities—was a natural subject for local journalists, playwrights, directors, writers, and songwriters. The social scene they observed was easily packaged and more often than not sensationalized for national consumption. News of avant-garde metropolitan shows and social customs, not all of it accurate, was enthusiastically consumed by fascinated (or horrified) countrymen. Pitched to a growing tourist market as well, all of the district's businesses prospered.

By the end of the 1920s, Times Square was the country's most successful big-city downtown, but Prohibition (1920–33) brought changes to its nightlife. With many restaurants closed and movies undercutting an already weakening Broadway theater, the Depression had a cataclysmic effect on the local economy. Although the crowds still came for amusement—drawn by the signs, the first- and second-run movies, and a growing number of burlesque and sideshow attractions—businesses that had formed the core of Times Square's prosperity were destroyed. Important commercial construction stopped, live theater was permanently damaged, and the network of famous restaurants, roof gardens, and hotels clung to its national reputation, however clichéd, ever more dependent on tourists for survival.

The balance and the tone of the district were inevitably altered as entertainment there changed from "high class" (a buzzword of the square's first twenty-five years) to working class (a fact of the next fifty years). With smart nightlife dead and the sensational stories that had promoted the district played out, Times Square predictably devolved into a down-at-the-heels area of inexpensive, carnival-style attractions. The decline actually took several more decades, but Times Square—still a magnet for tourists and a dependable source of profits—continued to be one of the most famous places in America. As the neighborhood became tatty, unsavory, and finally dangerous, its extraordinary national reputation was too well established to die easily and too valuable to retool radically.

After 1929 the kind of Broadway imagery used by boosters and marketers, which centered around nightlife, the theater, movies, and electric lights, evolved into a simpler focus on the lights. Unlike the nightlife and the theater, the electric signs of Times Square weathered the Depression well. From the 1930s on, in a period of innovation whose guiding spirit was a brilliant young sign designer named Douglas Leigh, millions of pictures of Times Square signs were distributed to Americans in an unceasing flow of movies, mass-circulation magazines, and Sunday color supplements. These stock images made Times Square's streetscape one of the best-known in the world.

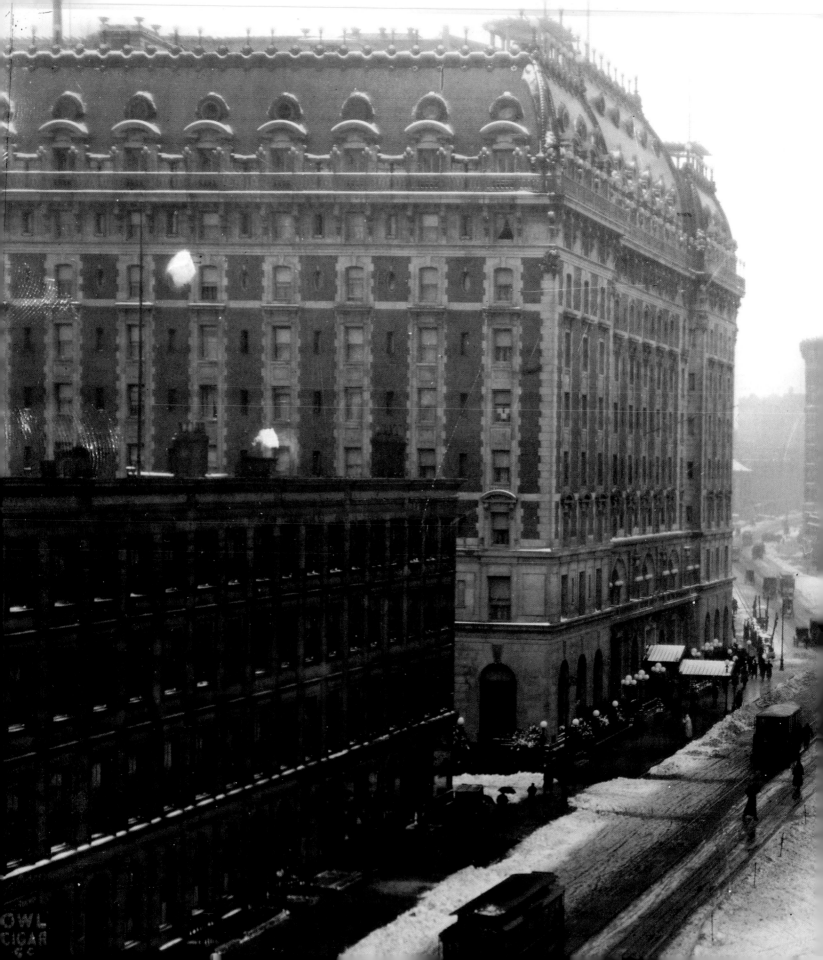

BOTH SIDES
OF BROADWAY

T HE STORY OF TIMES SQUARE IS ROOTED IN THE HISTORY OF BROADWAY, NEW YORK'S LONGEST STREET. RUNNING FROM THE LOWER TIP TO THE VERY TOP OF MANHATTAN—AND FOR MILES BEYOND—BROADWAY EVOLVED WITH THE CITY, FUNCTIONING FROM THE EARLY NINETEENTH CENTURY AS A CENTER OF COMMERCE AND AMUSEMENT: A KINETIC MÉLANGE OF HOTELS, SHOPS, RESTAURANTS, THEATERS, AND CROWDS. AS NEW YORK GREW NORTHWARD, SO DID BROADWAY'S COMMERCIAL AREAS. GROWTH FOLLOWED A REMARKABLY CONSISTENT PATTERN,

with development concentrating in the irregular open spaces formed wherever the avenue angled across the city's otherwise east-west street grid.

The first section to grow in this way, during the 1830s, was the area around City Hall Park, on Broadway between Vesey and Chambers Streets. Broadway south of Houston Street was built up in the 1840s and was anchored by A. T. Stewart's famous department store, which attracted many specialty and luxury shops to Broadway and created New York's first famous shopping district, noted for its press of window-shoppers and "promenaders" of all classes. Entertainment and retailing continued to move north in the 1860s, and by the 1870s Union Square at Fourteenth Street had become the center of the city's shops, hotels, and theaters. Catering to crowds of shoppers, businesses also expanded up Broadway and onto Sixth Avenue between Ninth and Twenty-third Streets, where the Ladies Mile was pa-

tronized by large numbers of New Yorkers and out-of-town visitors. The next such district to develop was Madison Square, at the intersection of Broadway and Fifth Avenue along Twenty-third Street. By the early 1880s, retail businesses, hotels, and amusements had drifted even farther uptown, to what would later be called Greeley and Herald Squares, along Broadway and Sixth Avenue from Thirty-second to Thirty-fifth Streets.

Hindsight makes it appear almost inevitable that continued development in the 1880s and 1890s would push the theater business—already spoken of simply as Broadway—ten more blocks uptown to its ultimate destination in the neighborhood surrounding an unusually spacious, hourglass-shaped plaza formed by the intersection of Broadway and Seventh Avenue between Forty-second and Forty-seventh Streets. Conveniently located at a major trolley junction, the area was easily accessible from the New York

J. Hoyt Toler, "Up Broadway," 1900, sheet music.

1

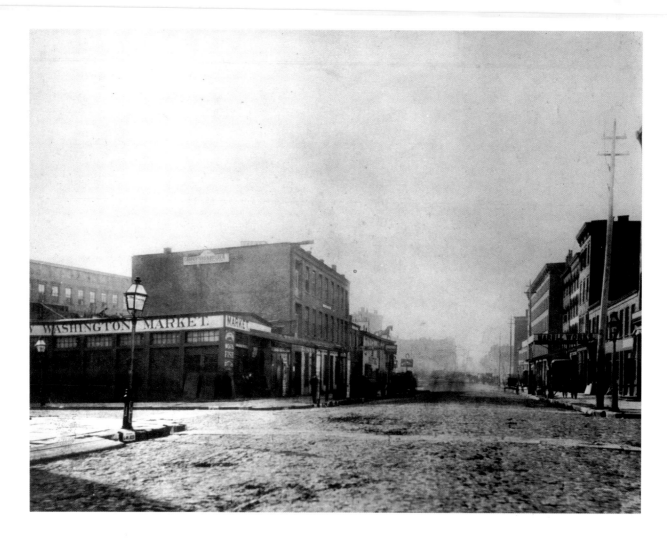

In the 1890s Long Acre Square between Broadway and Seventh Avenue in the West Forties was the nexus of the horse-and-buggy trade, anchored by the Brewster Company's luxury carriage factory at Forty-seventh Street and William Vanderbilt's enormous Horse Exchange at Fiftieth Street. Exceedingly convenient, the area was just blocks from Central Park and a few miles from the uptown trotting courses, where New York's richest equestrians staged sensational team races.

Central railroad terminal, the Sixth and Ninth Avenue elevated trains, and the Hudson River ferry stations. The neighborhood had already proved itself a viable address for at least one high-end leisure industry: the upmarket horse-and-buggy trade was headquartered there beginning in the early 1880s. Dozens of related establishments dotted the area, including an enormous horse exchange, a luxury carriage factory, livery stables, tackle shops, garages, and riding academies—so much horse business, in fact, that the

place became widely known as Long Acre Square, after the coachmaker's district in London.

In 1880, however, few ordinary New Yorkers would have imagined Broadway's Long Acre blocks as a future nightspot—only real estate speculators thought in such terms. The area was considered too far uptown and had yet to lose its reputation as a distant neighborhood. For most of the nineteenth century, the Upper West Side had in fact been a kind of frontier district of isolated vegetable farms, colonial-

A raft of profitable theaters was already operating just below Forty-second Street when the new city subway was announced in 1894. Oscar Hammerstein's block-wide complex of theaters, the Olympia, at left (with a later electric sign), opened in 1895, after which the older buildings in the lower square—stables, residence hotels, and small shops—began to give way to new development.

era country houses, rope-weaving sheds, and shantytowns. The opening of Central Park in 1859 and post–Civil War urbanization had brought significant changes, but not necessarily for the better. Indeed, much of the area surrounding Long Acre was rather forbidding.

The blocks between Thirty-sixth and Forty-seventh Streets just a few avenues west of Broadway and extending nearly to the Hudson River were dominated by light and heavy industry and associated wholesalers—carpet and piano factories, sawmills, several huge gasworks, streetcar roundhouses, breweries, and warehouse lofts. Near the Hudson River piers, railroad barns and sprawling freight yards served various steamship, ferry, and train lines. Most noticeable by far was the extensive network of stock pens and slaughterhouses concentrated there. At this time, New York was still the country's biggest meatpacking center; every year several million hogs, steers, sheep, and other animals were butchered and processed in the vicinity or else herded across town along Forty-second Street to similar markets along the East River—in either case, the slaughter occurred barely half a mile from what would soon become known as the Great White Way. The West Side abattoirs were cheek by jowl with fat-rendering plants, tripe dressers, fertilizer and chemical companies, tanneries, and candle factories. Every week these businesses collectively produced tons of blood runoff and animal waste, vast swarms of flies, and a stench that could sometimes be detected sixty blocks away; laborers from these industries, along with many of the poorest and most desperate New Yorkers, crowded into the notoriously dangerous local tenements.

Immediately to the east above Forty-second Street, by contrast, a more or less middle-class community could be found on the numbered side streets adjacent to Broadway and Seventh Avenue. Several were lined with handsome brownstones constructed in the 1850s by William B. Astor, one of the Upper West Side's largest landowners. Well into the 1890s, Forty-second Street between Seventh and Eighth Avenues—where just after the turn of the century a block-long stretch of theater marquees became the center of Broadway's last important theatrical district—remained an entirely nondescript collection of private homes, modest storefronts, and churches. And although it is true that the streetscape at the Forty-second Street entrance to Long Acre Square was always rather commercial, above the crosstown street the business presence was unremarkable until about 1905. Inside Long Acre were brownstones, residential hotels, and smaller apartment buildings, with the carriage trade clustered at the square's far northern end. The area, with its neighborhood stores and family businesses, looked like the main shopping strip of any other residential neighborhood in

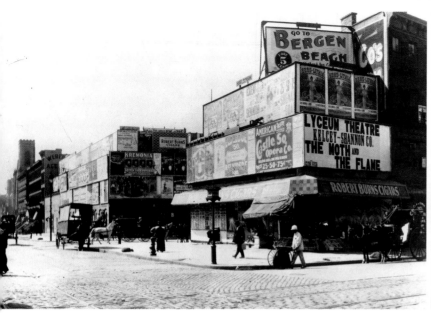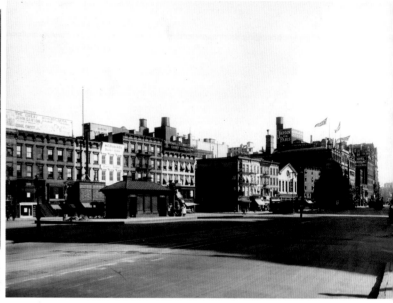

⦾ ⦾ ⦾ ⦾ *(Left)* The blocks surrounding the corners of Forty-second Street, Broadway, and Seventh Avenue had become important advertising platforms by the 1890s. A colorful patchwork of billboards hyped everything from shows to beach fronts to cigars to sparkling water and laxatives. The signs were posted high so they could be seen from all directions—east and west along the broad crosstown street and for blocks to the north and south on Broadway, where crowds promenaded before or after the theater or dining out.

(Right) In 1897 the city decided to pave Long Acre, seen here looking south from Forty-seventh Street. This "improvement" galvanized local residents, who noticed that the new asphalt streets made their houses much hotter and made the square intolerable for pedestrians. A movement was launched to plant trees and install a fountain. The *New York Times*, still headquartered downtown, endorsed the idea, but it came to nothing.

the city. At night its streets were dark and largely deserted.

"HIGH-CLASS" BROADWAY ARRIVES

Several blocks down Broadway, Long Acre's future was beginning to emerge. Between 1882 and 1893, five stylish new theatrical spaces opened between Thirty-eighth and Forty-first Streets: the Metropolitan Opera, the New York Casino, and theaters named the Broadway, the Empire, and Abbey's. For a few years, these elegant venues enjoyed a vogue among upper-class New Yorkers and added an aura of Fifth Avenue style to the area at night. When the Metropolitan opened in 1883 on Broadway between Thirty-ninth and Fortieth Streets, it soon replaced the Academy of Music on Fourteenth Street as the city's most prominent showcase for opera. The Broadway, the Empire,

and Abbey's were known for their beautiful interiors and hosted many of the era's greatest stars. Their elite tone and high-quality programs had a lasting influence on area nightlife as it pushed north above Forty-second Street in the coming years.

The most stylish and innovative of the new theaters was the Casino, which opened in 1882 at Broadway and Thirty-ninth Street. Like the Metropolitan, the Casino, designed by Kimball and Wisedell, was built at the behest of some of the city's most prominent millionaires. Under the management of a German orchestra director named Rudolph Aronson, the theater became a fashionable showcase for European operetta. Aronson's most significant contribution, however, was his invention of the roof garden. The Casino was the first theater in New York to open its roof in the summer, when the auditoriums down-

stairs were closed because of the heat. With land values high and Francophile nightlife fashionable among people like the architect Stanford White (1853–1906) and his society friends, Aronson installed a full European concert garden high above Broadway, with promenades, tables, and a central stage for performances. The manager's programming was appealingly light and essentially forgettable. By contrast, his use of hundreds of twinkling, rather mysterious, electric lights was a Broadway sensation for several years, before the theater was forced to adapt to an expanding, and increasingly popular, market.

By the mid-1890s, Aronson was gone, and the Casino's new managers shifted to vaudeville fare, an evolution that was less a sign of decline than a simple adjustment to the realities of New York's theatergoing public. Soon the Fifth Avenue types had for the most part departed, replaced by middle-class and local patrons who were eagerly cultivated by local impresarios hoping to exploit the chic reputation that had grown up around the Casino and its neighbors. An even greater incentive to growth was

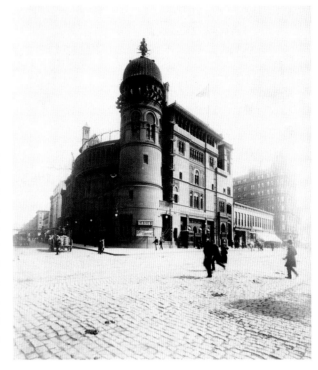

(*Right, top*) **The New York Casino,** a clubhouse and theater built in 1882 at Broadway and Thirty-ninth Street, was modeled on Stanford White's 1880 Newport Casino. Rudolph Aronson, the director of the exotic theater, showcased the latest in European operetta in the main auditorium. The impresario also hit on the idea of building an open-air amusement garden on the Casino's roof, behind the theater's Moorish-style tower.

(*Right, bottom*) **For a time the Casino's roof garden** was a brilliant success with society people, in part because of the beautiful views overlooking the whole of Manhattan. On theater nights, crowds of well-dressed men and women rode by elevator to the roof, where they enjoyed the frothiest of entertainment in a sparkling atmosphere created by thousands of delicate incandescent lights.

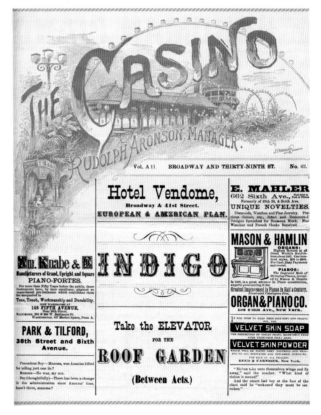

an important city project approved in 1894—a Broadway subway line whose midpoint was to be Long Acre Square.

Tantalized by the idea that mass transportation would soon bring thousands of new customers, competing producers expanded northward. Three important new theaters (all with roof gardens) opened in or near Long Acre Square between 1893 and 1899. The first was the American at Forty-second Street and Eighth Avenue. It was followed in 1895 on the east side of Broadway between Forty-fourth and Forty-fifth Streets by the Olympia, a giant multitheater complex designed by John B. McElfatrick and modeled on Stanford White's world-famous Madison Square Garden of 1890. Both this theater and the Victoria (also designed by McElfatrick), launched in 1899 at the corner of Forty-second Street and Seventh Avenue, were developed by the genius inventor-impresario Oscar Hammerstein (1846–1919), grandfather of the songwriter. Together these houses established the boundaries of Broadway's next theatrical nexus, which in the coming years grew west along Forty-second Street as far as Eighth Avenue and north past Long Acre Square as far as Columbus Circle at Fifty-ninth Street. To appeal to the new customers, producers and managers coined a new term they hoped would evoke the society tone that had briefly reigned at the theaters below Forty-second Street: "high-class" Broadway. Soon, as all commercial activity increased in the wake of expanding entertainment development, the phrase was used to push everything from shows and restaurants to shops to dance lessons and even soda water. The reality of course was quite different.

LONG ACRE BECOMES TIMES SQUARE

The neighborhood taking shape was not to be called Long Acre Square. In April 1904 Mayor George McClellan officially declared another name for the area—Times Square—in honor of a conspicuous new skyscraper being built by the *New York Times* between Forty-second and Forty-third Streets. (Since 1858 the newspaper had been located farther downtown, at 41 Park Row, near City Hall Park at Broadway and Chambers Street.) The day after the mayor's announcement, the newspaper modestly noted that renaming the square was simply preliminary to a much more important event: the opening of the city's new underground transportation system. But the next day's headline made clear what upper management was betting on: "Times Square Is the Name of City's New Centre."

The hype proved true. The new $40 million subway became the linchpin of New York's rapidly expanding transportation network—an awe-inspiring concentration of tunnels, bridges, stations, docks, and rails that ranged from elevated to surface-level to underground. The Times Square stop immediately became the system's most important hub. Set more or less in the middle of the subway route, which ran

⊕ ⊕ ⊕ *(Opposite)* **The Olympia Theatre opened in 1895** in the middle of Long Acre Square, an area that was still dark and unsafe at night. The enormous theater boasted Long Acre's first electric sign, four auditoriums, a roof garden, and a restaurant; Oscar Hammerstein hoped to attract a cross-section of New Yorkers by offering something for all tastes. Like its model, Madison Square Garden, however, the Olympia never made money. By 1898 it had been sold and broken up into three separate theaters.

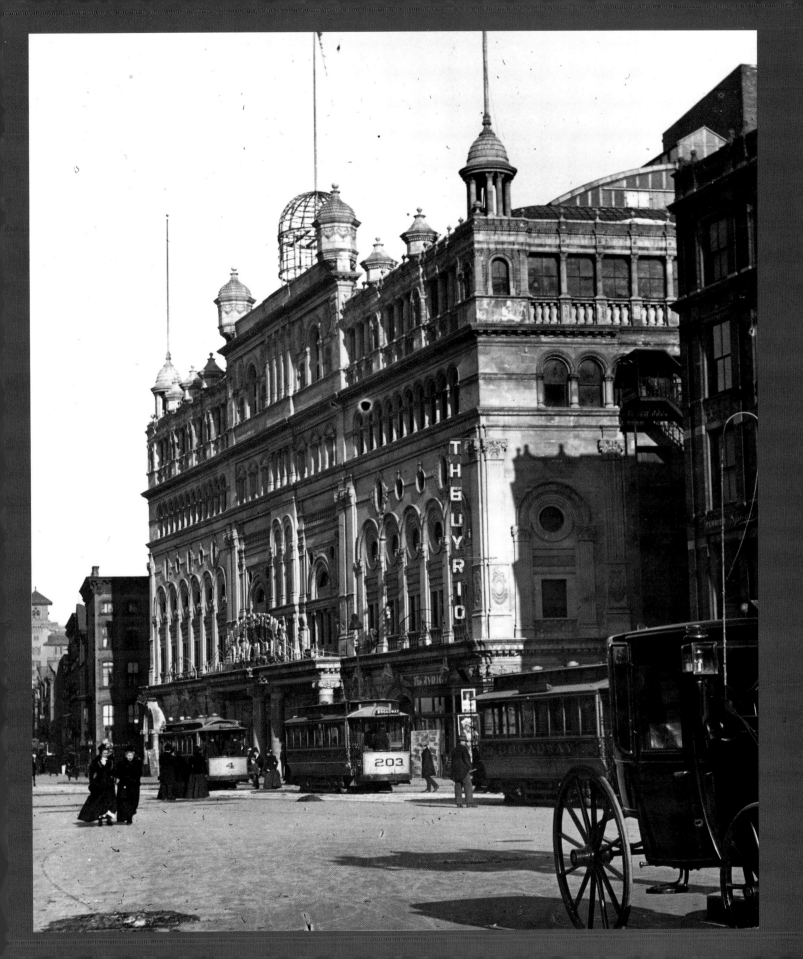

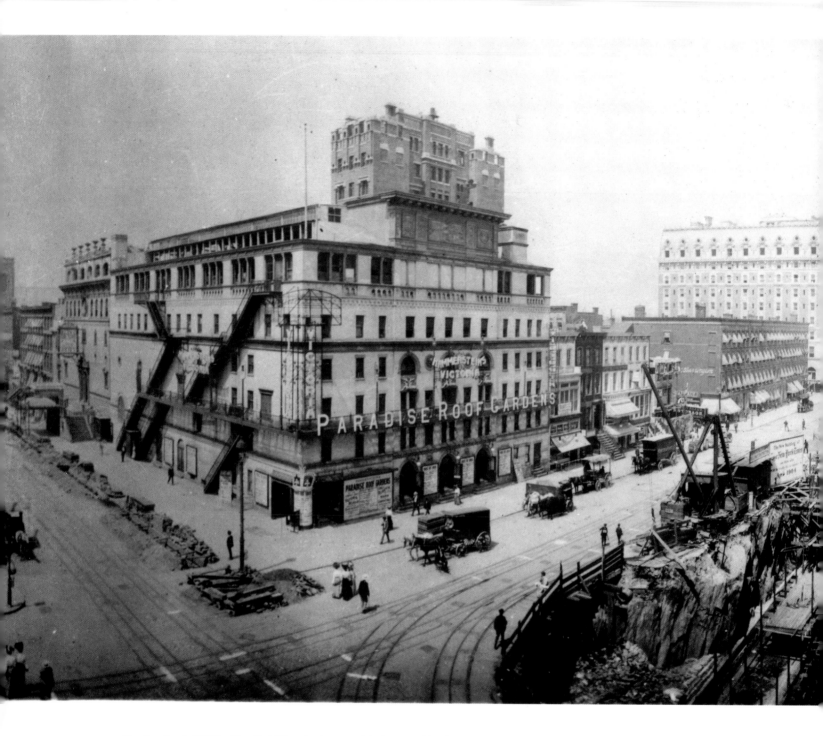

In 1903 the *New York Times* broke ground for its second headquarters, sited on the narrow triangular block bordered by Broadway and Seventh Avenue between Forty-second and Forty-third Streets. At the same time, subway engineers were building tunnels deep under the planned skyscraper's pressroom. Oscar Hammerstein's Victoria Theatre, the most famous vaudeville house of the day, is at left in this view looking north.

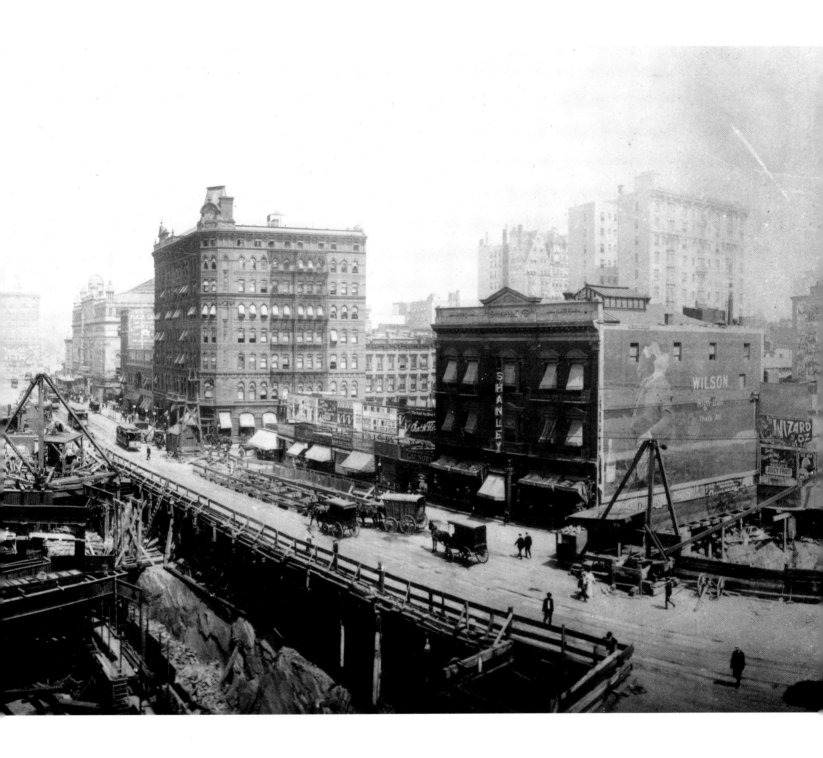

Remarkable Broadway

Long Acre Square developed into a district just as raucous and as mixed as the Broadway of old, where rich and poor had mingled easily, and both high and low fare was available every night on local stages. Stories of Broadway's distinctive street life appeared in travelers' accounts and newspapers that circulated widely in the United States and Europe during the nineteenth century. Certain elements were constant. The daytime avenue was portrayed as a lively place where teeming crowds of people strolled, shopped, ate, observed, or plied their trades. Broadway's nighttime spectacle was even more wondrous, a fascinating landscape of lighted theaters, shops, carriages, and streetlamps typically described as magical.

Some observers wrote admiringly of the famous avenue's elegant promenaders and theatergoers; others offered a salacious and moralizing look at the vice, danger, and extreme contrasts of wealth and poverty to be seen, especially after dark. Broadway had always been a magnet for prostitutes. The trade was brisk inside the avenue's theaters, on sidewalks, and at nearby restaurants, hotels, dime museums, parks, and brothels. Concert saloons, taverns, and dance halls—some of them elegant, most of them not—were particularly notorious sex markets. These places flourished throughout turn-of-the-century New York, offering food, drink, and scandalous entertainment to an almost exclusively male clientele. Men danced and drank with women who were not their wives and then headed off to a nearby hotel room or upstairs to a private cubicle provided by the management.

By the 1880s the uptown sex trade was widespread and open, as New York's notorious vice district followed the theatrical expansion north. Known the world over, the so-called Tenderloin originally extended from Fifth to Eighth Avenues between Fourteenth and Thirty-fourth Streets; by the early 1890s, its northern boundary reached as far as Fifty-seventh Street. Prostitution was everywhere. Concert saloons frequented by "waitresses" operated all along Sixth Avenue, one block to the east of Broadway. Dozens of brothels lined the side streets surrounding the Broadway theaters. Prostitutes walked the streets, accosting men on their way to the theater, scandalizing the neighborhood preachers, and harassing their law-abiding neighbors.

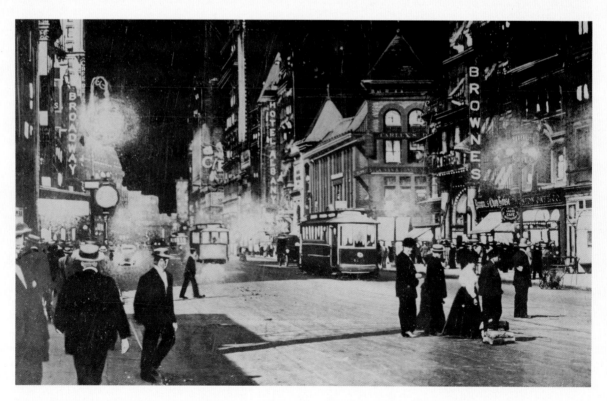

The Upper West Thirties: Broadway shops and cafés after dark at the turn of the century.

from the bottom of Manhattan all the way to 145th Street and Broadway, Times Square was the system's busiest station from the moment it opened in 1904, garnering more than four million riders in its first year alone. The effect on the surrounding neighborhood was dramatic. Over the next few years, with theater owners leading the way, real estate, investment, and retail activity transformed the district's economy, look, and feel.

In January 1905, three months after the subway opened and the square was rechristened, the *New York Times* started publishing from its new building. An elaborate Sunday supplement marked the occasion. This magazine-sized document read like the real estate prospectus it was, meticulously describing the Times Tower's modern amenities to potential business clients looking for office space. In addition to the subway station below, the tower featured seven entrances, four elevators, and three stairways. Two ground-floor arcades for retail shops were intended to be "attractive" spaces set off at night by their lights from the "deserted and quiet" streets outside. The building was close to the city's bridges and tunnels, entertainment, hotels, and Fifth Avenue's growing shopping mecca. At "approximately the geographical center" of New York (a mantra endlessly repeated in the next few years), the location was perfect for business of all kinds.

The most important new tenant was the *Times* itself. To give the skyscraper the highest possible visibility, the newspaper's owners had carefully chosen their site and design. The building sat on a narrow triangular parcel of land at the convergence of a broad crosstown thoroughfare—Forty-second Street—and two wide avenues—Broadway and Sev-

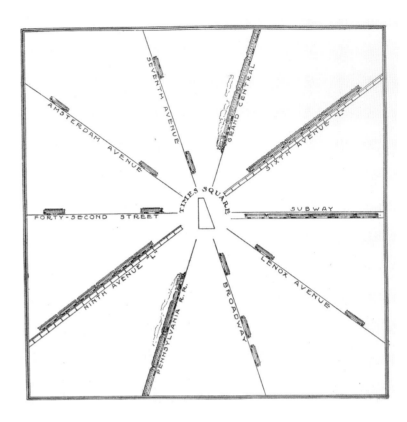

Times Square, as Long Acre Square was officially called after April 1904, was the hub of New York's new subway system, running from the southern tip of Manhattan to the Bronx. After the system opened in October, every day the underground trains carried tens of thousands of people to and from the Times Square station, which was close to railway, streetcar, and ferry lines.

enth. Although it was not as dynamic looking as the famous Flatiron Building (1901–1903) on Madison Square, Cyrus L. W. Eidlitz's Times Tower effectively defined the street space inside the newly named square. The skyscraper's triangular, prowlike form nicely complemented the long sight lines to its north and to the south, which offered perhaps the best vistas on all of Broadway.

The Times Tower perfectly expressed the paper's grand ambitions for its new square. Rising 362 feet, it was the city's second tallest building when it

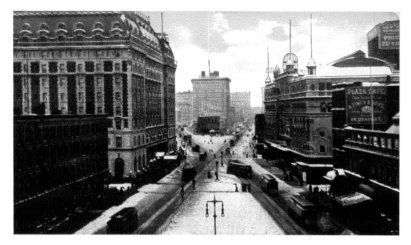

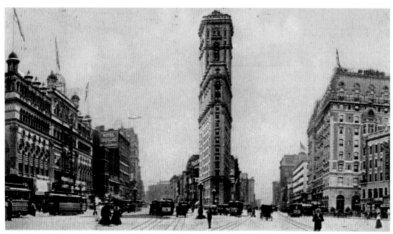

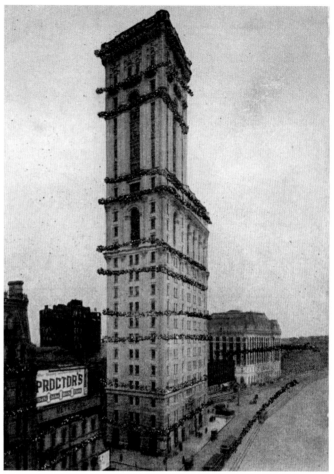

(Left, top) **This hand-tinted postcard** from about 1908 of the north end of Times Square shows three buildings that in a short time helped transform the rather ordinary Long Acre Square into a modern commercial neighborhood: the Hotel Astor at left, the Olympia complex at right (after it was converted into separate theaters), and at the top the Studebaker Building (1902), which housed showrooms for the company's newest product, luxury cars.

(Left and right) **After the Times Tower opened** at the square's south end in 1905, it quickly became the first iconic image of Times Square. The new skyscraper was depicted widely on postcards, book covers, programs, posters, magazine illustrations, tourist brochures, sheet music, and manufacturers' giveaways.

opened (after the Park Row Building of 1899). With it, the owners embodied their desire to create a "civic adornment" that could remake the dowdy neighborhood and inaugurate an "era of permanent growth" in the surrounding blocks. They also intended that Times Square, once remade, would become a municipal gathering place to rival City Hall Park, Trinity Church, and Madison Square, the sites of the city's most important celebrations since the previous century.

"Direct from Broadway"

Theater construction in New York surged after 1900, leading the way in Times Square's development. By 1910 seven theaters on Forty-second Street between Broadway and Eighth Avenue and six more in Times Square were being touted, not inaccurately, as the greatest concentration of theaters in the world. Four of the houses on Forty-second Street, erected in 1903 and 1904, owed their existence to a furious competition among Broadway producers. The struggle pitted the Theatrical Syndicate, a classic Gilded Age business monopoly established in 1896, against independent Broadway producers, including Oscar Hammerstein and David Belasco. The stakes were high—not only for success on Forty-second Street but for control of "the roads," the enormously lucrative market for theatrical entertainment throughout the country.

New York City had always been the center of theater in America. Before the Civil War, Broadway was built around resident stock companies that performed a changing roster of works during a lengthy stay at one theater. In the 1870s Broadway producers started to centralize theatrical production. They debuted star-filled shows on Broadway and then, after their initial runs in the city, sent them on tour, with either the original cast or "duplicates." With Broadway as home base, hundreds of touring productions crisscrossed the nation by train, playing stands in towns and cities of all sizes. By the mid-1890s, independent theaters across the country were pressured to join circuits, which were networks of local houses (in towns usually located along regional rail lines) whose bookings, productions, and schedules were controlled by theatrical combines based on Broadway. Soon the idea expanded to vaudeville and burlesque, which made up another significant part of the national entertainment market. By the turn of the twentieth century, live theater was the country's most popular entertainment.

"Direct from New York" billing ensured out-of-town success, and the powerful Broadway impresarios competed to supply bookings to hundreds of theaters around America. More and more theaters were built in New York City to launch the growing number of shows for the national market. As Broadway became a concentration of competing theatrical monopolies and circuits, New York producers gained both economic power and extraordinary cultural reach nationwide. Times Square—with its growing number of theaters, swarms of customers, and increasingly high-profile nightlife—became the undisputed center of American entertainment.

Headliners Lillian Russell (top) and Anna Held, two of Broadway's biggest stars at the turn of the century, toured their many hit shows throughout the country.

May 15 Cents

Everybody's Magazine

"LOBSTER PALACE
SOCIETY"
by Julian Street
assisted by
James Montgomery Flagg

THE RIDGWAY COMPANY PUBLISHERS NEW YORK

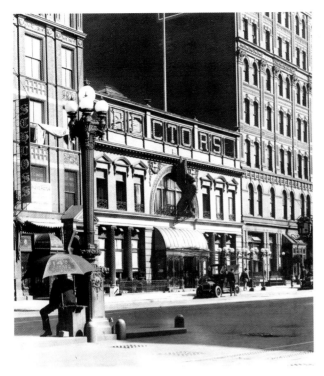

(Left) **Seemingly overnight** Rector's Restaurant, designed in a fashionable Italianate style, became the most famous nightspot in America after opening in 1899. Broadway's most glamorous celebrities and America's richest businessmen gathered here after the theater to eat broiled lobster, drink champagne, and amuse themselves. The Rector's griffin, Long Acre's second electric sign, was so famous that the owners tried to patent it.

(Opposite) **New York's lobster-palace craze** was launched at Rector's, which started the trend for ostentatious restaurants in Long Acre. The middle-class men and women who flocked to the lobster palaces after 1910 were easy targets for tireless and often sardonic coverage by the press as well as a predatory network of waiters, cabbies, and barmen who collected thousands in bribes and tips; the hatcheck concession alone was worth tens of thousands of dollars each year.

LOBSTER-PALACE SOCIETY

An establishment even more important than any single Broadway theater had come on the scene in 1899. Rector's Restaurant, located between Forty-third and Forty-fourth Streets, was New York's first "lobster palace," so designated because the restaurant's owners claimed to have started a craze in New York for fresh lobster. The nickname soon came to connote much more: Rector's glamorous demimonde and its exceedingly conspicuous consumption of liquor and extravagant delicacies. In true Gilded Age style, the restaurant cleverly imposed an expensive, "society" patina on amusements drawn from the dance halls and concert saloons of New York's least respectable districts. Rector's deliberately imitated the decor and menus of Fifth Avenue hotels and society places like Sherry's and Delmonico's, but it abandoned their exclusive atmosphere in favor of ostentation and Broadway theatricality.

Rector's created a remarkable scene that George Rector, who ran the restaurant with his father, Charles, fittingly described as a "cathedral of froth." Here his celebrity clientele could meet after the theater to drink champagne, eat pretentious and expensive meals, and, above all, be seen. Rector's signature was glamour; its in-crowd mixed Broadway actresses, playwrights, critics, chorines, producers, Wall Street types, Fifth Avenue heirs, out-of-town magnates, European princes, and social climbers of every variety. In a deluxe, ritualized atmosphere, men and women drank, gambled in the private rooms upstairs, gossiped, flirted, and made deals. Overnight, Rector's became the best-known nightspot in America. Imitators, many of whom already managed restaurants near the Casino, hurried to cash in on the trend for big new places above Forty-second Street.

Nightlife boomed, thanks to countless feature stories, gossip items, and exposés and satirical articles in the national press. In 1906 the *Times* estimated that eight thousand people dined in the neighborhood each night, with some spending a thousand dollars for a meal. Times Square's nightspots became

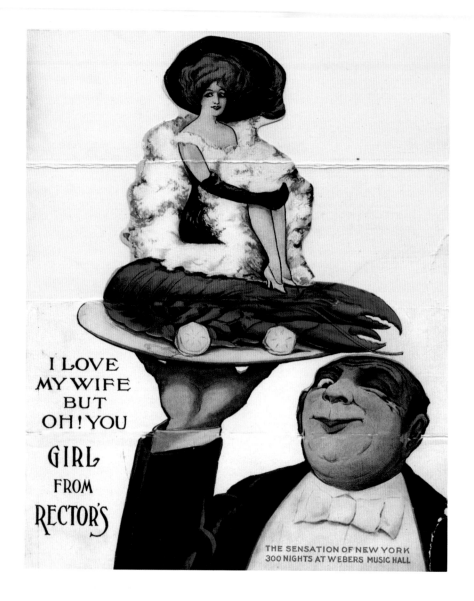

I LOVE MY WIFE BUT OH! YOU GIRL FROM RECTOR'S

THE SENSATION OF NEW YORK
300 NIGHTS AT WEBERS MUSIC HALL

famous for the curious, fashionable mix of elite and low-life activities in their dining rooms. In spite of the buzz (and the enormous profits), the new restaurants were controversial. As critics saw it, the scores of "nice" women who came to the lobster palaces—accompanied by their husbands or gentlemen friends—indulged in behavior that in earlier years only prostitutes and "loose" women would have dared to exhibit in public. Progressive reformers and "social hygiene" crusaders were vocal in their condemnation, and city authorities periodically cracked

down. Given the salacious and illegal activities that went on openly in parts of the neighborhood, more than simple prudery motivated these fears. Reform efforts notwithstanding, however, Rector's and other lobster palaces flourished. Nice women and even unmarried girls became a permanent fixture in the Broadway nightspots, where they smoked, drank, and (eventually) danced late into the night.

Many lobster-palace regulars publicized the local scene outside New York, using the "Broadway life" they themselves lived as material for plays, fiction,

poetry, song lyrics, and thousands of newspaper and magazine stories. Familiar themes from the past persisted. Some writers celebrated high society on Broadway, while others dwelt, in those class- and deportment-obsessed years, on the scandalous collision of cultures, the neo-Tenderloin amusements, or the fascinating extravagance of such Broadway celebrity patrons as Diamond Jim Brady and his friend Lillian Russell—larger-than-life figures famous for their sensational lifestyles. Whether exaggerated, critical, fawning, or simply descriptive, constant publicity made the new Times Square something everyone in the country had to know about.

FIFTH AVENUE AT BROADWAY PRICES

Times Square was clearly no longer too far uptown. At the turn of the century, important parcels of land in the area were still held by families and estates that had owned them for decades, but the arrival of the subway and the continuing publicity surrounding the theaters and restaurants made Times Square one of the city's hottest real-estate markets. At one point the neighborhood was so desirable that the city's police commissioner proposed moving his department's main headquarters to the central triangular block dominating the square's north end, between Forty-seventh and Forty-eighth Streets—a plan mocked as an act of hubris and rejected in short order, with the *Times* arguing that it would not be in the public interest to sacrifice such prime commercial real estate.

One strong trend emerged to support the *Times's* ambitions for the area: a boom in hotel development, kicked off by two rival Astor-family cousins, William Waldorf Astor (1848–1919) and John Jacob Astor IV

(1864–1912), each of whom backed a large-scale project in the square. The new hostelries were modeled on the Waldorf and the Astoria, which the cousins had built on Fifth Avenue in the 1890s, inaugurating a wave of new hotels on the East Side. At a time when the brightest lights and theaters were still massed below Forty-second Street, both Astors chose to develop large Renaissance-style hotels for the West Side above this boundary. The *Times* wholeheartedly embraced the projects, and "high-class development," as the paper called it, was successfully established in the square.

Opened in 1904, William Astor's Hotel Astor ran the whole north-south block on the west side of Broadway between Forty-fourth and Forty-fifth Streets— right in the middle of Times Square and directly across from Hammerstein's gargantuan Olympia complex. The twelve-story hotel, designed by Clinton and Russell, was a deluxe, commodious place with up-to-the-minute mechanical features that attracted droves of affluent tourists and businessmen. It had six hundred rooms, four hundred bathrooms, and a "great variety" of public spaces on the ground level and two floors below. A roof garden, a restaurant, private dining rooms, and banquet halls offered the same drinks, food, and ambience as the East Side hotels and the local lobster palaces. Like them, the Astor interiors were intended to convey a sense of luxury. Public rooms were extravagantly decorated in different historical styles popular at the time, including a hunt room, an Indian grill room, a Flemish room, rooms with Old New York themes, and three rooms designed to look like yacht interiors. Decorations ran to Chinese, Pompeian, colonial, oriental, and art nouveau. As one important social ritual of the

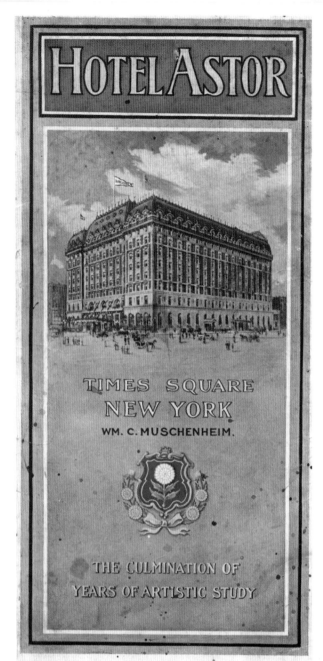

HOTEL ASTOR

TIMES SQUARE
NEW YORK

WM. C. MUSCHENHEIM.

THE CULMINATION OF
YEARS OF ARTISTIC STUDY

BELVEDERE DINNER RESTAURANT

(Above) **In 1909, just five years after** the Hotel Astor opened, its owners expanded the ballroom, doubled the rooms, and installed a block-long roof garden with sensational views of the Hudson River. Using an awe-inspiring battery of modern mechanical devices— elevators, electric shovels, heaters, steam laundries, dumbwaiters— the staff efficiently served thousands of elaborate meals each month.

(Left) **The Hotel Astor,** between Forty-fourth and Forty-fifth Streets, was the idea of a German-born restaurateur named William Muschenheim, who was convinced that Long Acre Square was destined to be an important commercial center. At night, the Astor's roofline, like that of the Knickerbocker Hotel, was picked out by bulbs that drew the outlines of the modern French-style facade in light high above Broadway, some-what in the style of the Casino roof garden.

Gilded Age—the banquet—persisted into the twentieth century, the Astor helped sustain the form.

The hands-on proprietor and driving force behind John Jacob Astor's Knickerbocker Hotel on Forty-second Street was James B. Regan (1865–1932).

Like many of the lobster-palace men, Regan had worked in the neighborhood long before the subway-and-theater boom got under way, and he had developed useful political connections in the Tammany Hall machine. After a shaky start—a disagreement

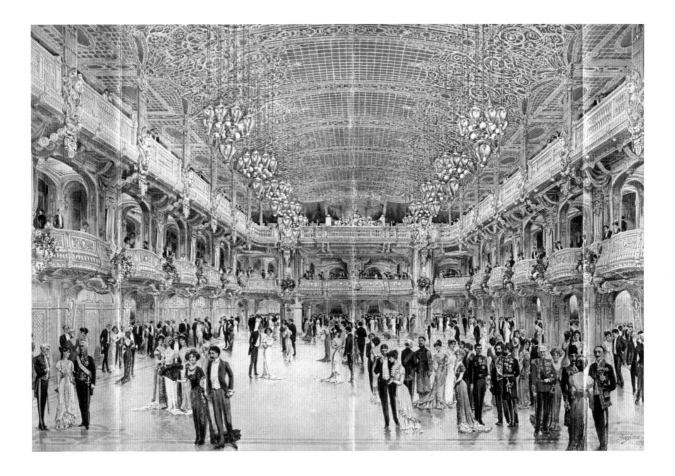

The well-known Broadway set designers Unitt and Wickes created a versatile new ballroom space for the Astor in 1909. Seating more than twelve hundred people, the room had a movable stage that could be raised to a balcony, an elaborate trompe l'oeil lattice ceiling installed with electric lights and reflectors, and the world's largest Wurlitzer organ. For a half century members of New York's social, civic, charitable, and professional organizations dined and danced in the Astor's public rooms.

between Regan and his partners stopped the hotel's construction for more than a year—he finally persuaded Astor to invest in it. Working with architects Trowbridge and Livingston, the two revised the original plans after office rentals at the Times Tower seemed to confirm the neighborhood's solid commercial potential. When the Knickerbocker finally opened in 1906, at sixteen stories it was taller and much more luxuriously outfitted than first envisioned. The upgrades put the project a million dollars over its original budget.

The Knickerbocker's interior was similar to that of the Astor. On the main floor was a French chateau-style dining room. The bar, known as the "Forty-second Street Country Club" because of its many society regulars, served a celebrated free lunch and was decorated with a Maxfield Parrish painting of Old King Cole that became famous. A grand ballroom occupied the second floor; and one of the hotel's many private dining rooms had a solid-gold table service for forty-eight. Although the Knickerbocker had no roof garden, an outdoor restaurant was open in the summer. Altogether, the various bars, restaurants, and grill rooms could seat two thousand people at once.

Like the Astor, the Knickerbocker aimed its services and amenities at traveling businessmen,

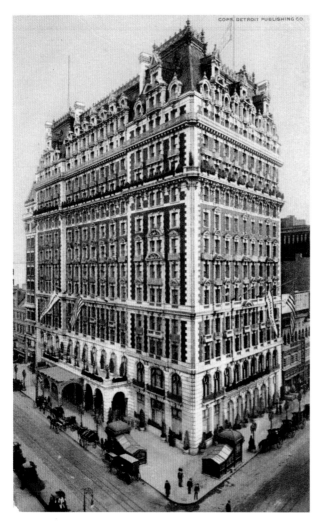

COPR. DETROIT PUBLISHING CO.

ALL THE NEWS FIT TO POST

Not surprisingly, the first attempt by the proprietors of the *New York Times* to bring mass attention to "their" square involved the news. In November 1904, even before their new building was opened, the editors mounted large bulletin boards on both the Forty-second and the Forty-third Street facades and posted that year's election results. (New York newspapers had used bulletin boards to post breaking news since the Civil War.) At the end of the evening, a rooftop searchlight broadcast the results to both ends of Manhattan and the region thirty miles around it—a steady beacon to the west was to indicate a win for Theodore Roosevelt and one to the east was for his opponent, Alton B. Parker, both of them New Yorkers.

The beacon was a daring touch. These large drum lights, which could beam shafts of bright light across the night sky and brought out dramatic, unexpected shapes and shadows when projected onto nearby buildings and streets, were famous by 1904. At a time when electricity was a cutting-edge technology approaching the height of popularity, millions of people had read descriptions of beacons and other dazzling light shows at recent world's fairs. New York City already had several well-known searchlights, including the electric beacon next to the figure of Diana on the tower of Stanford White's Madison Square Garden, and the sensational arc light at the Dreamland amusement park in Brooklyn (1904). The beacon on the Times Tower became an early signature

celebrity tenants, and affluent visitors. Everything was available to the hotel's patrons: two dedicated subway entrances, on-staff nurses, ticket brokers, a newsstand, barbers, and manicurists. Both hotels were popular for a while with elite New Yorkers, but like the fashion for roof gardens at the Casino and Madison Square Garden, the vogue was short-lived. As subway trains carried more and more people into the district, the resulting explosion of business activity—tourism, retail, real estate, entertainment, and advertising—soon overwhelmed whatever Fifth Avenue patina had been introduced.

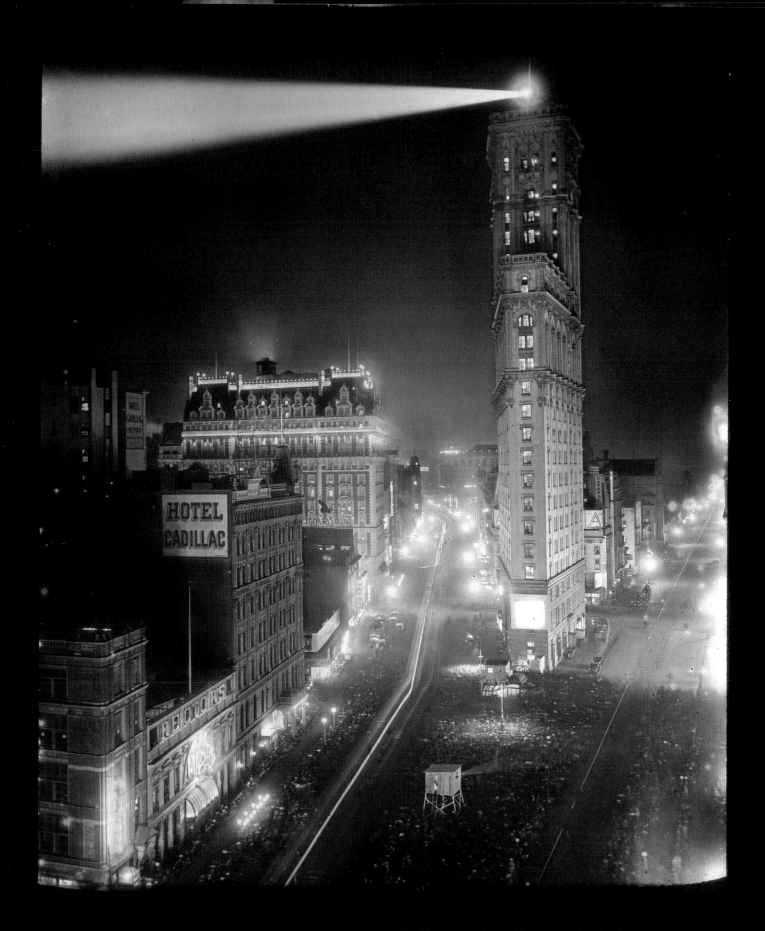

feature of what continues to be Times Square's most famous and celebrated event: New Year's Eve. The brilliant searchlight helped cement Times Square's association with bright, carnival-style lights and holiday abandon.

The first New Year's Eve show at the Times Tower took place in 1905, the year the newspaper moved into its finished building. At the time, the square—sometimes called "Thieves' Lair" before the turn of the century—was still relatively dark and forbidding. In the absence of municipal streetlights, an anonymous donor supplied several large gas lanterns that shed an eerie bright light surrounded by pools of inky darkness. Across the square to the east were only a simple electric sign on Hammerstein's old Olympia Theatre (the impresario had installed his own generator) and an electric sign at Rector's Restaurant; although renowned throughout the world as a symbol of Broadway nightlife, the latter was actually rather small.

So the *Times* went all out to greet the New Year. Perhaps trying to evoke the light extravaganza the city had put on for Admiral Dewey in 1899 after his victory at Manila Bay, the *Times* mounted a show with fireworks, electric decorations, and live music. Large colored dates were posted on both the north and the south sides of the building—large enough to be seen by people as far away as Queens and New Jersey. The skyscraper was illuminated from top to bottom all night, a tower of twinkling lights that changed from white to various colors at midnight. Fireworks started the instant afterward, the beacon played dramatically over the skies, and to the roar of a crowd that overflowed the square below were added cowbells, whistles, horns, and steam signals from ships, factories, and trains in and around Manhattan. Over

the next few years, the newspaper's lighting designers added new tricks, including electric streamers and arrangements of blinking bulbs that simulated waving banners. Seemingly overnight the festivities, lovingly reported in the next day's papers, became a permanent annual tradition. By 1911 the old-fashioned New Year's celebrations staged at Trinity Church, City Hall Park, and Madison and Union Squares were already fading from favor.

After city officials banned fireworks for safety reasons in 1907, the midnight "ball drop" was introduced as a substitute attraction. The lighted glass ball itself was a clever adaptation of the device ships then used to synchronize their chronometers. "Time balls," as they were called, were set atop poles placed at prominent spots in major harbors—New York's was on the Western Union Building at Broadway and Derry Street—and they dropped from their perches every day at exactly noon. The *Times* celebration stood this tradition on its head. At exactly midnight on December 31, 1907, a glowing, five-foot-wide electric orb descended down a flagpole on the Forty-third Street side of the Times Tower, triggered a circuit connection at the flagpole's base, and lighted up four giant arrangements of incandescent bulbs that spelled out 1908 on each side of the building. As usual, the tower remained illuminated all night long and bands played into the early morning. Except during World War II blackouts, much the same ritual has been performed every year since (although the *Times* long ago abandoned its sponsorship).

Thus the New Year set piece of a thousand Hollywood movies was born in Times Square: men and women in evening dress, wild noisemaking, staggering drunkenness. From the beginning, the area's

hotels and restaurants overflowed, but by the early 1910s—consistent with the neighborhood's general trend—the merrymakers were a little less stylish. Increasingly it was out-of-towners who booked the tables, and they did so by the thousands. Then, as now, hotels and restaurants inflated their prices for the occasion. Indoor festivities, meanwhile, grew increasingly baroque as the old lobster-palace scene gave way to cabaret and "general dancing." Dining rooms were festooned with elaborate lights, and chorus girls spilled petals on guests. Tightrope walkers, aerial dancers, and never-ending bottles of champagne enlivened the festivities.

Serious-minded observers disapproved. In 1913 the reformer Jacob Riis designed an alternative, "sane celebration" of hymns and choir music in City Hall Park and Herald, Madison, and Union Squares. The noise up and down Broadway, however, drowned them out, and the gathered congregants could not hear themselves sing. The next year, the *Times* estimated that on December 31 a half million people went to the theater and movies all over the city, and fifty thousand of them eventually made their way to Times Square to greet the New Year. The Times Tower became the first real icon of Times Square after thousands of pictures showing it circulated around the country. The image they showed of a lone tower looming over Broadway, often lighted from top to bottom, did not reflect reality for long. By 1910 the neighborhood was changing rapidly. Between three hundred thousand and seven hundred thousand buyers, businesspeople, commuters, office workers, restaurant and theater patrons, and tourists were traipsing through Times Square night and day. Although it resembled other downtown entertain-

Although **Fifth Avenue** continued to be the site of New York's most important parades, from its first years Times Square hosted dozens of colorful regimental parades, jazz funerals, vaudeville stunts, and welcoming and farewell ceremonies for celebrities and political figures. Local merchants decorated with the usual bunting and flags seen here to celebrate the 1908 Paris–New York automobile race, which ended in Times Square.

ment and shopping districts in America, the scale and the growing celebrity of the square were unmatched anywhere in the world.

Before long, the most popular attractions in the district were free: enormous electric advertising signs that sprouted on roofs all around Times Square. Even on Sunday evenings, when the theaters were closed, crowds came to stroll up and down Broadway to stare at the latest dazzling spectaculars. The neighborhood would never be dark again.

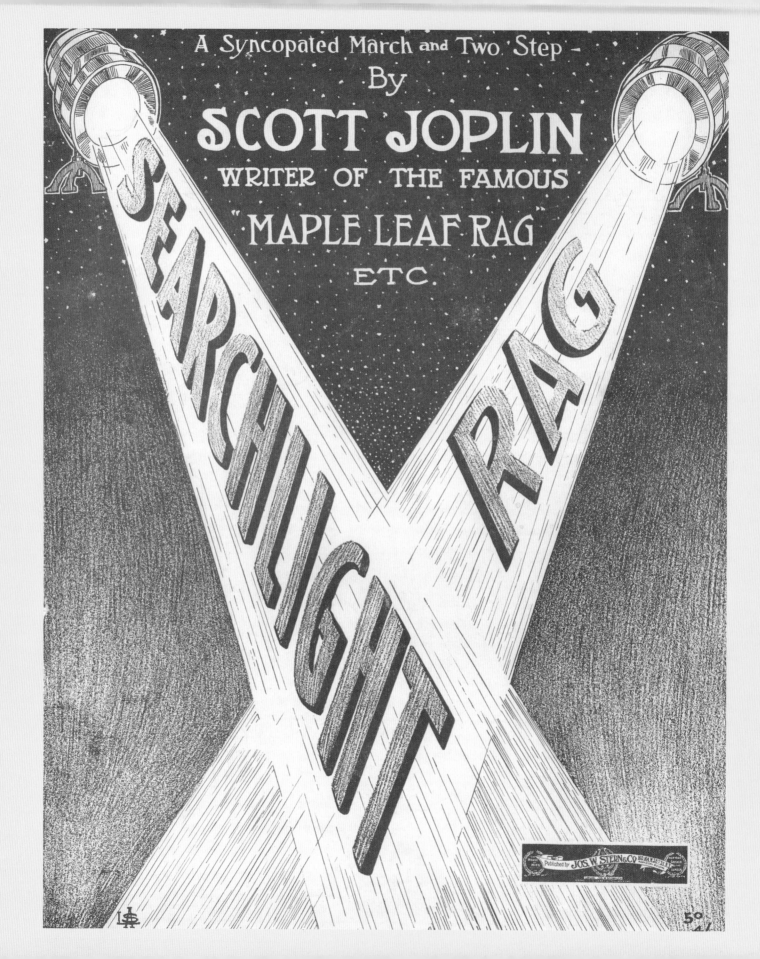

ALREADY WORLD FAMOUS FOR ITS BRIGHT GASLIGHTS, BROADWAY BECAME NEW YORK'S FIRST ELECTRIFIED STREET IN DECEMBER 1880. STREETLAMPS DEVELOPED BY THE BRUSH ELECTRIC COMPANY (AN EARLY INDEPENDENT DISTRIBUTOR) WERE INSTALLED AS AN EXPERIMENT ON ABOUT A MILE OF THE AVENUE'S DOWNTOWN SECTION, FROM FOURTEENTH TO TWENTY-THIRD STREETS. BY THE EARLY 1890S, LIGHTS COULD BE SEEN FROM THIRD TO EIGHTH AVENUE ALL THE WAY NORTH TO CENTRAL PARK, AND MOST OF THE MIDTOWN CROSS-STREETS

were lighted from river to river. In just ten years, New Yorkers had become accustomed to the brighter, more reliable electric lights. Tourist guidebooks regularly raved about the city's electrical system, which was rapidly becoming one of the most advanced in the world. New York continued to be an important electrical showcase as the United States shifted to electricity in the next few decades.

European inventors had experimented with outdoor lighting as early as the 1840s, when arc lights were demonstrated in several squares and streets in Paris. As the century progressed, American companies took the lead in perfecting the new power source for industrial distribution. Thomas A. Edison (1847–1931) made important advances. In 1880 he patented a commercially viable incandescent bulb, which cast a softer light than the blindingly bright arc lamps then coming to market. Edison also improved electri-

cal generation and established distribution systems in the United States and Europe.

Incandescent lights, which opened the way for the use of electricity indoors, were a watershed advance for outdoor lighting as well. Marketers and lighting engineers, to their delight, found that the new artificial light could excite and enchant viewers with bold as well as subtle effects. Quickly thinking beyond electricity's obvious utilitarian potential, they rushed to exploit it as a visual medium. In particular, incandescent bulbs could amaze people by mimicking natural features they loved—moonlight, stars, comets, fire—making electricity the perfect vehicle for all kinds of decorations and spectacles.

Merchants in Broadway's smart commercial sections began to use electric lights for signage and interiors in the 1890s. At the time, these street fronts presented a busy collage of words and images: names

Scott Joplin, "Searchlight Rag," 1900, sheet music.

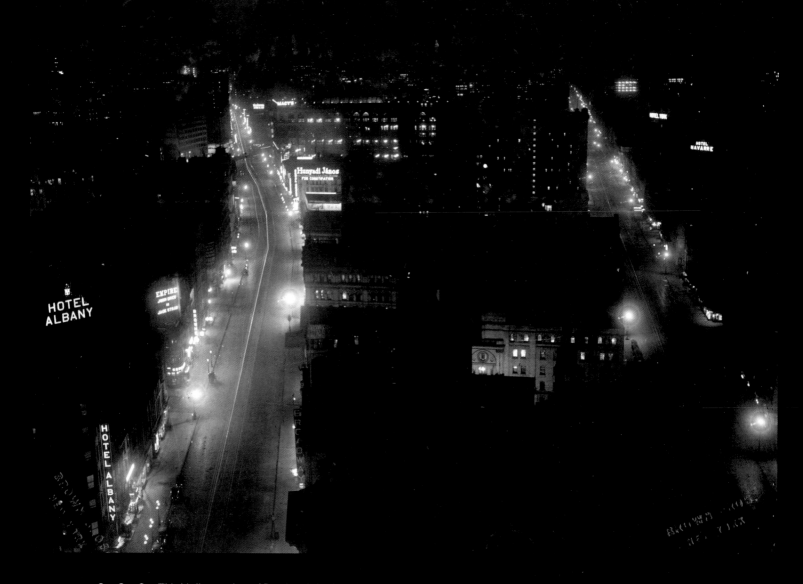

● ● ● **This bird's-eye view** of Broadway lights from the turn of the twentieth century, probably taken from the Times Tower, was a novelty. Enthusiasm for electrical decoration created by Broadway photographs like this one helped inspire thousands of lighted downtown shopping streets across the country, many of them also called Broadway.

● ● ● **The year after** Broadway was electrified in 1880, more lights were commissioned for the avenue. Among them were startling 160-foot-tall fixtures known as "sun towers." The bright arc lights on the towers—seen here in Madison Square near the junction of Fifth Avenue and Broadway—were immediately popular with New Yorkers.

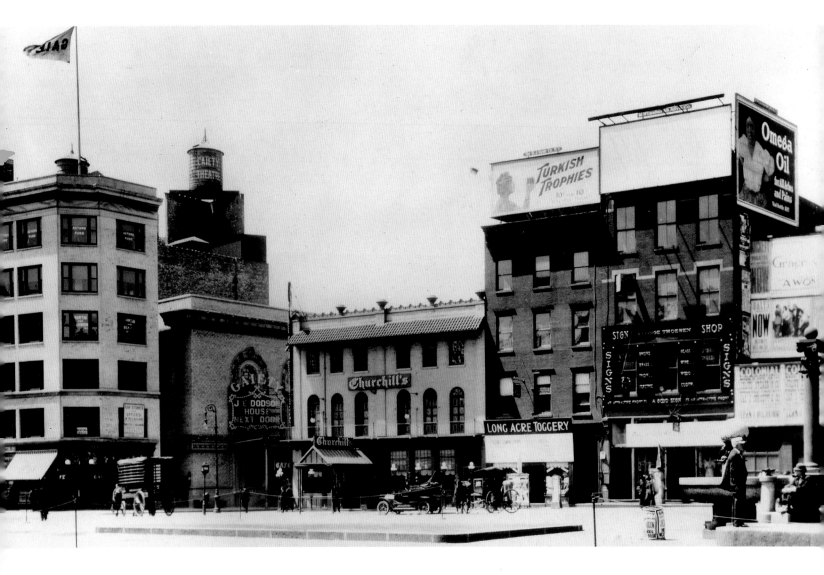

Churchill's restaurant and the Gaiety Building and Theater (1908, Herts and Tallant) at Forty-sixth Street were typical of the real estate development that transformed Times Square after 1904. The neighborhood had yet to acquire its distinctive visual identity; this block on the square's west side still looked very much like the older commercial stretches of Broadway farther downtown. Signage varied from the latest in electrical marquees on the theater to traditional shop signs and giant billboards promoting Turkish cigarettes and patent medicines.

As the market for rooftop spectaculars developed in Times Square after 1904, many theater signs remained in the manner of older Broadway trade signs. This brilliant 1908 herald for the New York Casino (1882) at Broadway and Thirty-ninth Street, twenty-seven feet tall with a twinkling star and "ruby rays," was closer in both spirit and action to the extravagant advertising giants then going up in Times Square north of Forty-second Street.

(some of them gaslighted after dark, some not) ran across windows, roofs, and facades; trade signs hung above doors; windows were packed with goods; and banks of enormous wooden billboards were everywhere, sporting huge, brightly colored pictures. Most of this was invisible after dark until the first electric signs appeared, pioneered by local nighttime businesses: theaters, cafés, restaurants, hotels, and drugstores. Modeled on gas trade or theater signs, the early electrics were small in scale, designed to be seen by people passing close by. Specialty and department stores also embraced the good-looking, clean-burning new lights, which were seen as extremely stylish because they were associated in the public's mind with the rich men who had installed the first experimental home generators in the previous decade. When smaller Broadway shops started to electrify, the growing number of lighted fronts along lower Broadway became a model for New York's luminous shopping streets of the 1910s.

In contemporary newspapers, magazines, diaries, and books, the imaginative transition from a gaslighted to an electric Broadway was seamless. The avenue of magnificent shops, bright theaters, and well-to-do shoppers that had been described so often in the nineteenth century became something new by 1900: the Great White Way, a wonder famous for its electrical spectacle. At night the brightest parts of Broadway, then still below Forty-second Street, were transformed by flashing, moving, electric light. Facades were outlined in incandescent bulbs, trolleys gleamed with lights, and the side streets were dotted with lights that looked like jewels. The lighted cars of the city's elevated trains, as described by an English visitor who raved about the

magical atmosphere, ran like "luminous serpents" up Sixth Avenue.

Such verbal extravagance was common. Published descriptions were rapturous and often highlighted the beautiful or unusual effects of the new electric lights—how they looked against the stars and moon, in rain, on clear nights, and in photographs. The ubiquity of the items reflected the novelty, wild popularity, and excitement of electricity.

The early electrics on lower Broadway were simply trade signs rendered in lightbulbs. But by the turn of the century technical improvements and falling costs allowed electrical designers to conceive their signs much more boldly. Instead of small, old-fashioned name or attraction signs mounted to attract immediate passersby, designers began to develop larger, colored-light signs intended to project up and down longer vistas made up of full city blocks. Giant electric advertising signs—soon to be known as spectaculars or sky signs—were the next advance.

On June 10, 1892, the first large electric sign of this type ever to appear on Broadway was switched on at a showcase site that had been much sought after by billboard companies: the large north wall of a hotel on Twenty-third Street. The space faced one of New York's most important public spaces, Madison Square, at the junction of Fifth Avenue and Broadway. The sign, despite its unusually large scale, was a straightforward broadside type advertising a Coney Island resort. Plain letters, three to six feet tall, spelled a multicolored text that filled most of the hotel's wall. Electric flashers, newly invented, blinked six different lines in sequence:

SWEPT BY OCEAN BREEZES

ORIENTAL HOTEL

MANHATTAN HOTEL

SOUSAS BAND

PAINS FIREWORKS

HAGENBECK

The sign became a sightseeing destination. Press accounts reported that it could be seen up Fifth Avenue as far as Fifty-seventh Street and on Broadway as far as Thirty-fourth Street. People (the writer Theodore Dreiser among them) were fascinated by its "talking" format and amazed that they could see it from blocks away. In 1896 the *New York Times* snatched up the site for its own sign, another primitive "talking" broadside that mimicked a newsboy's spiel in on-off rhythm:

New-York Times

.

**ALL THE NEWS
THAT'S FIT TO PRINT**

.

Sunday
Magazine
Supplement
Have You Seen It?

The Cumberland Hotel signs kicked off the era of spectaculars in New York. Advertisers would soon come to prefer a different site, however—twenty blocks to the north, in Times Square.

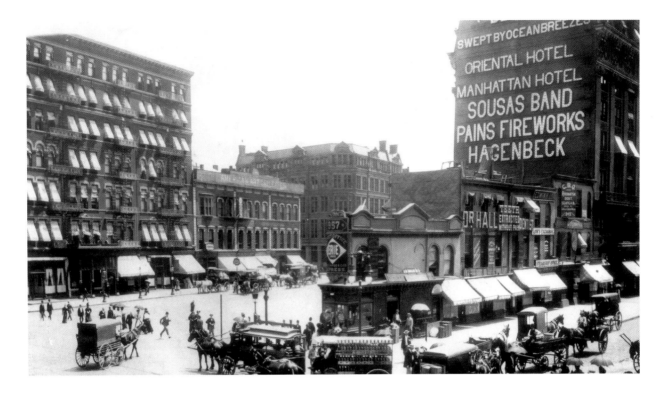

At eighty feet high and sixty feet wide, the Ocean Breezes sign of 1892 was the first giant electric sign on Broadway. It was built by the Edison Electrical Company on the Cumberland Hotel at Twenty-third Street to advertise the Long Island Rail Road's Coney Island resort. Lacking any images or ornamental elements, it looked like a building-sized handbill in lights—in fact, it had replaced an old-fashioned painted wall advertisement.

SPECTACLES OF LIGHT

The mania for all things electric that started in the 1880s and did not end until the middle of the next century was an international phenomenon. Because New York was both America's largest metropolis and the first place in the country to electrify on a broad scale, the city's electric lights—especially Broadway's—became by far the most famous in the world. Though towns and cities across the nation built lighted shopping streets at roughly the same time as New York's, in homage to the city's famous avenue many of them were called Broadway. As the enthusiasm for electricity grew in these years, lights were installed everywhere in these downtowns, from theaters to trolleys to store windows and outdoor signs that sold goods, hyped shows, and promoted electric parks (as amusement parks were sometimes called). Electric parades, electric holiday celebrations, electric floats, electrical weeks, and light festivals for seemingly any occasion also became extremely popular throughout the country.

Large electric companies—including Edison's and J. P. Morgan's General Electric, Brush, Western Electric, and Westinghouse—were in large part responsible for the worldwide craze. Beginning in the early 1880s, when Thomas Edison was establishing subsidiaries in both hemispheres, electrical entrepreneurs sought to promote the new commodity by introducing it at international trade shows and world's fairs. At first the electrical displays were grouped with other industrial exhibits at the fairs, but soon electric light began to claim a central role. Prominent international expositions, from the 1883 electrical display in Louisville to the 1915 Panama-Pacific Exposition in

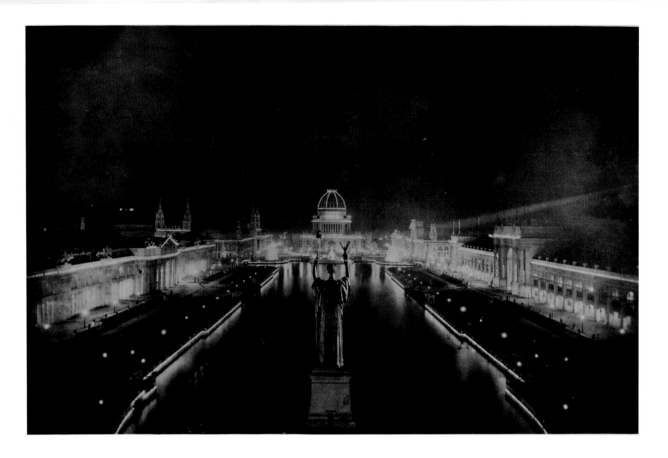

The lighting engineer Luther Stieringer (ca. 1845–1903) used 130,000 incandescent bulbs to outline buildings surrounding the great Court of Honor at the 1893 Chicago World's Fair, most dramatically on the dome of the Administration Building. The sixty-five-foot-tall *Statue of the Republic* by Daniel Chester French (1850–1931) overlooked the Grand Basin, where at dusk lights lining the water's edge and searchlights mounted around the court turned brilliant yellow, purple, red, green, and blue.

San Francisco, showcased a flood of electrical innovations developed by the companies' laboratories and factories. Visitors to the earliest expositions were amazed by pavilions full of such electrical novelties as tall columns studded with masses of bulbs and indoor fountains animated with colored, flashing lights. Through these first displays, designers and engineers proved that electric light was a theatrical medium of the first rank. Their electrical displays became increasingly elaborate.

The first great American showcase for electric light was the 1893 World's Columbian Exposition in Chicago. The fair, which profoundly influenced American architecture and urban planning for a time, followed an organization that became standard. The grounds were divided into two sections: an official area featuring trade and national pavilions, and an amusement zone that housed concessions, rides, and sideshow attractions. Electricity was used in both sections, but the big-budget light installations at the official grounds are better remembered today. The Chicago fairgrounds along Lake Michigan housed a magnificent ensemble of classically inspired structures that were impressive enough by day. At night, however, lights transformed the site into a wonderland beyond anything that most Americans had ever imagined.

At the 1900 Paris Exposition, for the first time

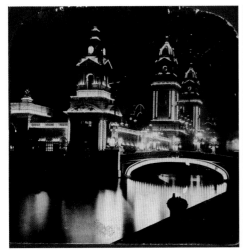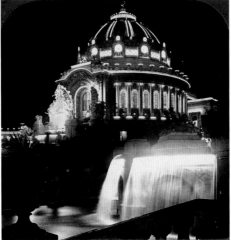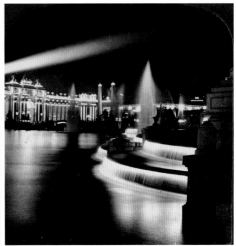

The lighting for the 1904 St. Louis World's Fair was the greatest work of Henry Rustin (1865–1906), who favored incandescent lights over the bright arc lights used for the first outdoor lighting. Rustin hid bulbs behind architectural elements instead of installing them on building facades, creating strong sculptural light, seen here in views of the domed Festival Hall, the Machine Building towers, and the arched colonnade at the Education and Mines Building. Later expositions began to use more floodlighting, although outlining continued to be popular in commercial displays for amusement parks, theaters, shops, and advertising signs.

people could wander the fairground outdoors after dark on long avenues bright with artificial light. In 1898, 1901, and 1904, engineers at the Omaha, Buffalo, and St. Louis fairs staged even more sophisticated outdoor light spectacles using timers and sequential lighting for the most dramatic effects then possible. For the 1904 fair in St. Louis (officially the Louisiana Purchase Exposition), President Theodore Roosevelt threw the first switch and turned on the power from hundreds of miles away. A rheostat gradually lighted the 1,200-acre Beaux-Arts complex, which was larger than all previous American fairs put together. Starting with a rosy sunset flush, the lights went up to fiery red and then to brilliant white as all the buildings, colonnades, and towers were fully illuminated and three terraced waterfalls were lighted from underneath in colored lights.

Presented with an emphasis on their artistic rather than utilitarian qualities, these electric shows won extensive and extravagant press coverage. Millions either saw or read about the stunning displays, and the expositions became tourist events for which cities

aggressively competed to host, even though they usually operated at a loss. In a few short years any lingering concern about the safety of the new technology had evaporated; electricity was now a blockbuster entertainment guaranteeing a commercial market in decorative lights that lasted over fifty years.

Two decorative lighting styles evolved from the world's fairs. A Beaux-Arts mode pioneered at the World's Columbian Exposition deployed tasteful schemes that used lights to highlight architectural elements and to mimic starlight, northern lights, rainbows, sunsets, and dawns. This style was used around the world to decorate important civic spaces where grand facades were outlined with bulbs and graceful fountains were lighted after dark. Illuminated municipal celebrations had traditionally used fireworks, torches, and candles. As electric light became popular, city leaders replaced them with fully electrified light shows styled after the fairs. New York hosted two sensational festivals of this kind in 1899 and 1909; even more monumentally scaled than the world's fairs, these pageants of light used the city's

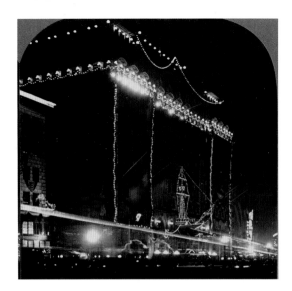

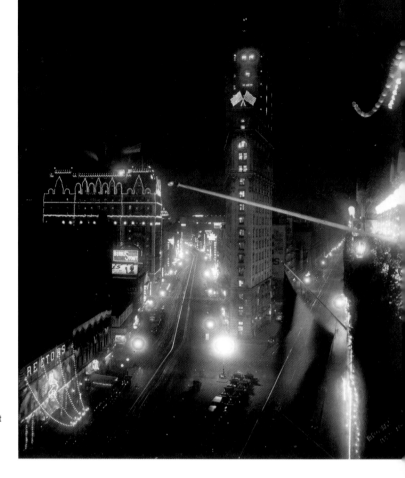

● ● ● *(Above)* In honor of the three hundredth anniversary of Manhattan's discovery by Henry Hudson, the Hotel Astor was decorated with ropes of lights for the 1909 Hudson-Fulton celebration. For the citywide festivities, the lighting engineer Walter D'Arcy Ryan (1870–1934) staged a stupendous electrical show, lining parts of the coastline and all the East River bridges with lights, installing a huge battery of searchlights ("The Scintillator") at the top of the Hudson, and floodlighting and outlining the city's most important buildings and public places.

(Right) For a holiday or celebration about 1907, Rector's Restaurant in the left foreground, the Knickerbocker Hotel at left rear, and the Hotel Astor at right all experimented with swags of bulbs to imitate the effect of world's fair structures outlined in lights. Real and electric flags on the Times Tower added a patriotic touch.

streets, harbors, rivers, and sky to present astonishing electrical displays, attracting large numbers of tourists to New York.

The carnival style of the world's fair midways, which were named after the Midway Plaisance at Chicago's World's Columbian Exposition of 1893, had humbler roots. Echoing popular entertainments stretching back centuries, the style deployed flashing, blinking, and colored electric lights to give people the gaudiest show possible. Amusement parks, lighted downtown shopping streets, and theaters—vaudeville, legitimate, and eventually movie—commonly featured the showier midway lighting style, often in tandem with Beaux-Arts motifs.

LIGHTING UP BROADWAY

In Times Square's earliest years, both the dignified and the showy style were on display. The first electric spectacular went up there in late 1904, within months of the *Times's* first election-night and New Year's Eve light shows, which both attempted to introduce a Beaux-Arts tone. The flamboyant new sign advertised a whiskey named Trimble, a popular brand whose familiar painted billboards around New York displayed two large hands raised in a toast. The spectacular rendered the giant disembodied hands in lights, clinking glasses high in the sky above Forty-seventh Street in the middle of the square. The *Times* was not shy about puffing up the district to which

Flashers

Thomas Edison's trusted engineer William J. Hammer (1858–1934) was one of the world's first experts in electrical distribution systems. Working for the inventor in Europe, Hammer built the first large electrical sign, which he debuted at the 1882 Crystal Palace Exposition in London. Making the circuit of electrical and world's fairs for the Edison company, he became one of the first prominent electrical engineers to develop electric light's potential as a marquee attraction.

Hammer laid the groundwork for electric sign development with his important invention, the commutator switch, popularly known as a flasher. This device allowed electrical circuits—groups of connected bulbs in the case of spectacular signs—to be turned on and off in sequence. This meant that sign designers could spell out words or animate shapes outlined in lights to simulate movement. Animations like these became the most important visual tool of electric advertising signs.

Hammer quickly made improvements to his invention. In 1883 he introduced the automatic, motor-driven flasher in Berlin (his 1882 sign had been operated by hand) and in 1889, at the famous Paris Exposition, he presented color and pictorial animation in two larger signs representing the French and American flags intertwined. These flags miraculously seemed to wave in the breeze, thanks to the flashers, while another of Hammer's inventions, rheostats, dimmed the lights.

As bulbs, controllers, and circuitry improved, electric signs also became cheaper to make, a change that allowed designers to fashion larger signs with increasingly intricate moving forms. Hammer's innovations opened the way for big animated signs, which became a thriving commercial medium in the next twenty years.

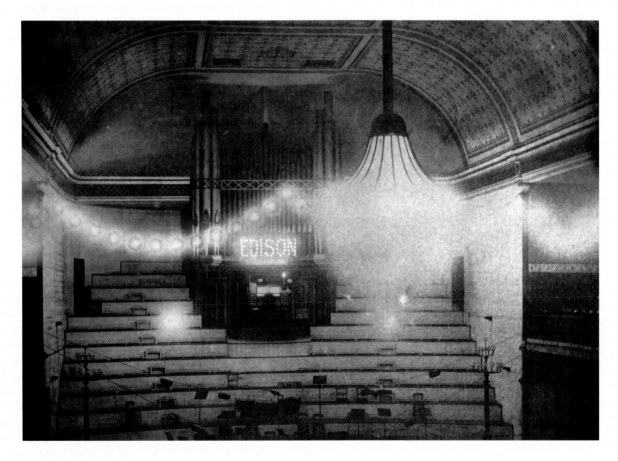

"Edison": William J. Hammer invents spectacular signs, London, 1882.

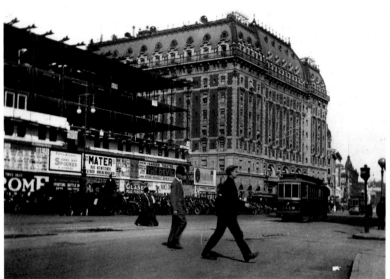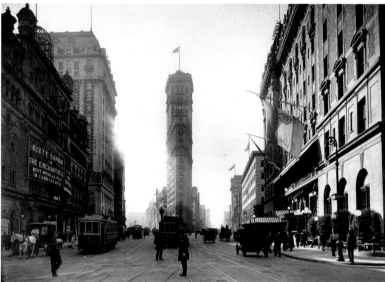

⊕ ⊕ ⊕ *(Left)* **In early 1909** the Astor estate opened a new building (shown here under construction) of the kind that the *Times* hoped would attract corporations and high-end shops to the square. Sited at Broadway and Forty-third Street, just to the south of the Hotel Astor, the six-story Putnam Building also housed Shanley's, a Tammany hangout-turned-lobster palace. Despite its prime space, its roof was rented only occasionally for spectaculars; later its owners gave in and rented to the O. J. Gude Company.

(Right) **By the early 1910s,** the *Times* was jubilant about the ensemble of expensive new buildings that had transformed the square's south end. The new Hotel Rector sat to the east at Forty-fourth Street across from the Putnam Building, below the Hotel Astor to the right. Shanley's had opened its grand new space there in November 1910 with a parade and a party in the new nine-thousand-square-foot dining room.

it had given its name, but the newspaper made no mention of the new sign. Although the aesthetics of outdoor advertising—undignified and brassily commercial in tone and design—were then a hot-button issue in New York, the paper's editors likely just considered the newfangled Broadway razzmatazz of the spectacular to have no news value. The really important story, as the *Times* reported it in these years, was the booming midtown that the paper was so instrumental in creating.

Times reporters tirelessly cataloged the ins and outs of the surging local scene. They surveyed theater construction, audience numbers, and the class, personality, and rhythms of the huge crowds moving through the square at night. They analyzed election turnouts and New Year's Eve noise levels and de-

scribed the racy drinking and dining habits of the lobster-palace swells. The paper ran dozens of articles and items on investment, transportation, theatrical stars, and of course the hundreds of shows playing the district's theaters; European professors and visiting celebrities, sought out for their expertise or fame, held forth in print on the strange new scene. The *Times* described an unstoppable rush of new buildings and businesses that fed a buoyant upward spiral of rents, land values, and tax assessments. Echoing the Broadway impresarios, the paper coined a new term to describe the growth: "high-class" development. With Fifth Avenue the ideal, electric advertising signs—so reminiscent of circuses and other vulgar entertainments—did not project the dignity and cachet the *Times* was after.

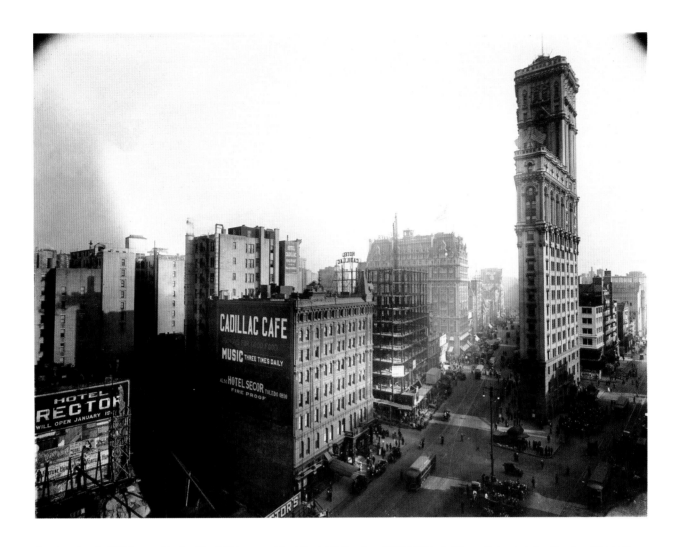

In 1909 George Rector hired Chicago architect Daniel H. Burnham (1846–1912) to build a multistory hotel on the site of Rector's Restaurant at Forty-third Street, in the left foreground. Two years before, out-of-town investors had snapped up the corner lot a block south, one of the last available big parcels fronting the square, for a theater and office project, the Cohan Theatre in the Fitzgerald Building, shown under construction. Next door to the south, the Astor estate initiated the million-dollar Longacre Building across from the Knickerbocker Hotel.

Perhaps not even the *Times* fully appreciated the nature of the expansion taking place. The first investors had been local, but as news coverage increased, entrepreneurs from all over America rushed to take advantage of the bonanza. To the *Times*'s enthusiastic approval, "daytime development" (retail and rental investment) became more important, but the highest-profile projects at this time were still hotels,

theaters, restaurants, and nightspots. These kinds of businesses had put the area on the map in the first place, and the *Times* notwithstanding, they indelibly marked the new neighborhood with a brash commercial spirit that would soon dominate Times Square.

Tourism was another important factor. The city had always had thousands of business visitors each year, but after the turn of the century, officials,

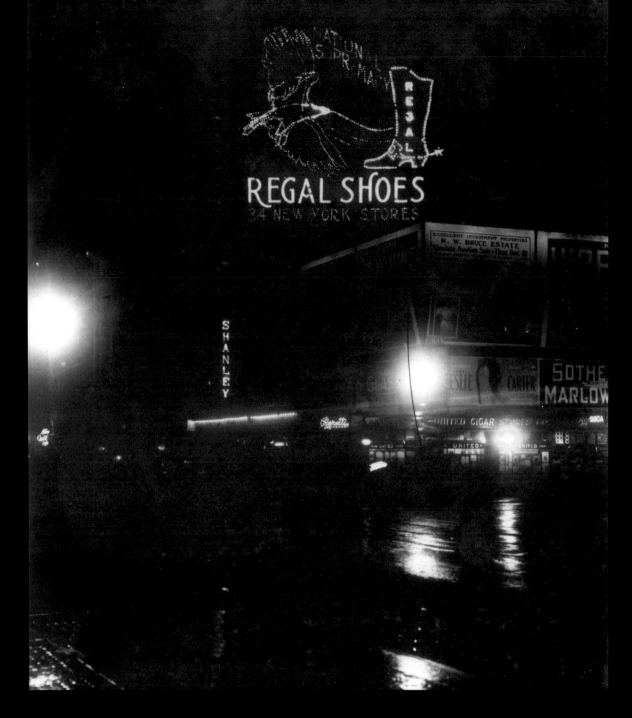

● ● ● **The Regal Shoes spectacular,** a Gude ad erected at the corner of Forty-second Street and Seventh Avenue about 1910, illustrates the evolution of electric signs. The boot continued the simple trade-sign types that were sometimes adapted to electricity, while the eagle was entirely new. Designed to appear to fly through the air, its wings moving up and down, the bird was a classic pictorial animation in lights of the kind Gude pioneered in Times Square.

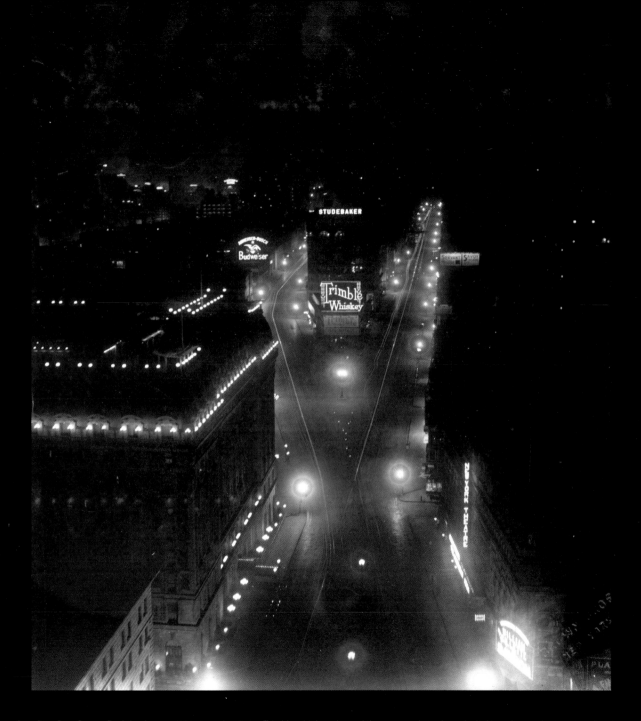

● ● ● **Oscar Gude's cheery** 1904 sign advertising Trimble whiskey showed the company's trademark clinking glasses (not captured in the photograph here). The sign was visible for many blocks from the head of the square, the central triangular block at Forty-seventh Street between Broadway and Seventh Avenue. Gude was the first adman to understand that Times Square, with its clear sight lines and throngs of pedestrians, was the perfect place to exhibit large electric advertising signs.

merchants, and hotel owners worked successfully to promote the city as a vacation spot, staging important events and targeting national advertisements to shoppers, conventioneers, and affluent businessmen. The boosters had an easy job of it. New York was—and deliberately marketed itself as—America's superlative city: the biggest, richest, boldest place in the country. To most Americans of the day, even the most ordinary sights in the city were exceptional, from the electric streetlights to Central Park to the shops along Fifth Avenue. But the city was also blessed with some exceptional things to see. After 1904 the astonishing new signs of Times Square easily took their place with the Statue of Liberty, the bridges, and the city's rising skyline as one of New York's signature attractions.

The Trimble Whiskey sign was created by a charismatic German American billboard magnate named Oscar J. Gude, who in the next decade became the force behind Times Square's quickly developing signscape. The O. J. Gude Company, one of the city's biggest billboard businesses, had offices nationwide and pioneered large national advertising campaigns for some of the nation's most aggressive marketers, companies like Quaker, Bull Durham, Uneeda, Franco-American, and H. J. Heinz. Gude persuaded such marketers to target the thousands of entertainment seekers and commuters moving in and out of Times Square by subway, on foot, or by surface transport—known ever after as the area's "circulation."

Soon the merchandisers were spending thousands with Gude to attract the attention of the affluent, well-educated, and free-spending crowds. As the trade in big advertising signs grew rapidly after 1904, nearly every business in Times Square was prompted to light up. Name signs, marquee displays, illuminated show windows, and architectural lighting brightened up buildings around the square. The electric lights being installed from roof to street were a hodgepodge with no overall design—a random combination derived from commercial signage, popular entertainment, and the latest in world's fair electrical fashion. Dominant, and by far the most original, was the constantly changing roster of enormous moving light displays in the skies above the square. These signs, most of them by Gude's designers, plugged every product imaginable: bran flakes, beer, cigarettes, chewing gum, shoes, gloves, and underwear among them. With a scale and intricacy calculated above all to compel attention, they transfixed the crowds. Within a few years, Gude almost single-handedly transformed Times Square into America's most important outdoor advertising market.

With its concentration of hotels, entertainment, shopping, crowds, construction, business, and publicity, Times Square would have been an advertising magnet even without the nighttime sky signs, of course. Initially, however, spectaculars were just a secondary attraction as Times Square became the country's best-known entertainment district in the years between 1905 and 1910. Its shows and nightlife, billed by publicists as bigger, saucier, and brighter than anything back home, remained at the center of the kind of Broadway–big-city stories that had been a literary tradition since the nineteenth century. The modern versions were often tall tales of the "Broadway life" as it was seen on the area's stages and lived in its lobster palaces. Exaggerated to mythic proportions

for out-of-town consumption, these accounts were retailed around the world in floods of plays, news features, and magazine stories about the district.

A modest but appreciable shift in perception came as Times Square's physical appearance—especially at night—became a more common focus for promoters. At first, descriptions of the signs injected color into Broadway stories, but soon, inevitably, pieces began to appear about the ingenious lighted advertisements themselves and the throngs of people out in the square looking at them. Pictures of signs became more common, too. Until 1909 or so, the dignified Times Tower was still the district's representative picture. After 1912 images of Times Square lighted up from street to roof with signs began to replace views of the tower. Lighted signs and bright marquees, it was clear, made a much more compelling attraction than restaurants and handsome buildings. Moving lights and colors were exceptionally exciting to look at and because they changed often as new signs went up (some every three to six months), they always looked fresh.

Pictures of the lighted square were almost as good as the real thing. Sellers of products and services, from beauty goods to cars, cigarettes, shoes, floor shows, vaudeville, and cocktails, were soon using the exciting pictures of the nightscape to promote their businesses. These images of Times Square helped make the place famous in its own right. The idea took hold of an independent Times Square that was not Broadway, not Rector's, not Fifth Avenue, but a place that was instantly recognizable as itself.

Although the Broadway theater scene continued to be known well into the 1920s by the peppy moniker Great White Way, in less than a decade Times Square became forever associated with an indelible nightscape of blazing electric signs. Its staying power as an attraction was disarmingly simple: it looked both familiar and thrillingly new. The huge, expensive spectaculars were the square's most distinctive feature, but what the millions of visitors each year remembered best was the square's dazzling atmosphere—a bright delirium of light and color that chased, blinked, and inscribed patterns in the sky every night beginning at dusk.

SPECTACULAR GENIUS AT WORK

Oscar Gude's first giant spectacular, the predecessor of his many great Times Square signs, debuted in 1900 twenty blocks south in Madison Square, on the sought-after wall of the Cumberland Hotel facing Broadway and Fifth Avenue at Twenty-third Street—the Ocean Breezes spot that the *Times* had rented in 1896. Gude's new sign was commissioned by the Heinz Company of Pittsburgh, one of the country's first important national merchandisers and an early proponent of branding. Gude's spectacular boldly supersized his client's already famous trademark, offering an astonishing fifty-foot-wide pickle in green electric lights. The cheeky commercial spirit of Gude's sign was striking, especially in Madison Square, where New Yorkers regularly attended civic ceremonies and admired monuments commemorating historical events and war heroes. Gude displayed his gigantic, colored, blinking, and unmistakably phallic pickle to be seen from blocks around, and it understandably caused a sensation. The sign was criticized in some circles for its vulgarity, but it had just the effect Gude sought: it drew huge crowds of loitering, gaping consumers.

Old-Time Amusement

Given that New York City was the first famous American city to electrify, it was no surprise that it became home to the world's two most famous urban electrical environments: Times Square and Coney Island. Geography, scale, attitude, and of course news coverage made all the difference.

Coney Island, a long spit of land on the Atlantic Ocean jammed with amusement (both licit and illegal, high and low), had been an important local summer resort since after the Civil War. Like the city itself, the island reflected the rigid class distinctions of the age. At the east end, genteel middle- and upper-class visitors fleeing the stifling heat of their town dwellings took their leisure—promenading, listening to band music, or bathing at private beaches associated with hotels backed by some of New York's most prominent men. Farther west, the atmosphere changed noticeably in less exclusive neighborhoods that were a frenetic crush of carnivals, oyster houses, gambling dens, beer halls, saloons, hotels, rooming houses, dime museums, brothels, and circuses complete with sideshows. Spectacles featuring pyrotechnics and re-creations of famous disasters were especially popular along with vaudeville and other more commonplace shows.

Several amusement parks had opened on Coney Island in the years just after the World's Columbian Exposition of 1893, but they were local undertakings typical of the island's west end. The Coney Island parks that achieved fame, Luna Park (1903) and Dreamland (1904), represented something quite new. Both were financed by outside investors and pitched to a growing demographic: middle-class people with more free time and money to spend. The pioneers were Luna Park's backers, Frederick Thompson and Elmer Dundee, two professional showmen who had run the midway ride concessions at two important world's fairs, most recently the 1901 exposition in Buffalo. They hit on a successful formula for their New York enterprise, building walls around their parks to shut out the raffish chaos of the old Coney Island and attracting thousands of visitors eager to avoid Coney Island's seamier neighborhoods. The operators then installed standard carnival amusements in a setting where pools, courts, pavilions, electrical halls, and towers imitated the look of the world's fairs. Recalling the grand electric spectacles of Chicago, Paris, Buffalo, St. Louis, and San Francisco, the showmen transformed the parks after dark with hundreds of thousands of electric lights. Running on their own enormous generators and serviced by fleets of technicians, the light displays amazed the crowds and drew national and international press coverage. Against the night sky and above the ocean, the extravagant light effects of Coney Island were like nothing else in America—except Times Square.

From the first, Times Square and the Coney Island parks were closely identified. Although Times Square's lighted streetscape was actually a product of many individual advertisers and owners (as was the old Coney Island), once the signs and theaters had reached a certain stage of brightness and sophistication, the square reminded people of the Brooklyn amusement parks at night. Combining lights with the kinds of decorations found at traveling circuses and carnivals, both places were examples of the fusion of old and new forms that developed as electrical display became a profitable, popular, and nearly ubiquitous new visual medium.

Scene in Luna Park, Coney Island, N.Y.

Coney Island at night, 1906.

The giant form of Oscar Gude's Heinz pickle sign, which faced Broadway and Fifth Avenue at Twenty-third Street in about 1900, spread up to the roof and across the whole side of the Cumberland Hotel, where it flashed against a strident blue and orange background. Images and motifs in early spectaculars like this were formed by rows of bulbs screwed into sockets mounted in frames.

Within four years Gude had perfected his idea twenty blocks uptown, in Times Square. Gude saw that the square's layout was a perfect showcase for bigger signs and longer perspectives because of its exceptional sight lines along Broadway and Seventh Avenue, its low roofs, and the abundance of open space for milling crowds of potential customers. In 1904 he tested his observations when he positioned his first large picture spectacular there—the Trimble Whiskey sign at Forty-seventh Street—for maximum display around the neighborhood. The tall sign with its supporting metal framework was placed on a low two-story building at the most visible point looking north: the middle of the square between Broadway and Seventh Avenue. Seen from blocks away, the bright lights appeared to loom over pedestrians and made a fantastic show of moving light forms.

Despite the *Times's* neglect of his Trimble spectacular, Gude's sign business in the square thrived and made him rich. Within three years, he gained con-

trol of the most visible rooftops around the square, which building owners rented to him for a decade and a half. Gude controlled prominent spots as far north as Columbus Circle (then an important extension of the Times Square sign market) and on both the east and the west sides of the square itself. The magnate also had the most important roofs to the south, including the pivotal corners at Forty-second Street between Broadway and Seventh Avenue. There, gigantic Gude signs overlooked the crosstown stretch of lighted theater marquees that ran all the way to Eighth Avenue, as well as the bright Broadway blocks to the south around the Metropolitan Opera and the Casino Theatre. These spots, sought after by clients who paid Gude to design, build, and maintain the signs over the course of a contracted period (usually computed at a monthly rate), were Gude's most important assets.

For the next fifteen years, Gude's network of signs dominated the rapidly growing nightscape and helped create the extraordinary vistas that sealed Times Square's image as the shimmering center of Broadway's Great White Way. By 1911 or 1912, beautiful spectaculars appeared to float against the evening sky as if on a stage set, and the far north end or "head" of the square was offering a nightly performance that became the district's most famous and photographed feature: what seemed from a distance to be a single, fantastic tower of lighted signs stretching hundreds of feet into the air. It was an optical illusion, actually. At the base of this colossus was one sign—like the Trimble Whiskey spectacular—on the Forty-seventh Street tip of a low-roofed block of buildings between Broadway and Seventh Avenue. Behind it, on the same set of roofs, rose a taller scaffold

holding a second, separate sign. And behind them both, atop the Studebaker Building (1908) at Forty-eighth Street, was perched a still-taller, third spectacular. To nighttime pedestrians—and postcard buyers all over the world—the fact that it was all just an elaborate depth-of-field trick was irrelevant. They loved how it looked, and Gude brilliantly exploited the site until 1925.

Gude's showmanship was totally calculated. Never one to shy away from a theatrical gesture, he espoused what might be called advertising of visual dominance that in one form or another prevailed for decades in Times Square signage. Light designers and billboard men at this time worked from the unquestioned premise that consumers responded to pictures more readily than to words. Accordingly, they attempted to use eye-catching images to stop people in the street and "burn" products into their minds with as little conscious mediation as possible. Gude's company made a specialty of animated pictorial signs that "burned" with supreme effectiveness. His signature spectaculars were not simply enormous electrified billboards that borrowed images from vaudeville, comics, and other popular entertainment; they were vivid shows that commentators at the time described as outdoor theater in lights, and people remembered them for years. Gude's signs became famous around the world and generated the rush of publicity about lights and signs that flowed so constantly for decades to come.

Gude's most memorable large-scale pictorials were boldly original. Electric spectaculars worked something like a cartoon in which many images, filmed in order, gave a sense of moving forms. Sign "animations" (as they were called) were made up of

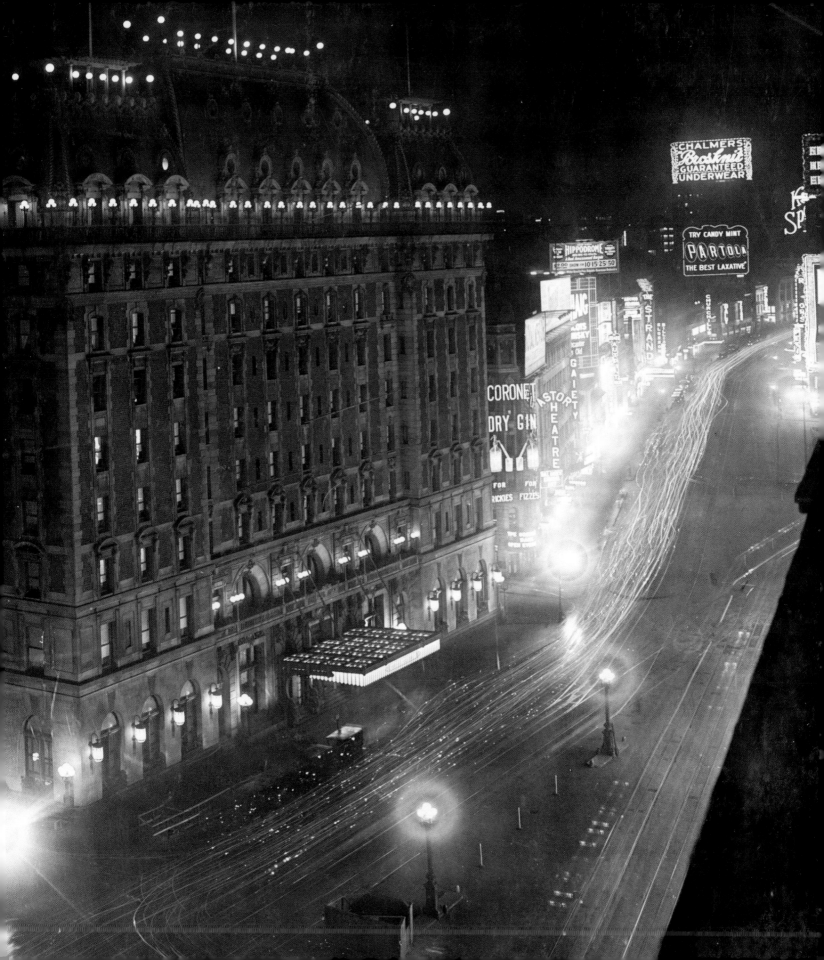

many separate "poses" rendered in bulbs that when lighted one after the other in sequences (by flashers) gave the illusion of movement against the night sky. In Gude's best work, the lighting magnate married his hard-sell mode to popular entertainment, fusing the scale and visual bombast of billboards and the hypnotic pull of electricity with extraordinary moving light forms that imitated motion pictures. In the early 1910s, motion pictures were a startling new medium scarcely a decade old. Millions of Americans went to the cinema each year, and Gude's designers cleverly adapted the style of the earliest films and some of their most familiar subjects. Boxing matches, acrobats, babies, horses and horse races, ordinary street scenes called "actualities," servants, vaudeville actresses (often in sexy clothes), or close-ups of female faces all appeared in early Gude signs. The signs themselves were simple, straightforward imitations of cinema's moving figures—the equivalent in animated lights of several frames of film action, adroitly edited to have a beginning, a middle, and an end. Gude's giant pickle had astonished people by simply blinking on and off. His movie-style signs stopped them with the drama of cinematic animations that were unlike anything ever seen before in advertising.

Gude's company put up approximately twenty large spectaculars in Times Square between 1909 and 1915. They included several gargantuan women mopping and polishing, a golfer, a pair of wrestling cartoon imps, boys boxing in their underwear, and a polo player galloping on a horse and whacking a ball in an arc above Broadway. One of Gude's most remarkable moving-picture spectaculars was the Kellogg sign of 1912 above the Studebaker Building

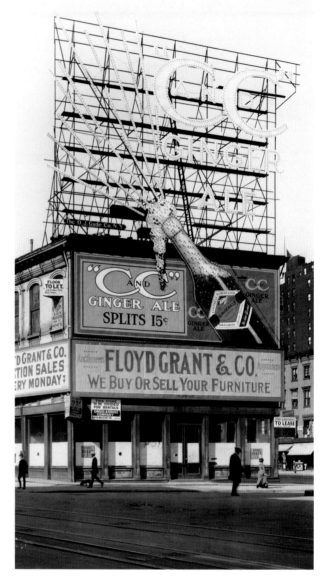

(*Above*) **Before the advent** of taller buildings in the 1910s, many sky signs were actually placed relatively low to the street. Mounted on the roof of a three-story building at the head of the square in 1909, Gude's Canadian Club ginger ale sign featured a sparkling soda exploding and frothing as the logo lighted up. Consistent with painted billboards and printed ads of the 1890s, it probably had a bawdy association.

(*Opposite*) **Gude's arresting signs** for women's products imitated a certain kind of print advertisement in fashionable ladies' magazines. Like this 1910 ad, they featured beautiful women (often modern versions of the famous Gibson Girl of the 1890s) in public or vamping at home in front of their mirrors to sell stockings, gloves, corsets, and other apparel.

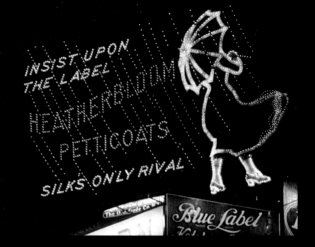

●　●　● *(Above)* **Gude's first spectacular** or Heatherbloom, a line of synthetic silk petticoats, featured the "largest petticoat in the world" swishing back and forth to uncover a delicate set of ankles and feet over Broadway. His second sign for the line, shown here, presented a sequence of cinemalike actions in lights. As the Heatherbloom girl struggled through a rainstorm under an umbrella, the wind blew her skirts to reveal her red petticoat and shapely legs.

(Left) **In one risqué** Times Square spectacular from 1910 for the deluxe New Haven corset maker Straus and Adler, at Forty-seventh Street between Broadway and Seventh Avenue, Gude had an enormous woman walk up a staircase. As she ascended, her skirt lifted, showing her feet. At the same time, her corset was revealed through her suit, as if seen by an x-ray. Gude's C/B Corsets sign series was much noticed by professionals, but after several signs the company never bought any more

of 1912 was haunting. Performing her stunts on an electric tightrope that stretched a full block from Seventh Avenue to Broadway, the pretty acrobat in a short skirt seemed to have walked off a vaudeville stage or out of an Edison movie. As she posed and balanced with an umbrella across the tightrope, each position was rendered in bulbs that turned on and off sequentially to give a sense of movement.

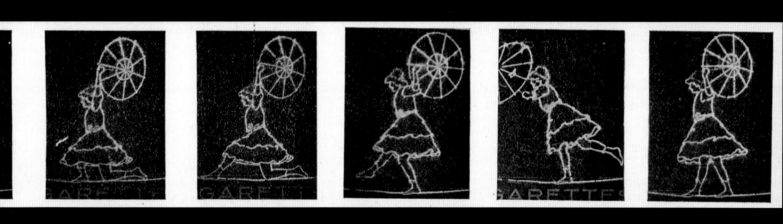

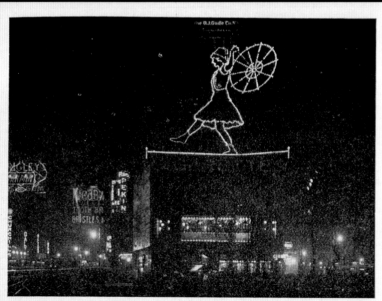

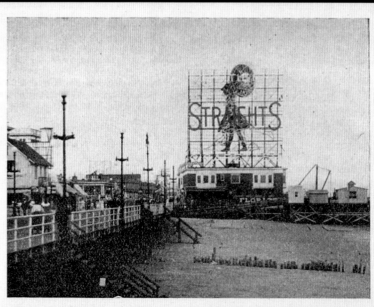

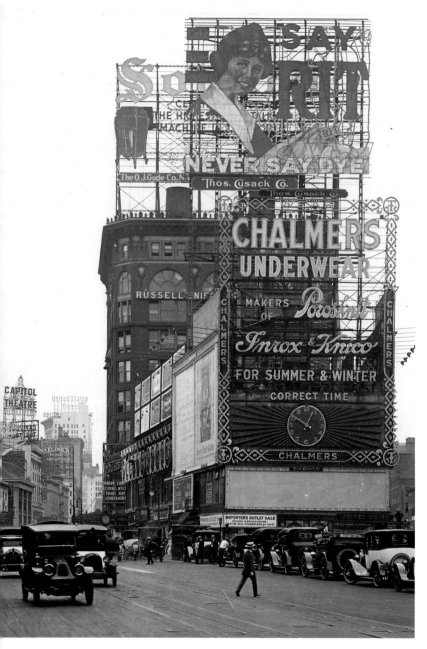

● ● ● **This uncharacteristic** (middle-distance, angled, daylight) photo of the north end or "head" of the square dates from the late teens. Viewed at night from just a few blocks south—and for several miles beyond on either Broadway or Seventh Avenue—this complex of rooftops appeared to be a single, skyscraping tower of lighted signs: the Chalmers Underwear spectacular at its base, one for Rit Dye at its waist, and a Sonora record player ad on top. In fact, the three signs were staggered, front-to-back scaffolds spread over two separate blocks.

at Forty-eighth Street, which showed a gigantic baby's head (babies polled as one of the most popular movie subjects well into the 1920s); the baby screamed, red faced, and pounded a spoon as it called for cereal.

Several of Gude's masterpieces were coyly erotic, such as the famous Heatherbloom girl, who stopped traffic as rainy gusts of electrical "wind" blew her red petticoat to reveal a naughty glimpse of ankles and leg—a common cinematic trope that reworked the tantalizing climactic action of Edwin S. Porter's famous *What Happened on Twenty-third Street, New York City* (1901) and other early films. The 1912 Wrigley gum spectacular on upper Broadway (probably on a block in the West Fifties) was striking and mysterious: a woman's head nearly seventy feet wide appeared over Broadway, her twenty-seven-foot-wide staring eyes, reminiscent of the famous Broadway soubrette Anna Held, blinking; then the slogan "Wrigley's Spearmint Pepsin Gum" appeared sequentially, the second word framed in a large spear pointing east. Simpler signs were often just as effective: animated logos, flying eagles, flowers, wheels, siphons, steaming cups, and bubbles were enormously popular.

Inevitably the streetscape became brighter as even the smallest businesses in the square began to install lighted signs. Although Gude's spectaculars remained enormous and expensive, his designers developed another style that was dazzlingly decorative, in noticeable contrast to the close-up, cropped forms of the moving picture signs. Ornament and beauty replaced film-like movement: huge tasseled ropes made of colored lights swinging fifty feet in the air, giant fountains flowing gracefully with electrified cascades of water; columns; clocks; butterflies; flowers; and huge letters.

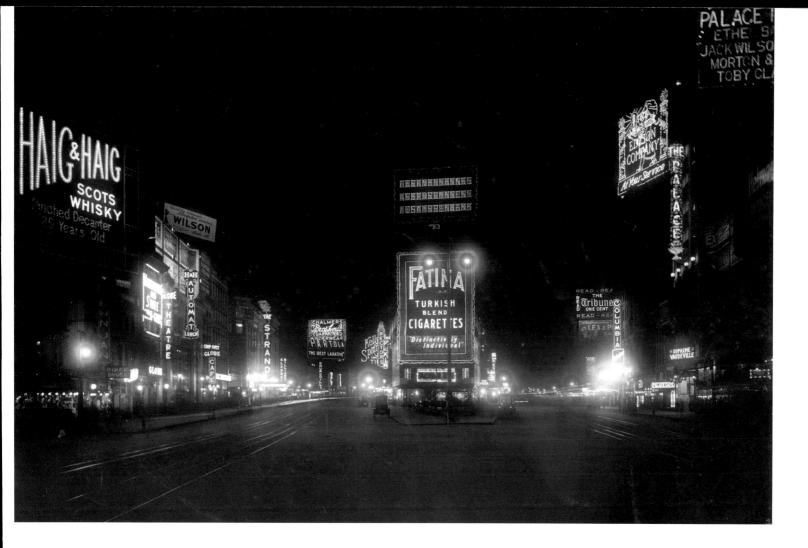

● ● ● **In the fifteen years** after 1904, Gude's fantastic night environment grew even more rapidly than ever. The signs were brightest above Forty-fifth Street, where spectaculars advertising fashionable novelties such as cocktails, Turkish cigarettes, and Broadway revues proliferated. Theaters, cafés, and restaurants eager to compete raced to install electric signs and decorations.

Such jewel-like elegance was not without precedent in Gude's work, but the change no doubt came at least in part as a response to political pressures from outside the Times Square community of merchandisers and showmen. Like the theaters and the lobster palaces, the nightly sign show had been much noticed by everyone from flaks to celebrities, intellectuals, playwrights, newspapers, magazines, and city and business boosters who regularly commented on them. The local crowds adored the signs, but elite opinions ran the gamut from

horror to skeptical amusement to nationalistic appreciation. From our vantage point, the rise of the spectaculars in Times Square seems uncontroversial. From 1904 to about 1915, however, electric signage and decoration began to meet with powerful and well-organized opposition. The electrical ballyhoo created by Gude and his colleagues was increasingly targeted by aesthetic reformers whose City Beautiful agenda, inspired by Daniel H. Burnham's White City at the World's Columbian Exposition, put them in direct conflict with the sign men.

O. J. Gude, 1925.

Oscar J. Gude's rise to fame was extremely rapid. Born in New York City in 1862 into humble circumstances, by the age of twenty-one he had worked his way up from a sign hanger to head of a soap company's advertising department. In 1894, five years after opening his own billboard business, he filed papers with the state that listed $50,000 in capital. By 1906, two years after his first Times Square spectacular for Trimble Whiskey, Gude filed incorporation papers that showed assets of $500,000; this figure was more than three times what Oscar and Willie Hammerstein, then two of Broadway's most famous impresarios, declared on the same day.

Gude was the very picture of a successful self-made man and lived a quintessentially bourgeois life. He was a clubman, was well connected politically, went to banquets, traveled, networked. During the first two decades of the century, he was mentioned as a member of such clubs as the New York Motor Club and the New York Athletic Club, as well as local and national advertising groups, including the Sphinx, which he helped found. Like many of Manhattan's old- and new-money figures, Gude was especially active in equestrian circles and also became an enthusiastic motorist when cars were the height of fashion. He had a box at the Metropolitan Opera each Thursday during the season, gave musicales at home, was said to be extremely well read, and donated generously to charity. Gude collected and exhibited art and over the years tried to inject "artistic" qualities into his billboards.

Outdoor advertising was a notoriously tough business, and Gude's company was constantly involved in disputes over leases and payments, as both a complainant and a plaintiff—an indication of the violent competition and litigiousness typical of the billboard industry's early days. His signs, mounted in prominent spaces all over Brooklyn and Manhattan, were frequently burned, axed, or otherwise defaced. Although nothing like this was reported for his Times Square signs, he may have used strong-arm tactics to gain control of all the best sign spaces. This hint of street-fighting business methods never affected his reputation or his profits.

In January 1917, Gude resigned as president of his company; he later returned briefly, but within a few years he announced that he was selling control to another sign business. He cut a deal that guaranteed him an annual salary of $50,000 and moved to the south of France, reportedly because of ill health. The new owners of the O. J. Gude Company operated the firm independently until 1925, when it was folded into a new sign conglomerate along with twenty other companies. Gude died suddenly in Germany the same year, at the age of sixty-three. In 1930 it was revealed during a lawsuit that Gude's retirement had come after some kind of physical or mental breakdown, and other reports after his death made clear a pattern of mental instability in the family.

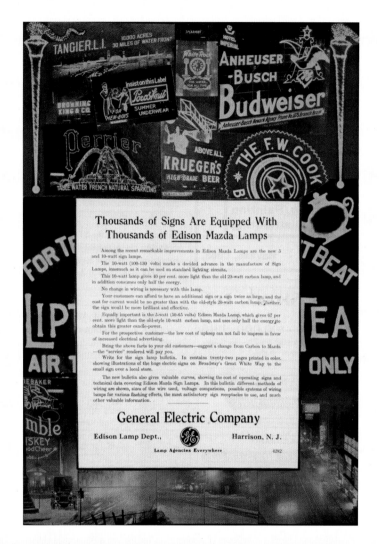

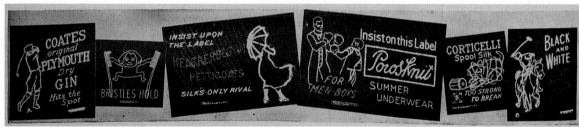

"Dozens of Resplendent Displays": Gude's spectaculars, 1904–1913.

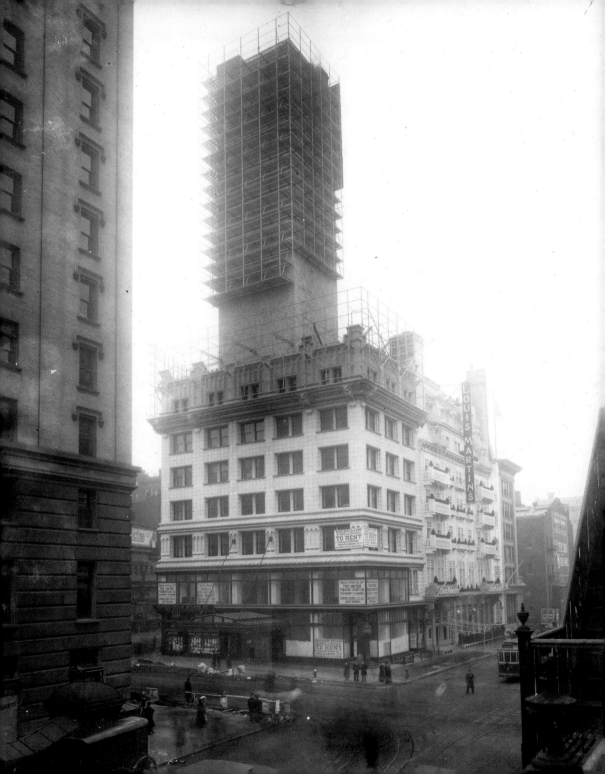

THE SIGN WARS

New York's sign wars of the early 1910s pitted merchants and powerful advertising men like Gude against upper-class professionals and civic reformers. Many of the signs' critics were members of the Municipal Art Society, a civic group that hoped to remake New York into a showcase worthy of the city's enormous wealth and healthy sense of its own importance. The two camps held irreconcilable philosophies: sign men favored an electric midway atmosphere that was part carnival and part world's fair, while Municipal Art Society members cherished as an ideal Baron Haussmann's revitalized Paris. Organization members viewed billboards and electric signs in their neighborhoods and parks as unsightly, vulgar, freakish, and often downright immoral. In many ways similar to struggles over Broadway nightlife and vice that also flared up after 1910, these disputes had a powerful undercurrent of class difference, as revealed in sensibility and taste.

Although they came close at times in 1902–3, reformers never managed to impose a total ban on the signs or to implement legislation giving them control over the advertising's content. In 1910, when Gude's Times Square nightscape was well established and already famous, reformers again made electric signs a flash point. That year Gude—evidently caught between his livelihood and his place in New York's genteel circles—seems to have decreed the new decorative, less racy sign style in response to their new initiatives.

The battle ramped up over several years. Development in Times Square was turning away from luxury hotels and restaurants, perhaps in response to moral criticism of the local nightlife but certainly because of the increase in more general commerce in the neighborhood. Theaters continued to open at a brisk pace, but business projects featuring offices were suddenly much in the local real estate news. When a large Astor-owned office building and a second theater and office project made a full block front of high-rent property available at the southeast corner of the square, the *Times* crowed. High-class development, it asserted, had finally triumphed, and the remaking of Times Square into a tony commercial nexus was at last complete. A third ambitious project announced in 1910 was not so favored. Although it, too, incorporated a multistory rental building, its bona fides were anything but high class. The building was to be a showcase for electric spectaculars—an architectural first for the district. Seemingly oblivious to the tone set by its own building's pyrotechnics and fabulous lights, the *Times* expressed horror.

In spite of the dissent, plans went forward to construct the Heidelberg Electric Building (1910, Henry Ives Cobb) on the triangular block just south of the Times Tower. Its corner was the most important local billboard site of the 1890s and had become an excellent site for spectaculars, one where Gude had placed some of his best signs. The new tower, on land leased from a New York estate and rented to a company that manufactured flashers, was a flamboyant design calculated to evoke the electrical towers of the world's fairs and Coney Island parks. Announced as a kind of signboard structure that would rise eighteen stories, including a hundred-foot tower above the seventh floor, the building was designed to display big spectaculars on all four sides and would "show" for blocks in all directions. Sign men were predictably excited at the prospect. With such a prominent site, the

● ● ● **In 1913 an Ohio sign company** rented the new Heidelberg site and copied one of Oscar Gude's most famous designs, the Corticelli kitten spectacular, which had just been taken down. The original sign, at Forty-first Street and Broadway facing north, showed a kitten tangling with thread. The Ohio sign makers designed a more elaborate version featuring several cats and a sewing machine in action on a spectacular that wrapped around the corner of the Heidelberg tower. Gude successfully sued for copyright infringement.

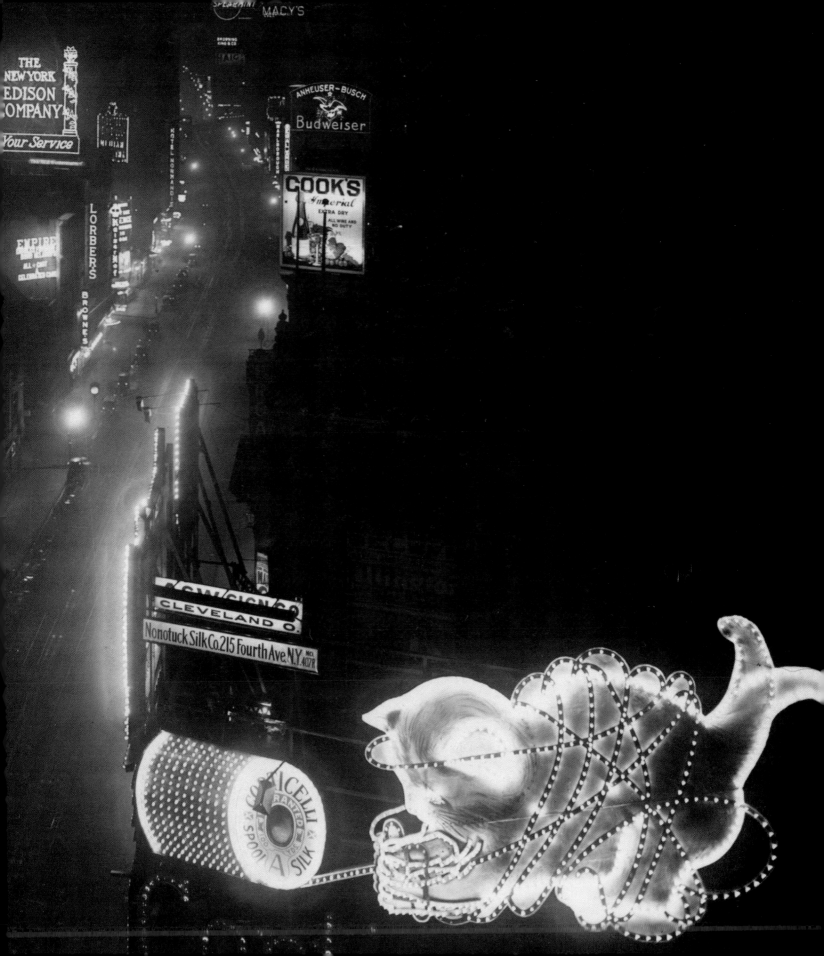

tall, purpose-built structure would be a step up from leased roof and facade spaces around the square.

Opposition to the plan was vocal, attracting the support of civic organizations such as the Municipal Art Society and the Fifth Avenue Association, which were gearing up for a larger effort to ban garment factories on Fifth Avenue. The civic groups particularly feared that Times Square's distinctive carnival style would move east along Forty-second Street. The very idea posed exactly the same kind of danger as immigrant workers did to the "exceptional character" of Fifth, which had until recently been an inviolable home to the city's most famous millionaires; only recently had it expanded to include luxury shops and hotels. In this climate, a giant tower of signs just two blocks away from Fifth Avenue was a threat.

City ordinances were too weak to stop the Heidelberg project. Despite the owner's policy not to rent to advertisers of "beer, whiskies, patent medicines and objectionable matter," the *Times* rallied public opinion against the building, calling it shabby, cheap, monstrous, and freakish. Even more instrumental, oddly enough, were the corporations that regularly bought spectaculars, who inexplicably hated the building as much as the newspaper did. In the end the project went bankrupt and remained unfinished, shorn of its tower and Gothic ornamentation. The site seemed jinxed for decades afterward, and as sensational electrics went up all around it, the Heidelberg site remained underused and never held the prominence it should have had at the entrance to Times Square.

Gude conciliated in the waxing and waning climate of disapproval, erecting his more decorative signs in Times Square. It was a tactic he had used in the past, mollifying critics by promoting "artistic" billboards and designing uniform latticework sign frames to curb the motley look of much outdoor advertising in the city. Gude's new spectaculars did indeed achieve softer, more elegant effects that, if they did not particularly please the aesthetes, were generally more admired than the cinematic spectaculars. Two of them were particularly notable: the Perrier sign and the much more famous White Rock ginger ale spectacular, both from about 1910. Seeking a Beaux-Arts tone, the Perrier sign in the upper square on the Seventh Avenue side featured a brilliant arrangement of lights that imitated a grand baroque fountain in Versailles. It was a new design that, according to the *Times*, had been created in direct response to critics. The White Rock electric at Forty-seventh Street and Seventh Avenue was equally refined and also showed a fountain. More high-toned than Gude's signs advertising corsets, gloves, or petticoats, these spectaculars' gentler style nevertheless failed to silence the critics.

In 1914 the aesthetes presented radical antisign legislation to New York's board of aldermen. Their arguments had changed little since the earlier offensives, when proponents of such legislation wanted to ban electric signs and billboards altogether in places such as parks and residential neighborhoods and sought the power to control the most outlandish signs elsewhere, especially in and around Times Square. The split between mandarins and capitalists broke out dramatically at public hearings, when so many opponents of the legislation turned up that proponents had to come back another day. The businessmen were vociferous in their denunciation of

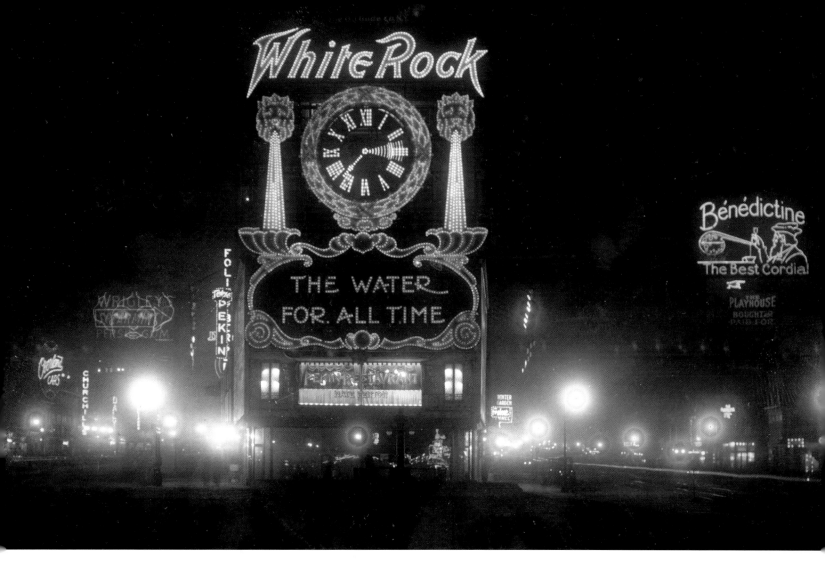

The famous White Rock ginger ale sign of about 1910, which took over Gude's Trimble Whiskey space at Forty-seventh Street and Seventh Avenue, presented a large clock that changed color every few seconds. It was bracketed by two flowing fountains of light—elegantly mimicking the lighted fountains Americans knew from recent world's fairs. It is still one of Times Square's most well remembered signs.

the bill, which they claimed (in arguments that had also been aired in earlier battles) would violate private property rights, affect their revenue, and cost workers their jobs.

In the end, the sign men outflanked the civic activists. In return for a milder law that regulated only the size and safety of signs, the sign companies agreed to sit on a commission of volunteers consti-tuted to monitor the appearance of the installations. The commission, with no real power and a divided membership, came to nothing after a few meetings. Real estate, labor, and business interests had triumphed over high-hat regulation. Times Square, the most dynamic electrical environment of the day, moved more or less unhindered toward its greatest development yet.

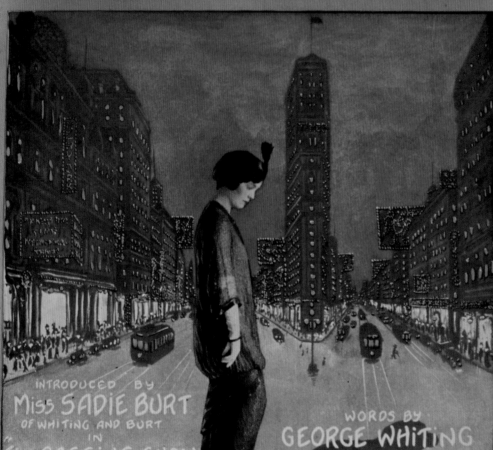

AFTER 1910, TIMES SQUARE DEVELOPED A FRANTIC NEW PACE THAT CONTINUED DAY AND NIGHT. SOME OLD-TIMERS—CRITICS, CARICATURISTS, THEATRICAL CHRONICLERS, MEN ABOUT TOWN—RUEFULLY NOTED THE PASSING OF THE SLOW MORNINGS AND THE LEISURELY LUNCHES OF THE EARLIER THEATRICAL ERA. THEIR MOST VEHEMENT CONDEMNATION WAS RESERVED FOR THE GROWING HORDES OF TIME CLOCK–PUNCHING MIDTOWN WORKERS WHO GULPED DOWN THEIR SANDWICHES EACH DAY AT CHILDS, THE AUTOMAT, AND ANY NUMBER

of new drugstore lunch counters. The critics' plaints opened a vein of Broadway nostalgia that flowed for decades but had no other appreciable effect. Times Square business just got busier and more varied even as most Americans continued to associate the area with nightspots, theaters, and lights.

The biggest development projects were in line with the *New York Times's* vision of Times Square as a high-class commercial destination. Later in the decade, however, the idea of elegant architecture and business of the "right" kind began to give way to a new reality: a Times Square dominated by gigantic movie theaters and ever racier nightlife. Within a few more years, advocates of a Fifth Avenue–style district were forced to surrender completely. By that time, movies, louche nightlife, and a midway atmosphere were permanently in place—and perfectly in sync with Oscar J. Gude's electric signscape.

Broadway theater and lobster-palace nightlife

were at a fever pitch after 1910. Religious figures, temperance activists, and progressive reformers had criticized Broadway morals for years, but as the crowds swelled and the night scene got wilder, opposition intensified. Reform leaders spoke out against the district's nightspots and shows, often using investigators to document abuses. Antivice forces organized boycotts and pressured authorities to curtail the theatrical debaucheries of local showmen. Broadway impresarios and restaurant owners trimmed their sails as necessary, but for the moment they were not greatly hindered by moral reformers and their government allies. Business was too good.

SEX SELLS

Of the thousands of people filling the square each night, a large number came to see Broadway revues, the theatrical form most emblematic of this era in Times Square. Revues were essentially vaudeville

Harry von Tilzer, "I'm a Little Bit Afraid of You, Broadway," 1913, sheet music from *The Passing Show of 1913.*

BURROW FROM ME

Words by JEAN HAVEZ · Music by BERT WILLIAMS

Song Hits of the

ZIEGFELD FOLLIES

Presented at
**ZIEGFELD
MOULIN ROUG**
NEW YORK

STAGED BY
JULIAN MITCHELL

The Broadway Glide
Down in Dear Old New Orleans ..
Dingle, Dingle, Dingle
Blackberrying To-day
You're On the Right Road
Borrow from Me
That English Rag
Mary Cary....................
Election Day in Jungletown......
Be My Little Lady Bug..........

JEROME H. REMICK & C°
New York — Detroit

performances built around the liberal display of pretty actresses. Girl shows in New York City dated to the late 1860s and were popular—and infamous—thereafter; originally, though, they played to male-only audiences. This changed around the turn of the century, when chorus shows in the uptown theaters grew popular with mixed audiences. During Times Square's first decade, the shows evolved into a Broadway staple, playing in theaters and roof gardens in the theater district and touring all over the world.

Florenz Ziegfeld (1867–1932), a local showman who started as a midway promoter at the 1893 World's Columbian Exposition, perfected the Broadway revue, making chorus shows fashionable with men and women alike. Perhaps more important, he made the local revues synonymous in the public mind with Broadway's other famous commodity: sex.

The impresario debuted his famous Ziegfeld Follies in 1907. To draw both men and women, he upgraded the usual leg-show formula with deluxe settings, famous headliners, and the prettiest girls in town. He spent enormous sums on luxurious productions, costumes, and scenery, later hiring the Austrian architect Joseph Urban (1872–1933) to design his shows and assiduously hyping them with the female market in mind. Ziegfeld refined his sex-and-celebrity formula for more than twenty years, spinning off Frolics, Gambols, and Midnight Frolics (boutique roof garden revues he developed when the standard Follies became too popular to be as stylish as they had once been). All of his revues featured topical humor and erotic scenarios toned down by expensive productions and careful stage direction. The franchise made Ziegfeld a household name around the country.

By the mid-1910s, the formula was legion on Broadway and on the roads. Ziegfeld's own extravaganzas vied with several Broadway copycats and even small revues and amateur productions mounted by clubmen, cross-dressing undergraduates, and charity committees. Revues became one of Broadway's most famous exports, promoted throughout America by advance men and publicists armed with scores of cheesecake photographs of chorus girls and actresses. Thanks to the coverage they garnered, revues clinched Broadway's reputation as a center for girls, glamour, and late-night fun, especially among tourists and businessmen.

Meanwhile, the sex trade continued to operate in and around the theater district, albeit less openly than before. City officials and powerful voluntary institutions lined up against the local vice merchants and successfully pushed area prostitution further underground. Paid sex became a more mobile and clandestine enterprise. Men were steered to certain hotels, apartments, or even taxis instead of upstairs cubicles in concert saloons. Brothels and streetwalking, epidemic at the beginning of the century, declined. A network of procurers and steerers, which had almost certainly existed earlier in the lobster palaces, continued among the bartenders, waiters, and cabmen of the thriving restaurants and hotel dining rooms.

CABARET

By 1909 the lobster palaces were at the height of their success and media fame, and a number of proprietors tried to expand. Several announced large restaurant-hotel projects and snapped up the choicest spots around Times Square. Their efforts fizzled within a year or two, however, as the public went crazy over cabaret. Cabaret hit the Broadway lobster

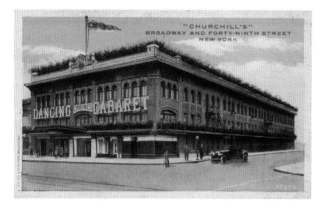

palaces rather suddenly in 1911, catching the owners unaware and contributing to Broadway's burgeoning mythology of sex and sin. As the public demanded the new entertainment, lobster-palace owners—most famously, George Rector, Captain James Churchill, the Shanley brothers, John Murray, and the dueling Bustanoby brothers—scrambled to adapt their business models.

Several famous lobster-palace showmen claimed credit for it, but the fashion for cabaret in Times Square was largely created by customers. Cabaret was a hybrid that evolved from New York's smaller and less upscale nighttime haunts, by way of San Francisco's "singing restaurants" and Parisian *boîtes* and *cafés-concerts*. At first the approach was informal: professional entertainers wandered among tables in the dining rooms and "spontaneously" broke into song. Later a cabaret show might include singing, instrumentalists, or a comedian or a storyteller. Intimacy and informality—however false—were the key novelties in customers' eyes, and lobster-palace managers soon installed small stages in their main rooms or set up separate cabarets in smaller rooms upstairs. After the first Rector's went under in 1913, George Rector logged three hundred thousand merrymakers in the first year of a new Rector's cabaret-restaurant he opened at Forty-eighth Street between Broadway and Seventh Avenue. Mourning the "gracious" lobster-palace heyday, the restaurateur said that people

"jammed, fought, and tore to get inside, and the worse we grew, the bigger crowds" became.

As demand grew, professional dancers performed for diners the kinds of raffish new dances that had been growing in popularity since ragtime emerged in the late 1890s. Their uninhibited performances were a hit, and owners soon added bigger dance floors for the demonstrations. Within a year or two, certain venues were allowing patrons to dance after dinner or the theater, assuming that the authorities were not enforcing one of their occasional curfews. Soon large crowds were drinking and dancing all night in the Times Square cabarets. Demand was so great that dancing was extended to the daytime hours. Pitching to women out shopping or attending matinees, several owners sponsored lunchtime and teatime dances. These *"thés boozants,"* as George Rector called them, were attended by droves of respectable girls and women, who tippled and danced with hired partners, the so-called tango pirates who were the models for movie gigolos in the 1920s.

For several years after 1911, Broadway nightspots struggled to make the incredibly popular cabarets pay as reliably as the lobster palaces had. A falloff in profitable meals (the restaurants' mainstay) and the addition of high overheads for entertainers and costumes squeezed profits. Many cabarets closed, disappearing or changing management in a blur of fire sales and bankruptcies. Curfews and prosecutions by

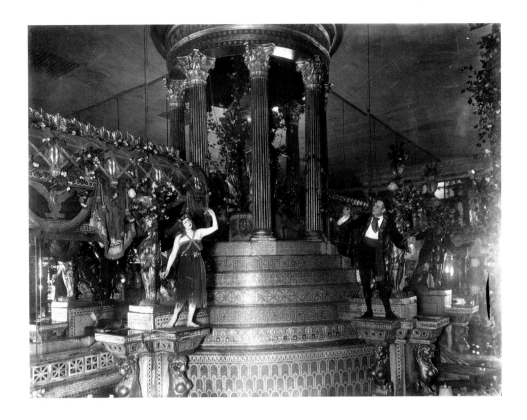

the city were briefly a problem, but not a serious one. Dancing at last helped make cabaret profitable by bringing a rush of new customers to the area. Liquor sales, cover charges, floor fees (incurred each time a couple danced), and late-night revues finally made the Broadway cabarets profitable.

Cabaret forever changed the ambience of the lobster palaces, and with it went the fiction that society people frequented the Broadway nightspots. Cabaret in fact drew a wider audience to the area, as would the district's influx of movie theaters after 1914. Owners promoted the old high-class aura of the lobster palaces among the new customers (tourists were a particular target of this pitch). Advertisements for the big cabarets continued to show the chic Broadwayites whom the restaurants had made so famous at the turn of the century. But in reality a new, faster, and less self-consciously elegant atmosphere prevailed. As George Rector snobbishly declared, the

cabaret crowd was a motley crush of white-collar and working-class men, wives in tow, out for a wild time, along with drunken, rampaging college boys, slummers, and on-the-make chorus girls.

Contemporary literature and memoirs like Rector's give a strong sense of the less gracious mood and changing clientele of the early Broadway cabarets. Owners walked a thin line between high-class marketing—exemplified by the famous dance team of Vernon and Irene Castle—and the highly profitable local reputation for fast living and beautiful girls. In an environment of "artificial . . . secrecy and sin," decadent men and women of all classes—fashionable habitués known as "Hectics," adulterers, Broadway regulars, rich couples—exploited each other. *Smart Set* (a magazine in some ways like today's *Vanity Fair*), the *Times*, and dozens of poets, playwrights, and magazine writers weighed in about neurotic, obsessive, or immoral Broadway types, occasionally with jocular

irony. As one old Bowery type was quoted by the *Times* in 1915: "Now the boys hit for Broadway, where they meet the daughters of those very rich folks . . . and, believe me, they get away with worse stuff than we ever thought of pulling."

HIGH CLASS GOES MASS

Projected film had been gaining popularity since the medium debuted in 1896 at a Broadway music hall, but until 1914 movies had never been particularly important in the uptown Broadway scene. After about 1905, most movies in the city played at penny arcades and small nickel-admission theaters called nickelodeons, humble outlets that generated enormous profits but gave the new medium a reputation as an irretrievably low-class entertainment. By 1912 motion picture exhibitors and producers around the country were flush with money and eager to expand beyond the stereotypical nickelodeon audience of immigrants and children. Naturally they gravitated to Times Square, America's most famous entertainment district and the center of its theatrical industry. There, they cannily adopted the local marketing term *high class* and kicked off another revolution in Times Square entertainment.

High-class movies (a term adopted by movie marketers nationwide) were first exhibited in the Times Square district around 1911 or 1912. Promoters reasoned that "tonier" Broadway audiences (in reality as mixed as any in the city) would give new prestige to the movies. They rented legitimate Broadway theaters and presented their own films or "special releases" imported from Europe. These films, whose self-consciously serious content reflected the push to upgrade the industry, were marketed in exactly the same way as Broadway shows. Road tours followed the New York runs and lasted until demand tapered off—in contrast to the nickelodeon programs, which changed at frequent intervals. As with Broadway shows, the movie exhibitors introduced advance ticket sales, orchestras, and high-profile advance promotion.

Theatrical producers did little or nothing to compete against the movie shows. Secure in their status as the most prestigious businessmen on Broadway, they badly miscalculated in their dealings with the movie companies. Hoping to share some of the sensational profits earned by the movie men and the nickelodeon owners, they instead ended up seriously undercutting their own markets. By licensing exclusive rights to Broadway stage plays, for instance, filmmakers stole the regional audiences from the legitimate road shows. Defections by stars and other talent to the photoplays (as the more serious movies were called) also weakened the legitimate theater producers at a time of intense competition for headliners. Although live Broadway theater remained exceptionally popular, the movie companies needed literally only a few years to take over Times Square.

The first Times Square theater built specifically to show motion pictures was the Strand (1914), a building of unprecedented scale that set a pattern for gigantic movie theaters (soon known as palaces) in the district. The Strand was developed by two penny-arcade magnates on a huge parcel of Broadway near the top of the square between Forty-seventh and Forty-eighth Streets. Designed by the famed theater architect Thomas W. Lamb (1871–1942), it ran 155 feet on Broadway and almost 300 feet on the side street.

The Castle Walk

The craze for fast, somewhat acrobatic social dances that emerged from the cabaret scene was portrayed by the press as a dangerous addiction—a national mania—with an equally dangerous pedigree. The new dances, with names like the turkey trot and the bunny hug, were introduced by the score in the early 1910s. Most of them had originated in saloons and dance halls frequented by African Americans, a fact that many at the time found scandalous. As the fashion for dancing expanded, professional entertainers enthusiastically adapted the dances for mainstream Broadway revues, vaudeville, and cabaret shows.

The new dances were fast and athletic, with close touching, dips, and splits that seemed lewd to critics. In the face of irate mothers and fathers stirred up by editorials and sermons, Broadway impresarios tried to modify the atmosphere, instituting regulations against extreme movements and closely monitoring the dance floors. A more refined cabaret style that soon mollified critics was developed by British-born dancer Vernon Castle (1887–1918) and his American wife Irene (1893–1969).

The Castles made their Broadway debut in 1912, launched with the help of talent agent Elizabeth Marbury (companion of the actress-turned-decorator Elsie de Wolfe). The Castles admitted that they had gotten their material from saloons and other dives, but they cleverly repackaged the dances for uptown audiences. They invented new names (the original animal names offended critics) and smoothed out the clutching, kicking, straddling, and bending, avoiding the jerky manners and the more extreme and embarrassing postures of the first wave of dances.

The pair became known the world over as the up-to-the-minute embodiment of a new Broadway chic, one that was eagerly adopted by local impresarios. Slender, aristocratic (the magazine version anyway), well dressed, graceful, fun-loving but never bawdy or out of control, the Castles were the first and most famous of a slew of celebrated dance teams.

The Castles were fabulous for the image of Broadway nightlife, which in the course of the 1910s had begun to tarnish as the partying around Times Square got wilder and the American social climate became more conservative. Aided by tireless press agentry and magazine coverage, they provided an elegant antidote to the threatening picture of predation and immorality that had become associated with the cabarets. After the Castles wrote dance manuals and opened dance schools, their gentrified image influenced everything from advertising to fashion to Hollywood portrayals of Broadway. Vernon died in a World War I flying accident, and Irene retired, eventually settling in Arkansas.

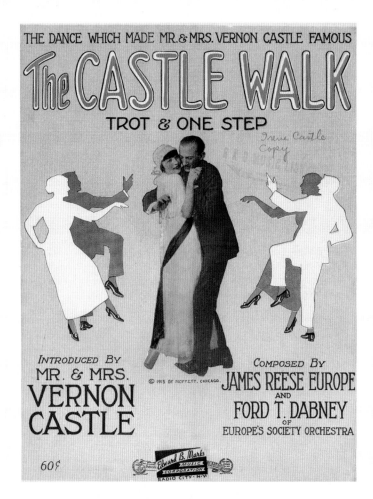

Broadway is elegant: "The Castle Walk," 1915.

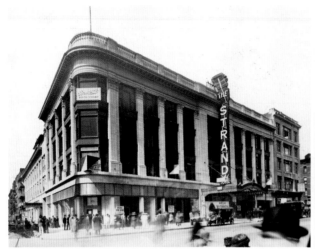
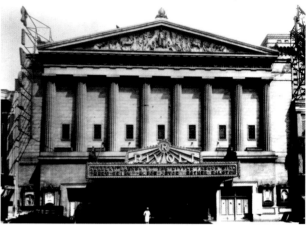

(Left) The Strand Theatre (1914, Thomas W. Lamb), Times Square's first movie palace, stretched almost a full block on the west side of Broadway from Forty-seventh to Forty-eighth Street. As the picture palaces moved in, prices for land fronting Broadway were pushed up. Most of the new theaters therefore incorporated income-generating office and retail space. The Strand's shop spaces rented quickly at record rates; spectaculars on its prime roof and facade spaces also generated additional income.

(Right) The second of four Times Square movie palaces designed by Thomas Lamb, the Rivoli Theater (1917) at Broadway and Forty-ninth Street re-created the facade of a Greek temple. Despite operating at a loss for Adolph Zukor's Famous Players–Lasky company during the later 1910s, the imposing theater was an effective flagship until the mogul put up the Paramount Theatre in 1926. All of Lamb's famous Times Square theaters have been demolished.

The plan included an auditorium with 3,000 seats, a six-story office building, a roof garden, and several highly desirable spectacular sign spaces.

Over the next seven years, movie palace shows became the most popular entertainment on Broadway. Enormous theaters, each seating thousands, went up all around the square: the Rialto (1916), the Rivoli (1917), the Capitol (1919), and Loew's State (1921), all designed by Lamb. Shows ran continuously from noon until late at night, bringing more than a hundred thousand new customers to Times Square each week. Inside and out, the palaces perfectly expressed their owners' desire to upgrade motion pictures and broaden their audience.

To project the desired high-class image, Lamb deliberately aped the dignified tone set earlier in the century by the Times Tower and the Astors' hotels. All of the big palaces were set into sites much wider than Times Square's legitimate theaters, and their designs were similarly outsized. Lamb used giant orders to give his theaters maximum street impact. His multistory colonnades defined the block fronts much more boldly than any legitimate theater ever had and, as a bonus, offered historical references to Greek temples, to Rome, to stylish Parisian structures; as one scholar noted, banks also came to mind. The huge spaces inside were decorated in a gaudy mix of architectural styles and acres of velvet and gold, in imitation of opera houses and elegant legitimate theaters. Extravagant lights evoked associations with world's fair electrical shows and the landscape of spectacular signs outside in the square.

THE INDOMITABLE SHOWMAN

Broadway movie shows became popular virtually overnight with the help of a theater manager named Samuel Rothapfel (spelled Rothafel after 1920), who as "Roxy" became the first nationally famous movie

showman. In the early days of one-reelers and store-front theaters, Roxy (1882–1936) became an expert on movie presentation while running a nickel theater in a small Pennsylvania mining town. After 1910 he worked as a columnist, then as a consultant to the Keith vaudeville circuit, and finally as the manager of two large movie theaters in Minnesota. He moved to New York in 1913 and took over management of the Regent (1913) in Harlem, the first theater in the country designed specifically for motion pictures. The following year Roxy was hired to revamp the fare at the newly opened Strand, where he immediately introduced a new kind of movie program he had made popular at the Regent. When transferred to the new palace on Broadway, his shows brought a flood of additional customers to the theater. Like the grandiose decor of the new theaters and the longer photoplays produced by movie companies, Roxy's programs sought to project an aura of culture that flattered the new audience's sense of dignity.

There was nothing subtle about Roxy's shows. Pitching somberly to audiences eager to leave behind the rushed, herky-jerky nickel-theater programs, Roxy arranged marathon evenings of film and live entertainment. Using a full orchestra, dance troupes, sopranos and tenors, instrumental soloists, actors, and lectors, Roxy interspersed unrelated segments of uplifting performance with a variety of films—travelogues, newsreels, shorts, and longer features. Audiences unfamiliar with high culture were entranced, and his peculiar mix soon became standard fare in deluxe movie theaters throughout the United States.

Roxy's shows defined movies on Broadway in the second half of the decade. As investors rushed to build

Roxy Rothafel's eponymous movie theater, the Roxy (1927, W. W. Ahlschlager), opened on Seventh Avenue and Fiftieth Street, a few blocks from the brightest stretches of Broadway. With its exotic sixteenth-century Spanish-style facade, the theater was more typical of the newer atmospheric-style picture palaces than of Thomas Lamb's Times Square flagships. The Roxy's exterior had few bright signs, in contrast to other palaces closer to the center of Times Square.

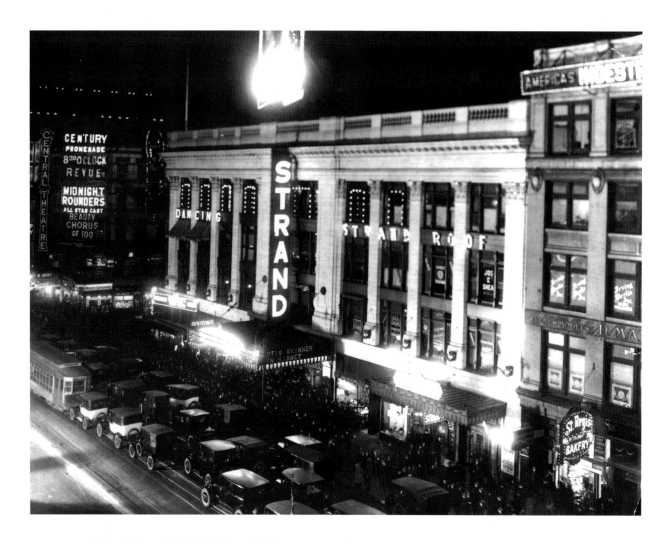

Basing their production in Hollywood while maintaining publicity and finance offices in New York, the new movie studios used their Times Square palaces to premiere their most prestigious films. Openings like this one at the Strand in 1920 brought throngs of celebrity-seekers to the square. Banks of klieg lights mounted on trucks or roofs lighted theater facades for the newsreel cameras, and large beacons played across the city sky.

movie theaters in Times Square, he was hired away to manage or develop each new palace. His tenure at the Strand was followed by positions at the Rialto, the Rivoli, and the Capitol. At each new house, Roxy installed ever gaudier, more expensive, and superfluous decorations and amenities and created shows that grew ever more elaborate. He hired fleets of impressive personnel—uniformed ushers, nurses, doctors, and dozens of other well-drilled atten-

dants—who shepherded patrons by the thousands through the giant lobbies, lounges, and auditoriums of the palaces. Concertmasters, music librarians, choreographers, art directors, vocal coaches, and costume designers were on hand to produce the extravagant shows.

Roxy's winning formula prevailed until talkies changed movies forever in 1926, by which time the impresario himself had become famous. For a time

he produced his own newsreels, and he tried, unsuccessfully, to build his own circuit of theaters. In 1922, in what were the first radio variety programs, he began to broadcast the live stage shows from the Capitol Theatre. Roxy's voice grew familiar to millions of listeners, and he became the country's first nationally known radio personality. He was a model pitchman for a kind of generic and increasingly conventionalized picture of Broadway glamour featuring spectaculars, troupers, and stage and movie premieres. With increasing play in the syndicated columns and feature news, these clichés, like the movies, were the future of Times Square.

By the end of the decade, the movies' primacy in Times Square was unshakable. The independent movie exhibitors who built the first palaces had started to sell out to the rapidly growing movie studios. Paramount and Metro-Goldwyn-Mayer were the first of these conglomerates, and more entered the market after the debut of talking pictures. They maintained offices on both coasts, and, most important, they pursued business strategies that were single-mindedly national in scope and outlook. The studios immediately developed a successful variation on the old theatrical trusts and exploited it until after World War II. In the flagship system, as it was called, the studios used the big Times Square theaters to launch their most important films. Elaborate premieres were staged for opening nights, and first runs on Broadway launched national publicity campaigns for high-profile releases. Emulating the theatrical syndicates, studios took control of exhibition by booking their movies into chains of theaters they had acquired all across America. Until the studios were prosecuted for monopolistic practices in 1948, "Straight from Broadway" billings were a central means of selling films outside New York, as they had been for Broadway road shows. Movies—much more efficient than the Broadway circuits—replaced live theater as the country's most popular entertainment.

HIGH CLASS MEETS HONKY-TONK

Movies became so popular so quickly in the later 1910s that Times Square's managers were able to revert to the nickelodeon methods they had been so eager to escape on the way up. In the process, they transformed Oscar Gude's spectacular Times Square signscape yet again. Their aim was simple and lifted straight from the carnival barker: bring the customers in from the sidewalk. Their giant theaters soon bore ornate marquees, gaudy front-of-the-house publicity that changed frequently, and enormous electric signs that covered whole block fronts.

Until the middle of that decade, when Gude's spectacular nightscape was becoming the focus of press coverage worldwide, signage on local legitimate theaters was relatively old-fashioned and went more or less unnoticed in the newspapers. Theatrical displays on the street typically used earlier forms: bronze marquees, small electric name signs, and lobby posters or small attraction signs framed in lights. The movie palace decorations that developed changed everything.

The most important innovator of the moment was an engineer-designer named Mortimer Norden (1873–1962), whose spectaculars for the Strand and the Rialto, in 1914 and 1916 respectively, immediately made him the premier maker of movie signs in the square. Under Norden's influence, movie signs grew

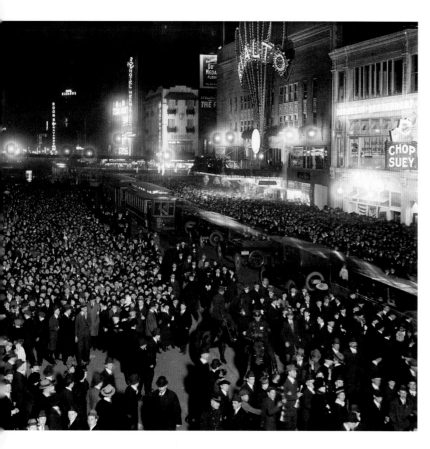

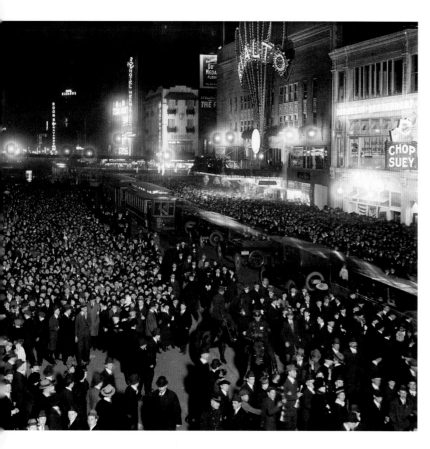 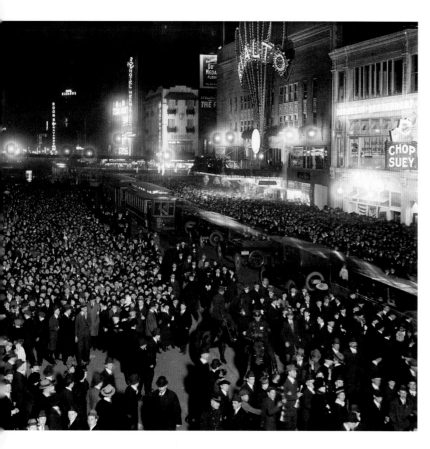 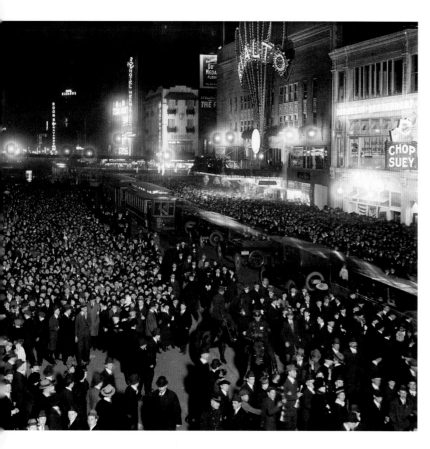 **The Rialto Theatre** opened at the corner of Broadway and Forty-second Street in 1916 under the supervision of Roxy Rothafel, who was hired away from the Strand. Graced with the designer Mortimer Norden's extraordinary spectacular sign, the two-thousand-seat, stageless Rialto had everything Roxy had offered patrons at the Strand: star-filled features, a full orchestra, fleets of ushers, nurses, plush lounges, filtered water, a Wurlitzer, and an elaborate light show.

brighter, wider, and taller. For the first time, in fact, they attracted as much attention as the big advertising spectaculars.

Norden's first important sign, for the Strand, maintained the standard formula for theaters: a vertical name sign above a marquee. However, the sign's huge letters, shot through by an enormous lightning bolt, could be seen for blocks. The design ignited a long vogue for monumental, oversized electrics to equal the bold movie palace scale.

The 1916 Rialto sign was a first for a Times Square theater. At the corner of Forty-second Street and Seventh Avenue, Norden's sign was riveting—a Coney Island–style attraction that was part light show, part spectacular, part holiday. Below the name "Rialto" was a ten-foot pinwheel containing three hundred colored lights covering the facade of the two-thousand-seat theater. The wheel spun, and rockets, in light animation accompanied by the sound of fireworks produced by an air compressor, shot fifty feet up the building to spell out the theater's name in lights; as each letter was lighted, a burst of stars imitated an explosion of fireworks in the sky. The operation repeated a second time as the name was inscribed in a different color. On the marquee, tongues of electric fire rippled and changed color from white to red to green.

Most of Norden's movie signs were nothing more than giant electric billboards. Within this simple format, he sometimes tried (often using projectors called stereopticons) to transfer to the street outside effects seen on the movie screens. He supersized cinematic effects of color, light, trompe l'oeil, and "dissolves" to fill entire building fronts. His signs showed flying carpets, sunsets, storms, lightning, clouds moving

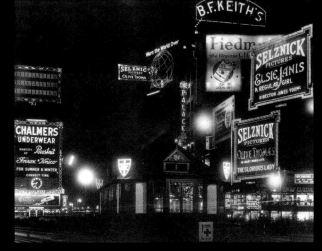
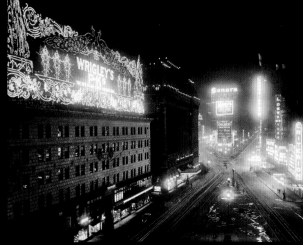
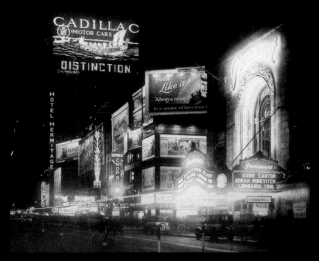
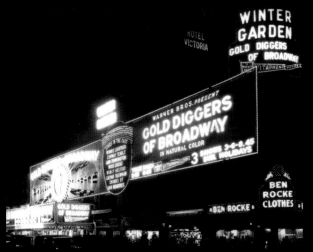

(Clockwise, from top left)

● ● ● **By the end of the 1910s,** movie signs were getting bigger, adding brilliancy to Times Square's growing profusion of spectaculars, electric and semispectacular boards, lighted marquees, and glowing shop and restaurant windows. The block to the right, dominated by billboards for Selznick Pictures (a silent-era independent production company with an important presence in Times Square signs), is on the east side of the square just below the Palace Theatre on Seventh Avenue between Forty-sixth and Forty-seventh Streets.

The Putnam Building to the left, between Forty-third and Forty-fourth Streets, was relatively dark until 1917; that year the O. J. Gude Company put up its famous Wrigley Spearmen sign, one of the era's brightest. The Hotel Astor a block north remained without signs throughout its existence, unlike the bright block across the street with two movie theaters (whose names changed depending on which company was leasing the space). Here these theater facades show the billboard-type signs that were also standard at this time.

By the late 1920s, Warner Brothers had three theaters in Times Square, including the Winter Garden at Broadway and Fiftieth Street. Its enormous marquee and facade sign show the monumental movie displays popularized by Mortimer Norden, although this one was not his work. *The Gold Diggers of Broadway* was the studio's first all-sound picture.

Mortimer Norden's Paramount Theatre (1927) marquee at Broadway and Forty-third Street was in the tradition of the metal and art-glass marquees common on area legitimate theaters. The supersized display, topped by Paramount's dramatically lighted skyscraper headquarters, finally brought bright light to the middle of the square on the west side. The Cadillac roof sign just to the south, featuring a traveling news sign at the bottom, was the work of General Outdoor Advertising.

The King of Movie Palace Signs

Even less is known about Mortimer Norden than about Oscar Gude. Norden started out as a lighting engineer, not in advertising. He was born in New York City in 1873 and studied at the Hebrew Institute of Technology, City College, and Cooper Union. At the age of twenty, he was in business in the city as an electrician, and by about 1898 he was listed in a directory as a sign maker on West Twenty-eighth Street.

A 1914 mention of the Strand sign is most likely only the second press notice Norden and his company had ever received, but after that he was acknowledged as the king of movie palace signage. He did all the important signs for the Criterion at Forty-fourth Street (the former Lyric Theatre within Oscar Hammerstein's 1895 Olympia complex, converted into a movie palace in 1914). With a large half-block sign wrapped around the corner of Broadway and into the side street, this job gave Norden's work one of the most conspicuous platforms in Times Square.

In 1927 Norden was given the plum assignment to decorate the marquee and front of Rapp and Rapp's grand new thirty-five-story Paramount Theatre at Forty-third Street and Broadway. Norden, perhaps evoking the tall, narrow entrances of area legitimate theaters, floodlighted the architects' soaring two-story arched window, which framed a stained-glass medallion at its center and was topped with the Paramount logo. In less than five weeks, he and a team of sculptors and fabricators turned out a monumental stamped-copper marquee with grillework covering backlighted stained-glass panels, changeable opal-glass display letters, and a brilliant ceiling of lights above the pavement in front of the lobby doors.

The same year, for some unknown reason, Norden sold out to a new large sign conglomerate, General Outdoor Advertising, and was named, with great fanfare, as the general manager of its commercial sales division. In 1929 he designed the fabulous "living" Hollywood Revue sign at the Astor Theatre, and in the early 1930s he worked on signage for the movie theater at Radio City. Mentions of him taper off later in the decade. During World War II, the designer went to work for RCA. He died in 1962 in New York City.

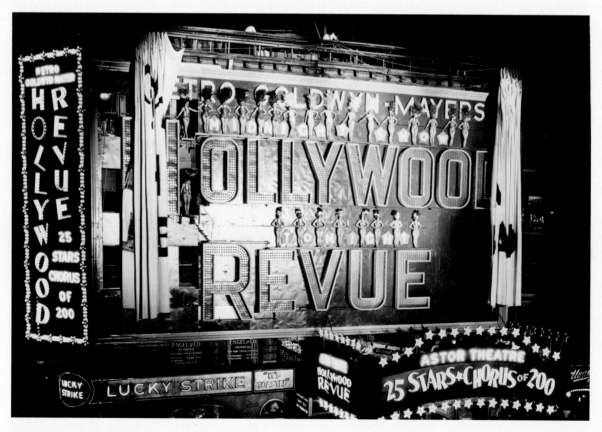

The Hollywood Revue sign, 1929.

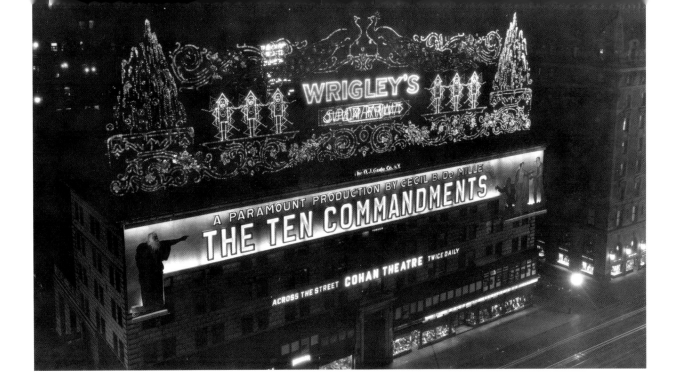

Oscar Gude's famous Wrigley Spearmen sign opened to great fanfare in 1917 at Forty-third Street and Broadway and remained up until 1924. Below it, Mortimer Norden's *Ten Commandments* sign from 1924 shows the growing tendency of movie signage to cover ever larger parts of local facade space. Plugging a show at a converted legitimate theater across the street, the Cohan, the sign represented a first: the closing off of office space behind an electric sign that rented at a better rate.

Gude and other spectacular men continued to develop their own towering roof signs. As a result, large sections of block fronts in Norden's Times Square were covered with brilliant, moving electric forms after dark. Lighted increasingly from bottom to top, Times Square got even brighter.

ADVERTISING PAYS

With the influx of movie customers, some choice sign spaces in Times Square started to become more profitable than commercial office rentals or hotels. Inspired by the movie palace practice of covering Broadway frontages with gaudy electric signs, landlords aggressively rented space on their facades, not just on their roofs, even though by covering up windows, they closed off leasable space inside the buildings. Sky signs also started to become taller as a result of changes to city law. Although movie signs now held a commanding presence in the always expanding signscape, the best advertising spectaculars remained competitive in size, income, publicity, and, above all, ingenuity.

In keeping with the movie palaces' carnival style, by the early 1920s, sign images were everywhere in Times Square—lighted, painted, or a hybrid lighted-and-painted form called semispectacular. Before the movie palaces opened, attention had been focused on electric roof signs. Now, in the spirit of the giant movie boards on Broadway, many corners around the square were covered with billboards in tiers of three or four boards, which were placed in floodlighted frames and topped with amazing spectaculars.

Two of the O. J. Gude Company's most famous signs were designed for the brighter, more visually saturated streetscape. Both signs were erected on the Putnam Building, right in the middle of Times

Clicquot

GINGER ALE

World's Largest Seller

THE RIVOLI COOLED BY REFRI

RATION ALWAYS 69 DEGREES

MOUNT PICTURE

● ● ● **Clicquot Club's** famous Eskimo boy replaced the Wrigley sign at Forty-third and Broadway in 1924. The block-long Gude spectacular was the last to appear on the Putnam Building's roof before it was torn down in 1924 to make way for the Paramount Building.

Square on the west side of Broadway between Forty-third and Forty-fourth Streets, a space that had not had an electric roof sign with any regularity since the first decade of the twentieth century. Each sign is still famous for its huge size, whimsical animation, and sensational electrical effects.

The first of these signs, the Wrigley's Spearmen spectacular of 1917–24, hearkened back to the earlier Gude style that was passing from the square. At a block wide, the sign was the company's biggest sign ever. It filled the sky fifty feet above the roof with stunning colored and white effects, bringing brilliant light to a stretch that had been relatively dark for most of Times Square's existence. Inside a frame of fountains, scrollwork, and giant rampant peacocks, two troops of stick-figure "spearmen" on parade performed eight exercises as the word "Wrigley" and names of different varieties of gum flashed on and off. The peacocks' tails, sixty feet long, were rendered in changing iridescent colors, and the thirty-four-foot fountains, also colored, were picked out with thousands of lightbulbs. Crowds came to stare, stopping traffic throughout the run of the sign, which during World War I helped to promote war bond sales.

The Clicquot Club Ginger Ale sign, which debuted on the Putnam Building space in summer 1924, was the Gude Company's last great sign. It was designed by Gude's art director, George Ihnen, the man who likely was responsible for dozens of the company's best signs. The complex animation of the Clicquot sign began with slowly rising northern lights, a favorite motif at world's fair light shows, which rose from a pale blush and flared to full multicolored light above an arctic landscape. A sleigh containing an enormous bottle of ginger ale was driven by a huge Eskimo boy and pulled by three smaller Eskimos. The sign was up for only a few months, but while it was, the sponsor made sure to plug the spectacular on its weekly jazz show.

By the end of the decade, the style of billboards and electrics in Times Square started to change. New spectaculars more closely resembled contemporary poster advertising, showing extremely simple, legible, and striking images. Light effects became more abstract, and images on the spectaculars got bigger. At the dawn of the consumer economy, product signs featured monumental pictures of brand names and slogans spelled out against the sky in enormous letters often enlivened by geometric patterns of light that flashed, blinked, and "talked" in carefully timed sequences. Immense logos rendered in the style of contemporary graphics appeared in elaborately patterned, supersized frames.

The booming advertising market at the end of the twenties reflected continuing local confidence in the "daytime development" long promoted by the *Times*. As the decade went on, retail, office, and residential projects dominated real-estate development, and theater construction was pushed to the side streets. But despite this growth, steady crowds, and two big new movie palaces, Loew's State and the Paramount, after January 1920 the atmosphere of stylish excitement that had prevailed in the neighborhood for most of the past two decades declined quickly. Within years the Volstead Act—Prohibition—changed Times Square forever.

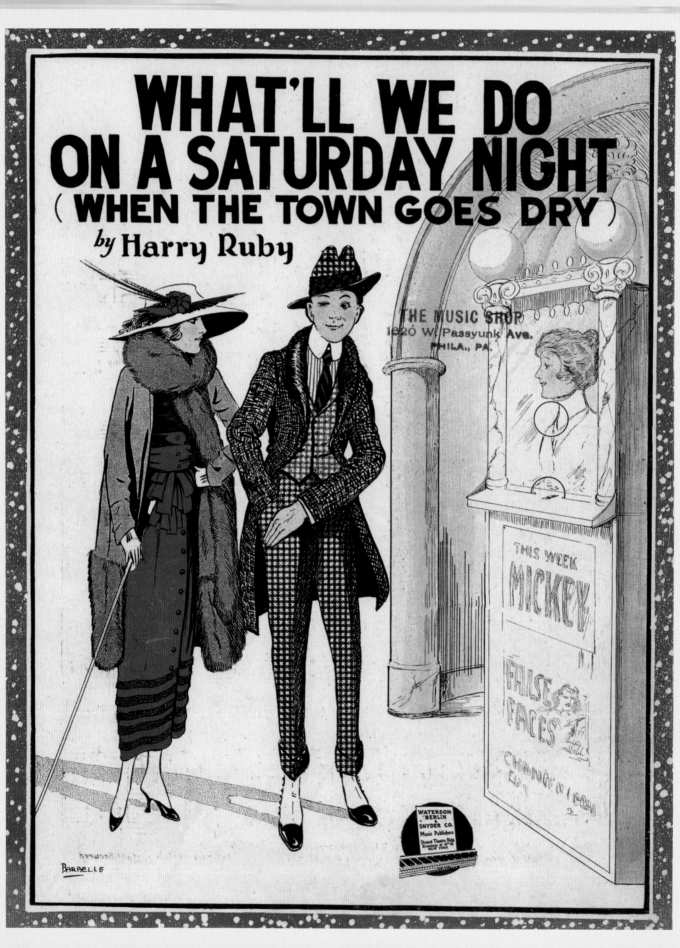

W HEN PROHIBITION TOOK EFFECT IN 1920, THE COMPLEX FABRIC OF BUSINESSES THAT MADE THE AREA SO FAMOUS BEFORE WORLD WAR I STARTED TO UNRAVEL. SOME COMMERCIAL ENTERPRISES BOOMED—TOURISM, THE MOVIES—WHILE OTHERS FALTERED OR FAILED—THE THEATER AS WELL AS CABARETS. AS THE LOCAL REALITY SHIFTED, THE PUBLICITY MACHINE, SPEARHEADED BY NEWSPAPERS, NEWSREELS, AND RADIO PROGRAMMING, CONTINUED TO PRESENT GENERIC IMAGES CENTERED ON BRIGHT LIGHTS

and glittering movie theaters, in effect creating a Times Square brand. The unchanging promotion during the decade ensured that people outside New York still viewed Times Square as it had been before Prohibition.

The federal law outlawing the sale of liquor had an almost overnight effect on Times Square's after-dinner and after-theater nightlife, if not on the movies or the theater. Without liquor, cabaret and club life was unsustainable. Over the space of one or two years, the old lobster-palace men closed their large, expensive places. Rector's, Bustanoby's, Martin's, Churchill's, Murray's, and Shanley's all folded, to be replaced by a network of illegal speakeasies, gambling houses, and town-house establishments (restaurants, cabarets, and bars run like clubs in what had been private houses) that opened and closed frequently as they tried to stay ahead of the law. The neighborhood's nightlife left behind its stylish beginnings.

Crime rose, initiating what Damon Runyon (1884–1946), one of the most famous Broadway writers of the 1920s and 1930s, called the "era of . . . the bootleggers and the gangsters, with murders a dime a dozen." The Longacre and Putnam Buildings, the two Astor office buildings touted by the *New York Times* in 1910 as the apogee of high-class development in Times Square, were raided in sweeps for gangs, drugs, and bootleg liquor. Pickpockets worked the movie houses, and burglaries increased. For the first time, murders, car chases, and gunfights were reported in the press; sometimes crowds of movie or theater patrons watched the action from the street. Circulation was undiminished, however, as people continued to travel to the square for work and entertainment.

There remained a core of dependable daytime and nighttime businesses to feed and amuse the throngs. Unpretentious restaurants such as Jack Dempsey's, Lindy's, the Automat, and Childs catered

Harry Ruby, "What'll We Do on a Saturday Night (When the Town Goes Dry)," 1919, sheet music.

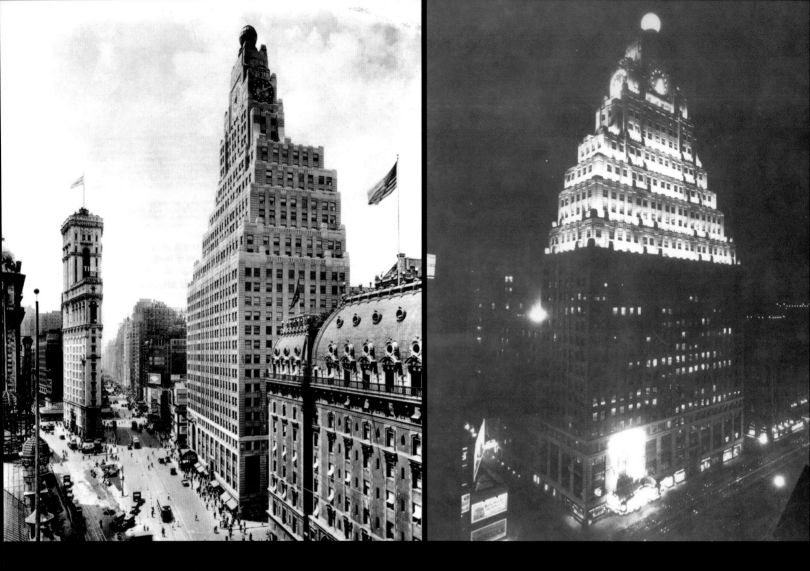

● ● ● *(Left)* **The Paramount Building,** designed by the famed Chicago theater architects Rapp and Rapp, opened in November 1926 on the west side of Broadway between Forty-third and Forty-fourth Streets. The 3,600-seat Paramount Theatre, entered on the building's southern end, was topped by a twenty-nine-story skyscraper, its upper floors set back to meet new zoning regulations. At left is the Times Tower and at right the venerable Hotel Astor.

(Right) **The *New York Times*** crowed that the Paramount Building, which replaced the Astor estate's Putnam Building, was the vanguard of the inevitable: the rebuilding on important Times Square parcels that had been developed in the rush of construction between 1904 and 1910. The movie companies were among the few businesses expanding in Times Square in the late 1920s, a reflection of their increasing confidence and the industry's consolidation.

● ● ● **The Paramount Theatre,** smaller than the pharaonic Roxy Theatre (1927, W. W. Ahlschlager) going up at the same time several blocks uptown, was among the last of the district's picture palaces. It was the flagship of Adolph Zukor's recently renamed Paramount–Famous Lasky Corporation, which had acquired the Publix chain run by Sam Katz of Balaban and Katz.

to people visiting or passing through the square. The movie palace trade started at midday and went until after midnight, creating a steady stream of people on the sidewalks. Most of the local hotels, big and small, continued to house tourists, although the Knickerbocker was converted into an office building after Prohibition. The Hotel Astor continued to host banquets, conventions, and balls, and its roof garden stayed open; gone, however, was its smart metropolitan style, a victim of the large tourist presence. Tucked in between businesses on the square and on side streets, ticket and tourist agencies, haberdasheries and clothing stores, tobacconists, jewelry stores, newsstands and flower stands, cafés, doughnut shops, coffee shops, barbershops, and drugstores flourished; upstairs, office suites and studio spaces housed beauty shops, schools, dance halls, and Chinese restaurants. Businesses related to the theatrical and publishing trades were still common: costumers, artistic photography studios, agents, composers, and music publishers, as well as publishers of journals, pulps, and publications covering Broadway and the movies.

An element of cheap carnival amusement that had always been found around the neighborhood crept in more visibly, at first in the area's margins. Billiard halls and arcades opened, and novelty shops and matinees began to bring Times Square a new and important audience: teenagers and children. In 1924, as the start of the Paramount Building's construction at Forty-third Street promised a prosperous new skyscraper era (briefly, as it turned out), Hubert's dime museum opened on Forty-second Street, the district's center after 1904—in the building that had once housed the famous lobster palace Murray's Roman Gardens.

(Above) In fall 1933 a sign magazine raved about the Hollywood nightclub's new, post-Prohibition sign. This thirty-two-by-thirty-foot neon-and-opal-glass spectacular featured riveting animation, replete with almost naked showgirls and brilliant red, blue, olive, gold, white, and blue-green neon tubes. After recent bad times, proclaimed the magazine, Broadway signs like this were finally adding "new life, vim, and vigor" to the Times Square spectacular market.

(Opposite) With the *Times* predicting that new construction in Times Square would ring the area with tall buildings, several designs for set-back buildings were commissioned in the later 1920s, including Thomas Lamb's "New" Palace Theatre and Radio-Keith-Orpheum Building at Forty-seventh Street. In the aftermath of the 1929 stock market crash and the Great Depression, however, none was completed.

By the late 1920s, the legitimate theaters—hurt by motion pictures and the ongoing effects of rising costs and falling profits—were forced to cut their productions. Some venues, especially those inside the square, converted to the more dependably profitable movie shows, but others carried on with live entertainment, enduring more dark weeks and shrinking returns. The stock market crash of 1929 devastated the Forty-second Street theaters, the flagships of Broadway's earlier theatrical trusts. The ten remaining houses on the street were forced to curtail or eliminate expensive live production and shift any way they could. By 1933 five of the important Forty-second Street theaters had stopped putting on any shows, three became burlesque houses, and the rest showed second-run movies. It was a metamorphosis that Broadway producers were never able to roll back.

CAFÉ SOCIETY?

Times Square's nightlife remained as varied, fast paced, and crowded as ever, but the criminal atmosphere created by Prohibition added a new element. In 1931 Charles Green Shaw, a wealthy cubist painter, wrote a New York City guide for *Vanity Fair* that showed the changes. He devoted a long section to Times Square, giving considerable space to a new kind of nightclub (the name replaced the pre–World War I term *cabaret*), along with chop houses, grills, chili parlors, drugstore counters, speakeasies, a bowling alley–billiard hall, several miniature golf courses, an ice rink, dance palaces, an exhibition of torture instruments, roof gardens, and hangouts "with a dash of lavender." "Anything might happen on Broadway at night," he wrote, "crowds shuffle by in endless streams . . . 'Snow' peddlers . . . a racketeer . . . song writers, college boys, pansies, big shots, bootleggers . . . dirty faced youths . . . a girl in no stockings and . . . a diamond ring . . . a blue-jowled yegg [burglar]" picking a fight. In Shaw's Times Square, cabs and limousines jammed the street, and the little *boîtes* and clubs were amusing but fleeting.

The sort of chic customers who had gone to Rector's, the Knickerbocker Grill, or Ziegfeld's Midnight Frolics in Times Square were now more likely to patronize the smart clubs in the East Fifties and

In his 1931 nightlife guide for *Vanity Fair*, Charles Green Shaw reported that he liked the sign on the Hollywood club, but he said nothing about its sister club, the Paradise Restaurant just across the street at Broadway and Forty-ninth. Like the Hollywood, the Paradise made money on its great floor show and volume of patrons, not on high prices. Because of its tourist clientele, the club was not the kind of place fashionable New Yorkers frequented often.

As the Depression set in, Forty-second Street's legitimate theaters had trouble staying in business. In 1931 David Belasco's Republic Theatre (1900, Albert Westover) just west of Broadway was acquired by owners of a burlesque circuit, the Minsky brothers. The tawdry midway atmosphere they brought to the Deuce was bitterly denounced by the mainstream Broadway community.

elsewhere—places such as 21, El Morocco, the Stork Club, El Patio, the Rainbow Room, or any of the city's many private speakeasies in brownstones where people went to drink contraband liquor. "Café Society," as it was called by Cholly Knickerbocker, the society reporter for the *Times*, was born. Times Square was not its center, however, even though columnists and marketers pushed the idea that Broadway nightclubs were still ultrastylish.

The gigantic new nightclubs drew out-of-towners and some Broadway and Park Avenue types, more or less the same mixed group that might have been found in the pre-Prohibition cabarets. Before the ban's repeal in 1933, nightclubs were careful to distinguish themselves from speakeasies and cab joints (so called because cabbies delivered the clientele), which made money by fleecing customers or worse. Serving high-quality food and, after 1933, liquor, the clubs strove to project an atmosphere of theatrical glamour for the tourist and family trade that found its way there. Floor shows were the main attraction, as they had been in revues and cabarets before Pro-

hibition, but they were slicker than the prewar acts. They were often promoted by regional tours, making the clubs nationally famous just as the lobster palaces had been in earlier days. A club at Forty-ninth Street and Broadway named the Hollywood originated the new big clubs in 1928; initially dry, it was run by Joe Moss and emceed by the radio personality Nils T. Granlund. Similar places could be found across the city, but the most famous were on Broadway near Times Square—among them the Casa Mañana, the Paradise, the Casino de Paree, the Cotton Club (a downtown branch of the famous Harlem club), and the Diamond Horseshoe.

The nightclubs' elaborate shows ("risqué and lavish," declared a critic in the *Times*) were not particularly original, in contrast to those of the teen years. Three times a night, around 8:00 p.m., midnight, and 2:00 a.m., a vaudeville-and-chorus program (of a kind still popular in Las Vegas) was presented. The clubs exploited Ziegfeld's successful formula by emphasizing showgirls in elaborate, sexy costumes. (Charles Green Shaw was careful to steer his readers to the

In the century's first two decades, Broadway publicity—including pictures of chorus girls and actresses in sheet music, programs, and upmarket magazines—had helped make Times Square synonymous with sex. At first, the local beauties were elegantly costumed and posed by photographers now famous for their artistry, men like Alfred Cheney Johnston (ca. 1884–1971) and Nikolas Muray (1892–1965). As Times Square's nightlife shifted toward mass entertainment in the 1920s and 1930s and slipped into tawdriness, though, the chic silk-and-lace titillation of the Ziegfeld Follies and other earlier Broadway revues fell by the way, and a new, bolder Broadway genre developed.

Pulps, fanzines, and nightlife guides joined the steady flow of mainstream Broadway tourist and newspaper material that continued to circulate throughout the country. Flogged locally (like star maps in Beverly Hills), guidebooks steered men to a mythical paradise of pretty girls, naked choruses, and outrageous shows. Images accompanying the new material updated the tradition of titillation and moralizing found in nineteenth-century sunlight-and-shadow tales. The pulps were populated with stock characters established in the lobster-palace and cabaret years. Saucy chorus girls, innocent dancers, predatory gold-digging actresses, gigolos, corrupt (or noble) scions of good families, and gullible "bald heads" (old rich guys who sat in the front rows to ogle the girls) cavorted wildly on Broadway and, if necessary, got their comeuppance. This clichéd world of chorines and millionaires remained a mainstay of the cheap magazines for decades. *Broadway* and *artistic* became code words (*French, gay*, and *spicy* were others), and they were commonly included in pulp titles and after-dark guides well into the 1950s.

BETTY

of

42nd

and

Broadway

2 Strips of Card Inserts in Back of Picture.

DIRECTIONS

• Insert first strip behind UPPER SLOT above picture.
• Insert 2nd strip behind LOWER SLOT above picture.
• For variation insert strips from bottom.

(Above) **Pulp Fiction:** *Broadway Nights* cover, 1930.

(Opposite, top) **New York Behind the Scenes, Uncensored!**, 1939.

(Opposite, bottom) **Betty of Forty-second and Broadway.**

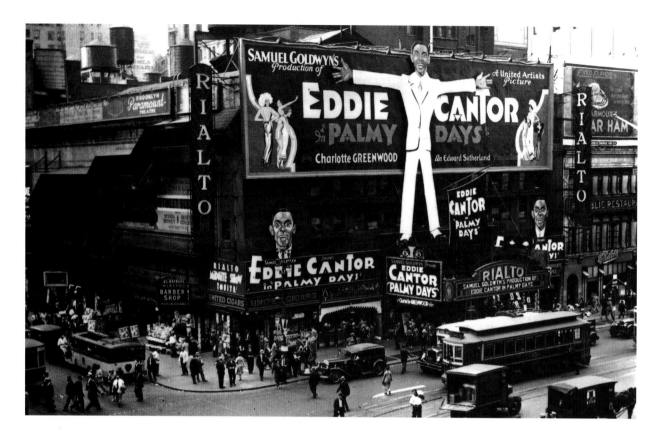

In the 1930s, publicity men stopped at nothing to attract movie customers. A welter of giant signs often covered many theater fronts above the marquees, some of them electric and some of them painted. This board for Eddie Cantor's *Palmy Days* at the Rialto Theatre on Broadway at Forty-second Street saluted one of the era's biggest comic stars.

"Hollywood girls [who are] the trimmest in town. In figure and physiognomy.") A glance at the glossy programs sold at the shows, however, gives a sense of predictable, rote display.

HONKY-TONK

After Black Friday, legitimate theater stalled almost completely, and burlesque shows became Forty-second Street's most prominent draw. The "burley shows" were much more sexually explicit than the bubbly, erotic froth that Ziegfeld had made so famous. Burlesque operators profoundly changed the atmosphere on the street, drawing fierce public criticism as well as scrutiny by the city. Until 1933, when the city banned such hype, street barkers and large street-level posters of almost naked dancers enticed male-only audiences to enter. To quell the increasingly raunchy scene, the city banned burlesque in 1937; after five years of court challenges, it denied licenses to the burlesque operators, which forced the shows to close for good. Most of the Forty-second Street theaters then converted to cut-rate second-run movies running round-the-clock.

Times Square became a broadly popular entertainment district that to New Yorkers at least never lost its associations with the new so-called grind theaters. The movie palaces continued on also, and lights, nightclubs, and premieres were still promoted

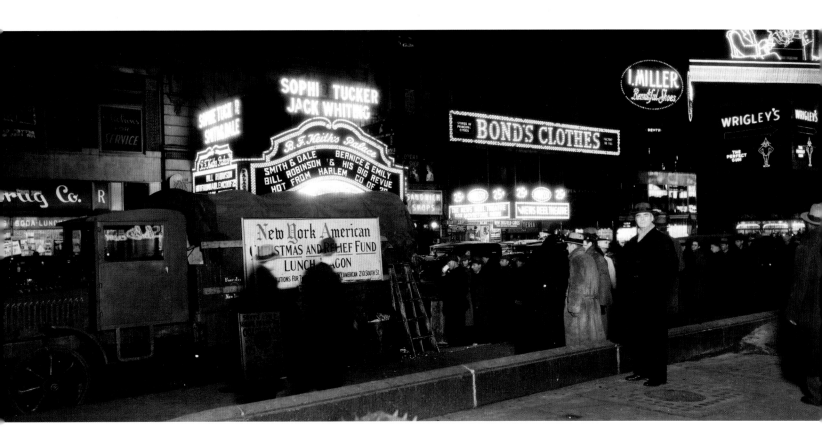

After the Depression, Times Square's location and round-the-clock activity made it a natural magnet for transients and people down on their luck as well as those who attended to or preyed on them: preachers, relief workers, grifters, and policemen. Much national publicity ignored the glaring changes, maintaining the image of the Great White Way as it had been in its heyday.

in radio and other national outlets. However, dance halls, bars, cheap vaudeville houses, billiard rooms, second-run movies, souvenir shops, and arcades gave stretches of the blocks inside the square and on Forty-second Street the aspect of an old-fashioned midway. Critics decried the new carnival atmosphere and the in-your-face ambience, but the onslaught of mass-oriented entertainment of all kinds was unstoppable after the early 1930s. Calls for "improvement" (gentrification) were resisted for decades.

Movie house managers were not troubled by the carnival atmosphere in the street, and front-of-the-house publicity at the movie theaters, like their facades, reached sensational proportions by the 1930s.

Street-level displays of outrageous complexity, scaled up to be seen from longer distances, enticed passersby inside. Ever since the movies' beginnings, producers had offered posters, hand cards, cutouts, and window advertisements for a fee to theater managers along with a movie. Now designers and movie publicists pushed lobby display to the limit using a style ultimately derived from painted carnival fronts, bright pictorial circus advertisements, and lighted nickelodeon facades. Under the marquee and around the lobby doors, workers installed bewildering accumulations of posters, show cards, over-door murals, and cutouts to plug the current shows. More posters and promotional cards were inside the lobby, often in

(Opposite) Hollywood movies were an important vehicle for Broadway and Times Square imagery in the 1920s and 1930s, as shown by the pert chorus girl and the lights in this program for *The Great White Way* (1924). The movie told three loosely connected Broadway stories, including a musical comedy subject and a story about the sporting life—the latter a favorite theme of the celebrity writer Damon Runyon, who made an appearance in the film.

cases or on freestanding easels; sometimes elaborate "lobby pieces" promoted upcoming shows. Eventually, sculptures, painted vistas, tents, ship interiors, battlefields, and Egyptian temples attracted customers, as did shadow boxes, mirrors, and all kinds of glittering surfaces. Construction was often done in the middle of the night, when no crowds could interfere with the teams of carpenters, electricians, and painters installing the displays. The lavish decorations changed with every show, and costumed actors hired by studio publicity men helped advertise the films during their runs. Electric marquees, facade signs, and hundreds of blinking lights enhanced the carnival tone. Observers of the local scene consistently complained that this kind of movie palace publicity created a midway honky-tonk atmosphere in the square.

In truth, the picture palace steerers only added to the chaos. Vendors flooded the streets amid stilt walkers, flower sellers, beggars, and mission preachers. In the middle of the square, enterprising men set up giant telescopes for star gazing. Hubert's packed in audiences with its sideshow attractions, among them a bearded lady named Lady Olga, a professional freak who split her time among Hubert's, Coney Island, and road tours; her attendance in 1940 at a swank party with Cole Porter was chronicled by Joseph Mitchell in the *New Yorker*. A flea circus, anatomical specimens, contortionists, peep shows, and the by-now ubiquitous arcade games were also popular.

Old-time Broadwayites remained dismayed by the area's descent into Coney Island tackiness, regretting the "lost parade of fashion" and the elegant "silver slipper era" that had given way to the bewildering crush of "igloos, tents, log cabins, covered wagons, forests, and streams" displayed each month

at the movie palaces. Nostalgia also flourished for the glories of theatrical Broadway at the turn of the century, an elegant Broadway that one wag cracked had been left to "shooting galleries and to legend."

MASS MEDIA, MASS FAME

Through it all, Times Square remained among the most frequent subjects in an American media that was increasingly national in orientation. The now-familiar images that Roxy and the early radio broadcasters had picked up—lights, show business, spectaculars—were pitched more widely as radio shows, photographs, columns, newsreels, and stories found their way in greater numbers to Americans. Before long, the lighted Times Square streetscape became a favorite motif used by the mass media to communicate quickly a vivid sense of Broadway's excitement. The positive qualities of Times Square's lights had been a touchstone of American identity since at least World War I, one that embodied what many people viewed as the country's best qualities: cheerfulness, confidence, energy, insouciant modernity. By the Depression, when spirits were so low, the lights were often used to boost morale.

Oddly enough, Damon Runyon, one of the most popular promoters of Broadway in this era, never mentioned lights at all. Runyon was a famous sports reporter and Hearst columnist whose syndicated Broadway stories sold millions of magazines. A westerner who moved to New York in the 1910s, he lived a certain kind of Broadway life until the early 1930s. Runyon gambled, covered the fights, and hung around gangsters, racetracks, speakeasies, and nightclubs. Influenced by O. Henry's stories, Runyon's best-selling collections of stories portrayed the neighborhood's

Programme of

"The GREAT WHITE WAY"

A Cosmopolitan Production

It's the life!

*Adapted by Luther Reed
from the Story by H.C. Witwer
Directed by E. Mason Hopper
Settings by Joseph Urban*

Special Music by
Victor Herbert
*and his Cosmopolitan Orchestra
Score by Frederick Stahlberg*

At the
Cosmopolitan Theatre
Columbus Circle

Presented by The Cosmopolitan Corporation

(Opposite) **Popular commercial images** in the early 1930s portrayed the city's most well-known sights—focusing on its speeded-up pace, bright lights, and skyscraping buildings. This photomontage is the work of Irving Browning (1895–1961), a movie actor-turned-photographer who specialized in New York buildings and streets shot for architects, developers, magazines, and ad agencies.

(Below) **Browning's montage** of spectacular lights (seen here in a detail) recalls a modernist photograph that German filmmaker Fritz Lang published in 1924. American art and commercial publications of the early thirties often printed similar images, including Walker Evans's now-famous *Times Square (Broadway Composition)* of 1929. In 1931 Browning made a documentary film about New York entitled *City of Contrasts,* one of the so-called "city symphony" films that had begun with Charles Sheeler and Mark Strand's 1921 *Manhatta.*

colorful grifters, chorus girls, and touts. As the typical Broadwayites of American fiction and feature stories, Runyon and his characters replaced figures like Richard Harding Davis (1864–1916), a star war correspondent of the 1890s and a member of the lobster-palace in-crowd married to a Broadway headliner. In the early 1930s, Runyon got rich writing movies and began to divide his time between the city and Florida. His alternative version of Broadway, showing a small town of lovable crooks and chorines, resonated strongly with Americans in the years after the Great Depression and into the postwar period, when the popular Broadway musical *Guys and Dolls* (1950) carried on the genre.

Runyon's equally famous protégé, Walter Winchell, chose the more conventional Broadway lights as his signature motif. Winchell (1897–1972) was a second-string vaudevillian who began to write a gossip column in Bernarr Macfadden's scandal-filled tabloid, the *New York Evening Graphic*, in 1924. Throughout his long and sensational career, Winchell made Broadway lights and other big-town imagery his bread and butter. Since the square's early days, descriptions and pictures of signs and theater lights had reached the country in a scattershot array of plays, musicals, sheet music, song lyrics, advertisements, and newspaper tidbits about city life and amusements. Winchell and his imitators (Leonard Lyons, Ed Sullivan, Louis Sobel, and Dorothy Kilgallen) simplified the genre somewhat. Sprinkling his daily column with mentions of Times Square lights—Winchell famously called them Mazdas after the Edison-invented lights used by spectacular makers—the columnist (or the ghostwriters he used) enlivened and unified unrelated items of celebrity gossip and theatrical publicity. The punchy, stripped-down symbology of the Broadway columns was quickly extended to radio and television shows hosted by Winchell and the others, who were read and seen by millions each week.

By the mid-thirties, Times Square and Broadway were ubiquitous in the media. Each week, dozens of pitchmen less well known than Winchell tirelessly plugged the neighborhood's high-end entertainment over the air waves, and movie studio newsreel divisions churned out images of the theater district taken at night and during the day. The motion picture studios frequently used New York and Broadway material in feature films that took up Broadway themes familiar to depression-weary citizens: old-time Broadway, backstage Broadway, and the Broadway of glitzy nightclubs and mirrored, spinning dance floors. Although New York's skyline was (and still is) the typical establishing shot for movies set in the city, the lights of Broadway were portrayed almost as often. Pictorial magazines and Sunday sections pioneered color photographs of the lights to produce countless virtually indistinguishable spreads that changed little over time. Fresh and thrilling before the Depression, these images became increasingly stale as, well into the 1960s, cut-rate schlock and everyday vice moved in but the media repeated the same hackneyed pictures of the Broadway lights, the shows, the sights, the ball drops. Such views nonetheless remained popular among art directors, editors, and advertisers appealing to a mass audience still eager to see or read about a mythical Times Square. The images of the famous streetscape, rather than its reality, proved to be Times Square's most reliable marquee attraction in the long term.

THE NEON REVOLUTION

Part of the disconnect between the seedier realities of Times Square and its glittering national image had a simple explanation: by the late 1930s, the streetscape was still developing confidently. This growth was helped along by a beautiful new light medium that had come of age during the decade—neon. It was soon adopted by sign designers and every kind of business fronting the streets of Times Square.

Times Square and most other American downtowns were changed radically by neon, which was first used in America in 1922 for a Packard sign in Los Angeles. Two decades earlier, Oscar Gude's Great White Way had been defined by incandescent lights; his early signs were studded with single bulbs that created surfaces in which dotted lines of lights—set like jewels against the sky or on marquees and facades—twinkled and glinted. Ever since the early days of electric spectaculars, sign men had sought to create cheaper, bigger, brighter, more dominant signs capable of intricate animations and greater visibility over longer distances. Neon perfectly fulfilled these desires, expanding the spectacular-sign makers' vocabulary and range.

Neon was introduced and patented in 1910–11 by a Frenchman, Georges Claude (1870–1960), whose new lights differed notably from incandescent bulbs. Glass tubing was filled with gases that, when subjected to an electrical charge, created extremely bright, vividly colored, stable, and long-lasting light. The tubes could also be lined with chemical powders that combined with different gases to make a variety of colors. The long, thin neon tubes could be heated and bent with crisp, legible precision, as if "drawn" into

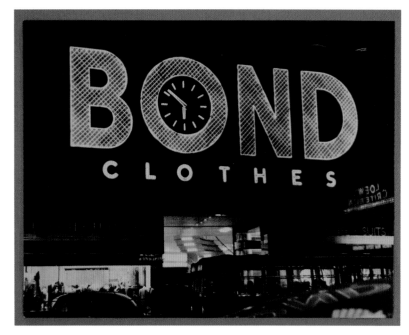

Although dated 1941, the Bond Clothes store on Broadway between Forty-fourth and Forty-fifth Streets used a lettering style popular in the previous decade. The bold fourteen-and-one-half-foot letters were diagonally hatched in white and gold neon tubes; first the white tubes flashed, then the gold, and then both together. Signs with clocks, thermometers, and weather information, always popular, reached a high point in the 1930s.

intricate, continuously formed shapes and letters, both curved and geometric.

The clear, bright colors and the steady quality of neon lights could be seen over great distances. Red, one of the first colors to be developed, was particularly fashionable. The neon palette was soon extended to include more shades: greens and blue-greens, golds, and turquoise. Reds, however, remained the advertisers' favorites until the mid-1930s because of their startling conspicuousness.

Signs of the Times (an important trade magazine) first mentioned neon-tube signage in 1924; by mid-1929, the influential journal's coverage showed how quickly neon was replacing incandescent light (without ever entirely supplanting it). As neon was

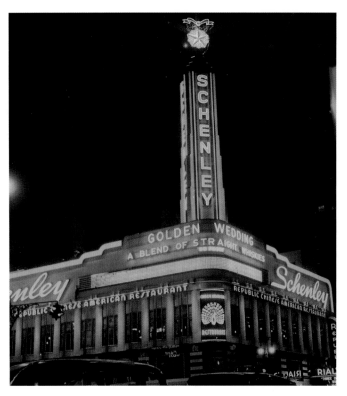

adopted widely, the basic street formula of billboards, vertical signs, animated spectaculars, elaborate marquees, and lighted storefronts continued to be the rule in Times Square. Neon excelled when used to outline the immense billboards and spectaculars that covered facades and rose above building tops around the district. Above all, it highlighted the gargantuan scale of local sign spaces, movie fronts, and spectaculars. Compared to incandescent signs, neon outlines and animations projected intense bands of light and allowed billboards, marquees, and architectural elements to be effectively brought out in brightly colored, continuous, luminous lines. From the street, neon was so vivid that it gave a solid sculptural quality to the brilliant lines of light formed by the tubes.

Neon was perfect for a new design trend made popular at Chicago's Century of Progress exposition in 1933–34. This so-called streamlined style emphasized horizontal lines and rounded edges, like those found on the marquee and sign of the newly opened

Radio City Music Hall (1932, Associated Architects), and was used widely to decorate or renovate stores, bars, restaurants, cafés, lunch stands, and drugstores in the theater district. A number of innovative industrial materials newly popular with architectural designers, including chrome and industrial ceramics or glass, were well enhanced with neon outlining and signage. Sans-serif lettering on spectacular signs and movie fronts also took its cue from designs presented at the Chicago fair.

In the early years of the Depression, the federal government encouraged downtown renovation in the hope that glistening modern storefronts would boost the country's morale. In Times Square, neon often formed the centerpiece of the new facade designs, and by the middle of the decade the area was full of "neonized" signage, marquees, and shops. Neon was particularly effective when used in new, aerodynamic-looking theater entrances and marquees that appeared in the district. By 1938 one sign man

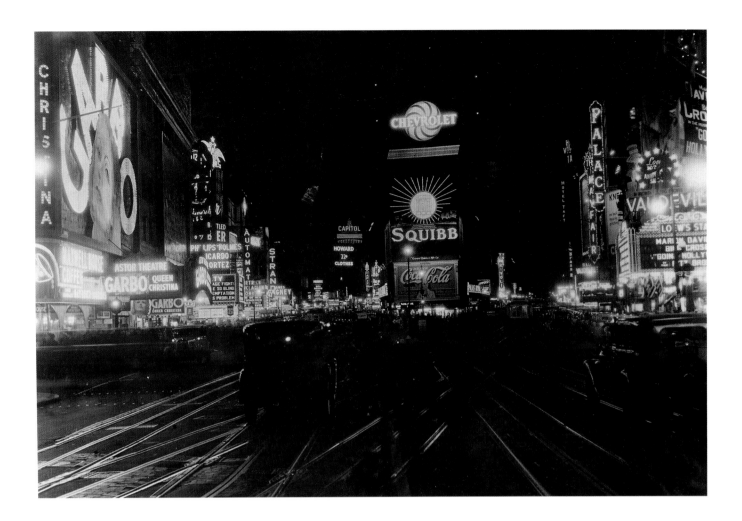

estimated that about 60 percent of the spectaculars in the square used the new light tubes. One of them, the Schenley Tower whiskey installation of 1936, was launched with a star-studded banquet covered by a live broadcast; costing $60,000, the facade renovation was the most expensive in the square to date.

Together, the new signs and the street-level lighting created a much brighter nighttime signscape of thrilling clarity and intensity. In the more virtuoso spectaculars and signs, the animated forms were bigger, more fluid, and more emphatic than anything that had come before. Gude's White Way (which actually had plenty of colored lights) was transformed into what Meyer Berger, a *Times* reporter who specialized in city subjects, called "Rainbow Ravine" and

"Red Square": "turning, wheeling, spinning, cavorting, flashing, and blinking . . . using up energy at the rate of 3,275 watts an hour." In the earlier incandescent streetscape, atmospheric areas of light and shadow had punctuated the blocks, and blinking sky signs had mysteriously appeared and disappeared against the dark sky. Now neon slogans, logos, and animated figures produced fast-paced, highly colored shows with a graphic punch and brilliant, flowing movement. The square (with its low buildings and sense of spaciousness) seemed like an evenly lighted, intensely glowing outdoor room filled with moving forms and reflections. Decades later, people called the effect "the bowl of light."

The fashion for simple movie fronts with giant

lettering, originated by Mortimer Norden about 1923, remained popular, but by 1930 the already oversized fonts became gigantic. Neon was used to outline the letters, increasing their clarity and impact for blocks around. Abstract, moving light effects included chasing frames—animations whose colored frames in changing geometric patterns blinked in rhythmic sequences that speeded up or climaxed in furious on-off flashes. By the mid-1930s, quite a few movie-front signs in the square spread out a hundred feet wide and rose to the rooflines, and several wrapped around the building corners and into the side streets. Dramatically framed in bright neon, they held aloft fifteen- or twenty-foot-tall neon letters and sometimes figures or animations. The Astor-Gaiety block, on the west side of Broadway between Forty-fifth and Forty-sixth Streets, appeared in still photographs almost like a wall with giant lighted posters. Across the street, the Criterion (until it was demolished in 1935) also displayed enormous boards. The brighter neon frames and letters on these bigger lighted signs seemed to hulk over either side of the square. At night, the array of lights completely masked the stone and brick facades and created dynamic, shifting electric architecture defined by lighted and colored lines.

Talking signs had flashed messages since the advent of Times Square's spectaculars, but now many advertising signs and some theater marquees incorporated more versatile running signs. These allowed news along with commercial plugs for features and could be changed quickly. The most famous moving news sign was the Motograph that zipped news headlines around the base of the Times Tower, installed on November 6, 1928, just in time for the November election. The *Times* had moved its presses and main offices to Forty-third Street in 1913 but had continued to use the tower to present the news. Headlines flowed smoothly across the new traveling bulletin, which ran 380 feet around the building, contained almost fifteen thousand lights, and flashed almost twenty-two million times an hour. Three times a day, Bakelite letters were composed into headlines (they were sent over from the newsroom at Forty-third Street) and then mounted in trays. The trays were inserted into an "endless metal trough," and the current was turned on. As the letters moved along, metal at the bottom was touched by brushes to make an electrical connection. Powered by more than a million feet of wires, the letters in lights circled the outside of the tower, forming "a ribbon of light amid Broadway's blaze." By the 1930s the Motograph, filmed in weekly newsreels and described in news columns and gossip pages, had become one of the square's most popular signs.

The tendency to mythologize what the Broadway wag had poked fun at in 1932 continued throughout the Depression, a clear response to the local entertainment's ongoing decline after the downturn. Though there were plenty of years of good business ahead for Times Square, its nightlife and entertainment never regained the ebullience and success of the pre–World War I heyday. With the center of American theatrical life long since moved to Hollywood, from the thirties on, Times Square's existence as an amusement zone was sustained by tourism, first- and second-run movies, and the inexpensive popular entertainment that elitists deplored. In contrast, buoyed by the crowds and reinvigorated by neon, the area's advertising spectaculars were entering a golden age.

Two sign companies became important in the first years of neon, a light medium at which they excelled: the General Outdoor Advertising Company, whose spectacular signs were the most prominent from 1925 until the middle 1930s; and the Artkraft-Strauss Company, which from the mid-1930s made almost all the movie signs in Times Square as well as many other kinds of electric signs.

General Outdoor Advertising was the enormous national outdoor advertising company formed in 1925 by combining more than twenty of the country's largest sign companies, including those of O. J. Gude and Thomas Cusack, an important sign business based in the Midwest. Using Gude's sign spaces, which were the best in Times Square, between 1925 and the early thirties the company erected a series of famous spectaculars for big-ticket consumer goods. These enormous if prosaic animations dramatized in lights the workings of typewriters, percolators, plumbing, gas pumps, Victrolas, stabilizers, and automatic washing machines. Most of these signs used incandescent lights, but the company quickly incorporated neon, creating important neon-incandescent hybrids in prominent spaces around the square for Cadillac-LaSalle cars, Maxwell House coffee, Anheuser-Busch, and Squibb tooth powder (the latter, located right at the head of the square, was one of the most sensational signs of the early 1930s). The company's 1931 Pepsodent spectacular, which featured a Ziegfeld girl swinging back and forth across the sky at the center of the square, was a reworking of a 1919 spectacular made by Gude for Realart Pictures. The lighting designer Mortimer Norden, who

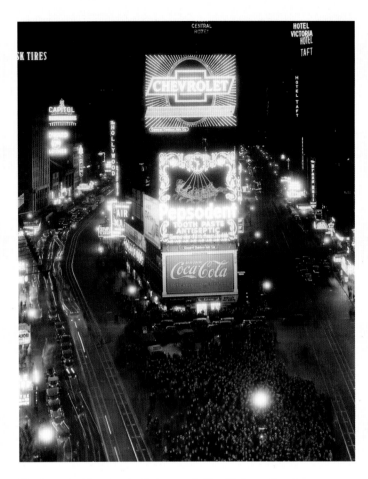

The Pepsodent Spectacular, Forty-seventh Street between Broadway and Seventh Avenue, 1932.

went to work for GOA in the late 1920s, produced some of his most noticeable movie fronts for the company; among them was the streamlined marquee at Radio City in 1932, one of the biggest sign contracts ever awarded for theater work.

Artkraft-Strauss was formed in 1935 from two older sign concerns: Strauss and Company, which was launched in New York in 1897 by Benjamin Strauss, and Artkraft of Lima, Ohio, which had opened a New York office in 1931. Strauss was a full-service sign maker who specialized in theatrical billboards, front-of-the-house decorations, and gaslighted marquees. After 1909, when he hired a Russian immigrant named Jake Starr, Strauss moved into electric spectaculars. In 1916 Strauss and Company had designed the signs for the Vitagraph Theatre (Hammerstein's Lyric Theatre, which converted to movies in 1914), which were the first big electric billboard-style movie fronts inside the square. The company started to work in neon in the mid-1920s, beginning with a 1924 sign for Willys-Overland cars, and by 1931 it announced that it was ceasing all theatrical work to concentrate on neon.

When Artkraft opened its New York branch, Jake Starr came to run it, and in 1935 he combined the two companies. The new business continued to specialize in neon, but, as before, it did everything: painting billboards; designing, building, and maintaining spectaculars; constructing the elaborate neon-and-porcelain shop fronts that were often wired by a new crop of companies specializing in electric circuitry; and overseeing the ball drop each New Year's Eve. By the mid-1930s, Artkraft-Strauss had an important fabrication plant as well.

CHAPTER

FIVE

⊕ ⊕ ⊕

OUTDOOR
THEATER

⊕ ⊕ ⊕

N LATE 1933 A TWENTY-SIX-YEAR-OLD SELF-EMPLOYED SIGN MAN NAMED DOUGLAS LEIGH MADE HIS FIRST MARK ON TIMES SQUARE. THERE, ON THE FACADE OF A SMALL BUILDING AT BROADWAY AND FORTY-SEVENTH STREET, JUST NORTH OF THE PALACE THEATRE (1912–1913, KIRCHOFF AND ROSE), APPEARED A NEON AND PAINTED SIGN MORE THAN FIFTY FEET TALL, FEATURING AN OUTSIZED CUP OF A&P COFFEE TWENTY-FIVE FEET TALL AND FIFTEEN FEET WIDE. AS A LOVELY YOUNG WOMAN (MODELED AFTER A DEBUTANTE) LOOKED OUT ONTO THE STREET, REAL STEAM ROSE FROM THE GIANT

steel cup and wafted up the facade and into the dark sky. The steam effect was heralded in the press as unprecedented for an advertising spectacular in Times Square, although in fact it was not: before 1909 the district had seen a painted, lighted representation of a steaming coffee cup, one of many such signs erected around the country, and in the 1920s Mortimer Norden had used smoke and sound in his movie theater signs. Nevertheless, the new spectacular was a near-perfect example of what advertising professionals called a dramatization—the use of advertising to evoke a product so strongly that onlookers would crave it.

The A&P coffee advertisement announced a new Times Square personality and a sign man to equal Oscar Gude. Many decades after his Times Square signs were removed, Leigh's works remain among the most famous advertising images of the twentieth century. Leigh's signs were so memorable, they have been de-

picted or quoted in movies, theatrical sets, books, magazines, postcards, and photographs ever since. Leigh's signs were outdoor shows. Their trademark special effects—rendered in neon, animation, color, smoke, water, and large-scale sculpture—had, as he put it, "memory value," and they had it in spades.

Leigh arrived in New York in 1930. The southerner had been working for General Outdoor Advertising in Birmingham and Atlanta and moved north to take a job selling sign space in Brooklyn for the company. News stories and Leigh's own press releases varied slightly over the years, but once in New York he quit GOA either when his pay was cut or when his bosses denied him the opportunity to work in the Times Square market. Whatever happened, Leigh was undeterred. A natural salesman, he found a prominent billboard space overlooking a commuter road in the Bronx, designed a semispectacular sign advertising a midtown hotel, pitched it with the help of a photog-

⊕ ⊕ ⊕ Hugh Ferriss's rendering of Douglas Leigh's Times Square of the future, 1944.

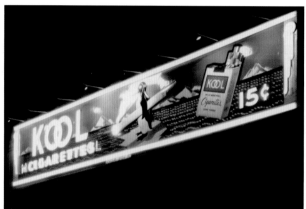

(Left) **Douglas Leigh's** Times Square debut showed the painted image of a young woman about to drink her A&P coffee as real steam, piped in from under the street, rose from an eye-catching metal cup. In the century's first decade, Oscar Gude had used a similar design for Runkel Cocoa, minus the steam. The A&P space was not prominent, but people remembered the 1933 semispectacular's fascinating special effects, which became Leigh's trademark.

(Right) **Leigh's Kool cigarettes sign,** a semispectacular combining painted and electric elements, showed a giant penguin holding a lighted Kool and riding an ice floe set in a shimmering arctic sea while winking at passersby one hundred thousand times each day. Although in the center of Times Square, and novel enough to be mentioned in the *New Yorker's* Talk of the Town in spring 1936, the sign was one of Leigh's least celebrated.

rapher and a printer, and traded his design fee to the sponsor for a year's room and board. Then, using hotel stationery and a stamp with "Douglas Leigh, Inc." on it, he pitched A&P. The national grocery chain hired Leigh to produce several spectaculars for the company around the city, most importantly in Times Square. Leigh's steaming-coffee sign made headlines and brought him immediate recognition. New business quickly followed.

An even bigger break came in 1935, when Walter Winchell, the country's most popular gossip columnist, did a column called "the Broadway Bulbs." Running down current Times Square signs in his trademark slang, Winchell gave Leigh a prominent mention and threw in a lot of factoids prepared by

the young sign maker. Winchell repeated statistics from "the Broadway light world" that Leigh was plugging: Times Square had a total of 90,500 lights and approximately 73,500 feet of neon burning in excess of two million watts an hour. The average sign had two miles of wiring. Sign rental rates each year totaled $355,000 and commonly exceeded interior rents by two or three times. The A&P spectacular stopped more people than any other sign in the area. Although Broadway was still bright, the Depression had dampened business: only eleven of thirty-two spectacular spaces were leased, and local movie houses no longer spent more than $20,000 for signs that lasted only a few days. The column established Leigh's fame as a Broadway figure, and Winchell and other

Broadway columnists continued to publish items on him and his work for decades. As a result, tidbits on Leigh and his creations were syndicated in hundreds of local newspapers and published all over the country. Carefully clipped and compiled in scrapbooks by the professional publicists Leigh retained most of his career, the items eventually ran into the many thousands.

Astutely placed, Leigh's story made inspiring Depression-era copy for news stories, columns, magazine profiles, and radio spots. He and his work were covered in both professional and mass-circulation periodicals, including the *Saturday Evening Post*, the *New Yorker*, *Time*, *Fortune*, *Newsweek*, and daily and Sunday papers. By the end of the 1930s, Leigh was ballyhooed everywhere as Broadway's newest sign wizard. He was interviewed on dozens of radio shows (by Rudy Vallee, Fanchon and Marco, Fred Allen, Ed Sullivan) and later on television. Leigh built on his good press and talent for promotion. He obtained sign commissions and bought up spaces in Times Square, some of them the choice spaces that GOA had controlled since the mid-1920s. By the mid-thirties he had leased ten such spots for "absolutely nothing." Before he was thirty, his work put him at the pinnacle of American outdoor advertising. By 1941 he had earned $1.5 million.

Leigh's status as Broadway's newest star was confirmed by a stream of brilliant signs he produced through World War II. Most of them were advertisements for national brands placed in the most famous ad market in the country—Times Square. His earliest signs were ambitious expositions of the familiar Times Square types, including the Broadway sign work of Oscar Gude and Mortimer Norden, but Leigh always aimed for more. He carefully considered the visual possibilities of his sites—how high they were, how far and from which direction they could be seen, and how they related to other nearby signs. By the late 1930s, Leigh had developed an antic, innovative style that summed up all the excitement of the Times Square spectacular tradition. Reaching beyond the sign tradition for inspiration, he embraced the spirit and scale of the electrical fairs, the hokum and theatricality of Broadway and movie stagecraft, and popular influences from cartoons to party games to toys to movies.

With each new spectacular, Leigh tried to top other Broadway signs with bigger effects, more sensational placement, and more startling technical displays. In 1935 a huge Schenley whiskey spectacular went up on the Hearst Building on Columbus Circle. Leigh's sign, which he called the biggest in the world (a common enough boast since Gude's day), was a monumental, pepped-up version of the subdued liquor signs of the post-Prohibition era. Showing a simple logo, the brand name, and a headline-like arrangement of words, the sign "talked" to passersby. In red, white, green, and gold neon, with letters ranging from nine to twenty feet tall, the four-thousand-square-foot sign showed a furious shooting-star sequence of images, words, beams of light, and bars of brilliant neon visible from more than thirteen blocks along Broadway. Leigh designed the sign to be completely overwhelming in color and size, helped along by thirteen virtuoso animations giving a seamless effect of continuous movement. As monumental as this sign was, years later Leigh buried it way down on the list of his works.

Leigh's 1936 Ballantine beer spectacular at Forty-eighth Street and Broadway is still remembered for

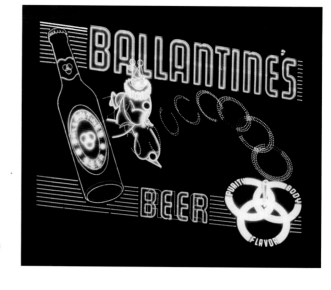

● ● ● *(Right)* **For the Ballantine** beer spectacular on Broadway, Leigh created an animation showcasing the company's three-ring logo. The sign ran from sunset to 1:00 a.m. each night and used 1,600 red-and-white incandescent lights plus 2,220 feet of neon tubes in red, gold, and a stunning new color, turquoise. The sign was part of a larger regional ad campaign that included point-of-purchase displays, neon signs, and painted billboards.

(Opposite) **This broadside displayed** at retail outlets plugged the Ballantine spectacular's virtuoso neon animation overlays. The sign's main action began high over Broadway as "Mr. Clown" took his bow. A red bulb in his nose winking at the crowd gathered to watch, he tossed his first ring, which spun "merrily through the air. . . . And it's over for a ringer!" Three more throws completed the Ballantine logo.

the perfection of its timing and its clever animation sequence. The graceful neon sign, sixty-eight feet wide and forty feet tall, showed a clown pitching three rings, one after the other. As each spun out over Broadway, it expanded in size to give the effect of coming forward in space and then settled over a pin. As the third fell, the three rings resolved into the Ballantine logo. Two bottles, a can, and a spigot filling a glass completed the little show, which contained fifty-seven neon images telegraphed in sequence against the night sky. Leigh might have stopped his explorations with these two neon masterpieces, but the very next year he began to work out a problem that had challenged sign men since Gude's day: how to combine moving pictures and advertising signs.

FUNNIES ON BROADWAY

Americans had been avid consumers of comic strips since the early twentieth century, and by the 1930s animated cartoons in film were a popular medium as well. In city walks and jotted notes, Douglas Leigh imagined buildings mounted with enormous spectacular-like signs playing cartoons. In 1937, using a new technology called Leigh-Epok, he introduced

the first filmed cartoons to the Broadway signscape. Leigh had licensed the Epok idea from an Austrian inventor, Kurt Rosenberg, but it was adapted for its Broadway debut by Leigh's chief engineer, Fred Kerwer, an experienced sign maker who had headed sign businesses of his own in the 1920s and worked for a few years with Artkraft-Strauss, probably as a shareholder. In Leigh-Epok, black-and-white (and later color) cartoons were projected against a bank of photocells from a manned control room behind a large screen-sign fronting Broadway. The cells triggered lights that were projected in silhouette over the street.

In June 1937 Leigh installed a long, thin test sign below Forty-seventh Street, one door south of the Palace Theatre on Broadway. It played simple cartoons below the name Leigh-Epok. From the minute it was in place, the sign drew enormous interest from spectators, who gathered in such large numbers that they stopped traffic—since Gude's day, the ultimate success for a Times Square sign. The sign landed Leigh a full-page item in *Newsweek*, and advertisers signed up immediately. A whiskey company bought space on the test sign. In October Paramount commissioned a huge Epok marquee sign for *High, Wide, and Handsome*

This "movie" shows you Broadway's BUSIEST Sign

| SUNDOWN and the stage is set for ACT 1 | | SCENE 1 — Sparkling, twinkling, the famous 3 Rings tell the world, "Here's Purity, Body and Flavor!" | | SCENE 2 — That old favorite, the Ballantine Beer Bottle, resplendent in handsome, eye-catching neon. |

 SCENE 3 — Ah, that Copper-Colored Can! Handsome! And what a sales-maker for enterprising merchants! SCENE 4 — Off with the Can, on with the attractive Ballantine Ale Bottle while the word "beer" changes to "ale".

SCENE 5 — Attention, "draught men"! A thirst-provoking, business-building picture presented for your benefit. INTERMISSION one second while the stage is set for ACT 2 SCENE 1 — Mr. Clown takes his "bow." His head twists right and left; the red bulb in his nose winks on and off.

 SCENE 2 — He's "wound up"—and there goes his first ring. SCENE 3 — It spins merrily through the air, growing steadily larger as it nears the pin—And it's over for a ringer!

SCENE 4 — Mr. Clown winds up for a second toss. Can he repeat? Just watch him! SCENE 5 — Safely over the pin, the ring spins 'round twice and settles down—for a second perfect ringer. SCENE 6 — And now, here goes the third and last ring . . .

 SCENE 7 — Going to make it? He has made it! Ringer No. Three—and the Ballantine trademark is complete! SCENE 8 — Grand finale! The famous name flashes on, amid cheers from merchants getting set for big sales.

AND so ends the first performance of the evening—but the 3-Ring Show goes on again—and again and again. A continuous performance from sunset to 1 A. M.

NEVER AN IDLE MOMENT ON THE BALLANTINE SIGN

An average of 70,560 different changes every night. The clown alone throws 3780 rings—and every one's a ringer. He can't miss! And neither can you— when you feature Ballantine's.

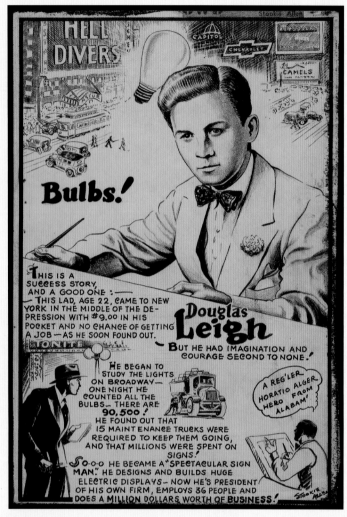

"Above the Crowd," cartoon, ca. 1935.

As publicity about Douglas Leigh (1907–99) grew, he crafted an unusual public image that he maintained for the rest of his life. Leigh united the persona and the highly commercial career of a successful advertising executive with an imaginative, even obsessive focus on signs and lights. He has been called an egomaniac and a huckster by his critics, but in many ways he simply acted like an artist, a term he was uncomfortable with until the 1970s. His highly original vision of electric light and the city expanded over his lifetime to include more ambitious notions of electrical showmanship. Times Square and its light signs were his starting point, and he approached his work there with an intensity belied by his gentlemanly, soft-sell manner.

Leigh, who was born in Anniston, Alabama, grew up when enthusiasm for electrical display was at its height and electrical spectacle of some kind was found in nearly every American city. He seems to have always been fascinated by lights. Hints about the reasons exist in his papers, and though they all give a strong sense of Leigh's lifelong obsession with lights, they are otherwise contradictory. In a radio appearance in 1937, four years after his first Times Square sign, Leigh told a story about visiting the square during World War I, when Oscar Gude's signs had achieved their greatest fame. In many press releases and quotes in the media over the course of his career, however, he claimed only to have been attracted by the glowing nighttime light of the foundry in his hometown. (Anniston was an important manufacturing center for the cast-iron lampposts used across the United States for the White Ways that General Electric sold in huge numbers between 1900 and 1930.) In a 1959 letter, Leigh wrote of a vivid, recurring memory he had of a red, white, and blue electric flag that seemed to wave in the breeze over the Anniston town square. This was a popular kind of patriotic sign that many towns and cities erected in the years before and after World War I.

Leigh always called himself an "idea man" (as a rule he gave the lead on technical matters to his colleague Fred Kerwer, a mechanical wizard in his own right), and in 1941 the *New Yorker* quoted him as saying that he considered his signs works of art. Using a unique working method throughout his career, he regularly walked the streets in search of unusual or inspiring sign spaces and rooftop views that he called "high spots." Leigh trolled a number of sources for ideas—print and outdoor advertising, old toys, parlor tricks, arcades, amusement parks, Sunday color supplements, illustrated papers, pictorial magazines, cartoons, popular stage shows, and movies. As ideas, gags, and images came to him, Leigh copied them down on dozens of small pads of paper kept in his car and scattered around his office and apartment. He noted approximately ten thousand ideas each year and passed them on to staff members, who filed them away by subject—"Babies," "Fog," "Magic," "Searchlights," "Sound," "Sparks," "Wind," and so on— to be mined later for signs or spectacles.

Fast-paced animated stories in electric lights distinguished Leigh's innovative 1938 Epok sign for Old Gold cigarettes on Broadway between Forty-third and Forty-fourth Streets. A long, horizontal billboard-shaped spectacular, it presented funny squared-off creatures in silhouette drawn by a staff of top-flight animators, among them Otto Messmer and Otto Soglow. In a repeating five-minute cycle of gags and plugs, Old Gold brought sunny humor to a stretch that since the 1920s had most often shown ordinary painted billboards.

at the Astor Theatre on the corner of Broadway and Forty-fifth Street, on the square's west side. The following year a third Epok sign, featuring cartoon characters to promote Old Gold cigarettes, also drew impassable crowds in the center of Times Square.

Leigh's rapidly developing style of spectacular signage, with its emphasis on mechanical excitement and popular material, was perfectly expressed by the more technically advanced animation allowed by Epok. He lavished much care on his Epok operation. The animations were drawn by a staff of professional cartoonists, including Otto Messmer (1892–1983), the creator of Felix the Cat, who worked for Leigh for forty years. The early Epok cartoons were several minutes long—simple comic stories featuring mice, ducks, and other humble characters, with an occasional geometric pattern to vary the gags and product plugs. In spirit they resembled the cartoons then shown in movie programs, but the novelty of seeing them in giant advertisements gave the figures an interest that went beyond animated neon signs and

the straight-up news bulletins flashed by the *Times* Motograph.

A second type of animated advertisement called the Wondersign appeared on Broadway at about the same time. The spectacular was built by Artkraft-Strauss for another company and opened in mid-1939 on a screen over the Palace Theatre marquee. The Wondersign was also a European import, licensed from the French poster designer Jean Carlu, who had shown it at the 1937 world's fair in Paris. The sign's chief although short-lived advantages over Epok were the ability to present animation in color and give a vivid sense that an artist was sketching the pictures in lights in real time. The color came from a bank of twenty-seven thousand lights that could be blended into many hues. Its liveliness came from a mechanism similar to a player piano, in which a long, punched scroll of paper, representing an artist's sketch, activated lights in sequence to mimic the action of drawing. The original Wondersign ran in a twelve-minute cycle and contained a series of simple product endorsements. After being darkened in

● ● ● *(Top)* **The control room** that ran the Epok sign was located behind the screen on the second floor of the I. Miller Building on the northeast corner of Broadway and Forty-sixth Street. Leigh installed a comfortable sitting room there to entertain clients and, often, celebrities. Here Leigh shows Mickey Rooney some of the Epok stills.

● ● ● *(Below and Opposite)* **The earliest Epok animation sign** used drawings like the cat seen on the facing page (possibly by cartoonist Otto Messmer). Sketches were turned into squared-off renderings to correspond to a grid of photoelectric cells in a control room behind a big screen made up of four lamps for each cell. The renderings were made into animated films and projected onto the bank of cells, which triggered the lights on the screen. The cartoons then unspooled out front, above Broadway.

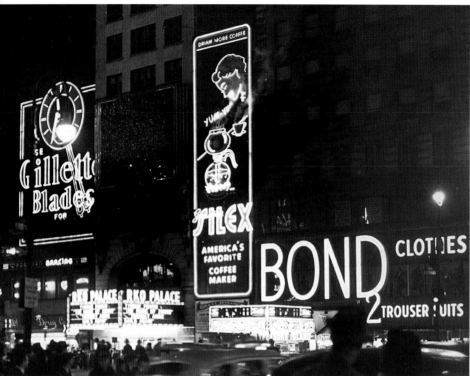
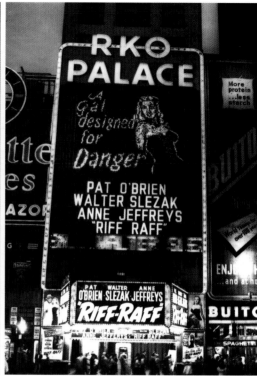

(Left) Between 1937 and 1941, unusual Leigh spectaculars covered prominent spots on the east side of Times Square, where their bright neon and large images gave them extra graphic punch. Lined in ruby red, white, and turquoise tubing, the Gillette sign featured a twenty-four-foot clock with a giant pendulum and NBC chimes. Next to the Bond Clothes sign, which was designed to compete with the spectaculars, the Silex sign used Leigh's signature steam effect and brilliant red tubes.

(Right) The novel Wondersign opened in 1939 above the Palace Theatre (1912–1913, Kirchoff and Rose) on Broadway near Forty-seventh Street. Built and managed by Artkraft-Strauss, the sign had thousands of lights that produced colored animated cartoons. Starting in September 1945, another firm supplied Wondersign movie fronts, refurbished with new neon identifications and a traveling message sign, for all RKO pictures that played at the Palace.

1942 because of World War II, the Wondersign later plugged RKO movie features playing at the Palace.

Leigh's vision of how to use animation in spectacular signs was broader and his effects were arguably more imaginative. His Epok technology also had a far longer working life in Times Square, continuing well into the 1960s there and at other national as well as international venues.

NEW CLASSICS

From 1937 to the beginning of 1941, Leigh premiered one impressive sign after another. In these years, while he was also producing signs in smaller cities such as Boston and Atlantic City, he put up sixteen signs on Broadway. Five in particular (not even counting the Old Gold sign on the face of the Claridge Hotel near Forty-fourth Street) added brightness and bigger-scale advertisements to the top and east side of Times Square. Viewed together, Leigh's signs were unequaled in the square's history for their memorable animations and ambitious theatrical presentation. They projected boldly onto the street and immediately held huge crowds of people rapt, just as Leigh intended. He used extremely large images and let-

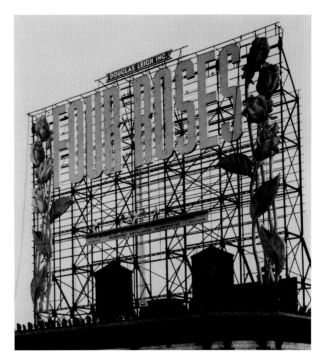

Leigh reached the pinnacle of the Times Square market with his 1938 Four Roses whiskey spectacular, which was realized in incandescent lights and fluorescent neon. When the sign debuted, invited guests watched two long-stemmed roses "grow" up the hundred-foot sign frame above the Studebaker Building at Forty-eighth Street. With its four thousand lights and thousands of feet of neon tubes, the spectacular, claimed Leigh, was visible as far away as the Statue of Liberty.

ters, framing them in bright neon for the strongest graphic punch and choosing bright colors and crisp, watchable animations.

The first sign, for Gillette, went up in 1937. For it, Leigh erected a forty-foot neon-and-aluminum clock at Broadway and Forty-seventh Street, where, four years earlier, his steaming cup of A&P coffee had made pedestrians crazy to drink the real thing. At the head of the square to the north was the huge Four Roses whiskey spectacular, which opened in July 1938 and dominated the middle view to the north. A third spectacular arrived at the southeast corner of Forty-sixth Street and Broadway in January 1939: the Bromo-Seltzer sign's giant bottle poured fizzy liquid into a nine-foot-tall neon glass four times a minute. By early 1941, Leigh had launched two more spectaculars—one for Wilson whiskey on November 1, 1940, and another live-steam sign for Silex coffeemakers just below the Palace the following January, making nearly a full block of great spectaculars on the east side of the square.

The most striking of Leigh's works from this group was the delightful Wilson whiskey spectacular, his fourth Epok sign in the square, located at the south end of the Palace block at Forty-sixth Street and Broadway. It represented a move by the sign maker to strike out in a new direction, beyond his first Times Square signs and early influences. Leigh's most ambitious prewar work (it took a year to build), the intricate spectacular introduced Broadway stage

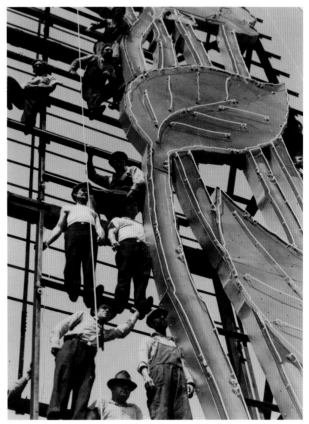

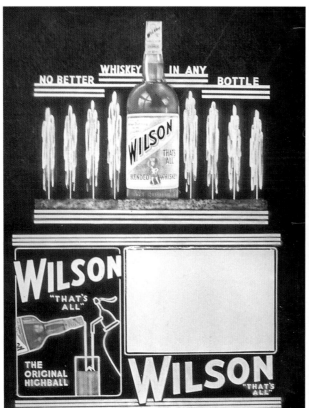 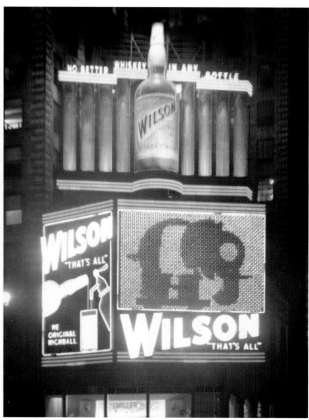

(Left) The 1940 Wilson whiskey sign by Douglas Leigh was part sign, part movie show. On the pseudostage at the top was a thirty-five-foot-tall metal whiskey bottle that appeared three-dimensional (the back was actually flat), surrounded by eight twenty-foot-tall fountains enclosed in clear plastic tubes; color wheels projected lights, hidden by a boxwood hedge, to make kaleidoscope patterns in the jets of water.

(Right) The Wilson spectacular at the corner of Forty-sixth Street and Broadway took a year to design and build. The larger screen was to be used to present Epok cartoons, and the smaller, to the left, boasted a neon animation of a highball being mixed, drained, and refilled every seven seconds.

showmanship to an advertising sign, the designer enthusiastically told interviewers. Over the square, Leigh mounted a multipart show in two and three dimensions, composed of a "stage," a movie screen almost as big as Radio City's, and a classic neon sequence that was a spectacular of its own. The sign combined light effects, neon animation, oversized three-dimensional sculpture, Epok cartoons, live fountains, and live trees. The Epok screen was the central attraction—a bigger version of the Old Gold screen down the street, with improved animations

that lasted more than five minutes each (with cartoon figures that were now rounded rather than squared off); mixed in were sponsor plugs that changed every couple of months. At four thousand square feet, the sign was as big as the Four Roses spectacular, but it was placed much closer to the street, over the second floor of a shoe store that had been on the corner since the late 1920s. Silly and un-self-conscious, the cheerful sign was audaciously big, bright, and full of amusing tricks. Leigh considered it his masterpiece.

In the Wilson spectacular, Leigh worked out some big ideas, chief among them his desire to create the kind of outdoor extravaganza that he had dreamed of as early as 1934. Just like Mortimer Norden's 1929 Hollywood Revue sign at the Astor Theatre with its live showgirls, Leigh's light show envisioned Times Square as an open-air theater or a sprawling world's fair environment rather than as the outdoor picture gallery, however monumental, that other sign designers before and after saw. The Wilson spectacular burst out of the usual flat, rectangular billboard format and demonstrated Leigh's lifelong love of sculpture and special effects, scaled to project for blocks. In it, Leigh moved away from the simpler local forms he had mastered in fewer than ten years and progressed from single-idea dramatizations toward a fantastic Times Square baroque.

Leigh opened the Wilson sign with the kind of ballyhoo that was pure Broadway. He issued tickets, put tables on the sidewalk across from the sign, and lined up Joan Crawford to throw the switch on opening night. Al Jolson, Eddie Cantor, Martha Raye, Bert Lahr, Ethel Merman, and others celebrated in the "luxurious" control room behind the sign. Jolson, Cantor, Raye, and the dancer Vera Zorina gave an impromptu live performance seen in moving silhouette from across the square; when they danced behind the screen, projected lights in front of them set off the screen's photocells. Leigh continued to run live Epok shows at the Wilson sign from time to time, and in the years before and after the war—when the government dimmed Times Square's signs as part of the war effort—Broadway stars like Bill Robinson, Fred and Adele Astaire, and Ann Miller performed in Epok to the crowds. Leigh used the sign technology and the

Forty-sixth Street space into the 1960s, selling Epok ads with updated animations to many national and international clients.

With his 1940 Wilson whiskey spectacular, Leigh took aim at a competing sign that had been a star presence in the square since 1936—the block-long Wrigley's aquarium sign put up by GOA on Broadway between Forty-fourth and Forty-fifth Streets. The designer of this virtuoso neon wonder, Dorothy Shepard, had created a seventy-five-foot-tall neon aquarium full of tropical fish the size of whales and colored in vivid ultramarine, yellow, turquoise, and vermilion, all of which swam in slow motion around the tank. In a conscious departure from the screwball pace of most contemporary spectaculars, the sign's hypnotic animation cleverly demonstrated the sponsor's message—that chewing Wrigley's gum was relaxing. As a press release from Douglas Leigh, Inc., made clear, the Wilson whiskey sign aimed to outdo the Wrigley's aquarium spectacle in size, technology, and the complexity and novelty of its various acts. And it did. By the time the aquarium was taken down in February 1942 (when Wrigley turned it off to save electricity—enough, it claimed, to light a city of ten thousand people), Leigh had become the dominant figure in the Times Square sign world.

In the end, only war and changing times hindered Leigh from fully realizing his aesthetic vision in his commercial spectacular work. With the Wilson sign's sensational run cut short, Leigh had to wait until after the war to again try out some of his bigger ideas. Although he continued to record fantastic, improbable, and visionary sign ideas, he was never able to give Times Square exactly the kind of gigantic advertising environment he envisioned.

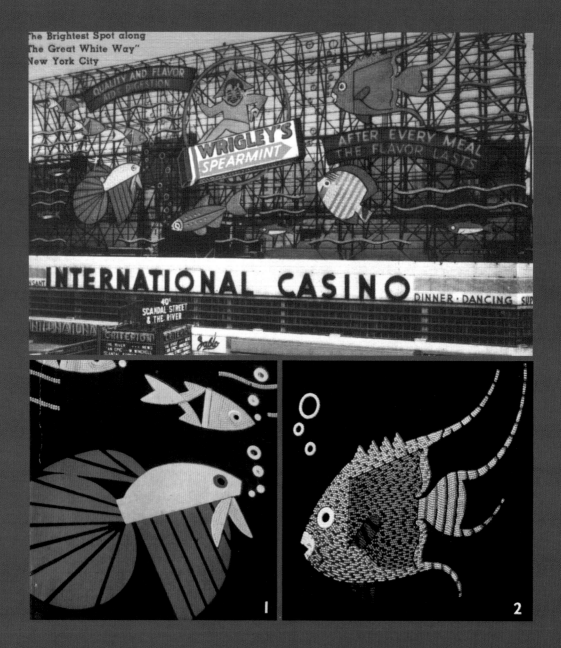

Facing the Hotel Astor, on the roof of a two-story building that had replaced Oscar Hammerstein's block-long Olympia Theatre complex in 1935, Wrigley's aquarium towered over the middle of Times Square from 1936 to early 1942. The enormous size of this GOA sign—188 feet long and 75 feet high—as well as its brilliant neon color in new tropical shades and slow-motion animation helped it dominate the view from every point around the square.

The World of Tomorrow

In 1939, the year he started to work on his groundbreaking Wilson whiskey sign, Douglas Leigh's imagination was jolted by an overwhelming new influence—the New York World's Fair in Flushing Meadows, Queens. Called the World of Tomorrow by its organizers, the fair was a 1,200-acre showcase for science, technology, and modern industry and commerce. Thousands gaped at model rooms and stood in line for demonstrations of every conceivable process and product, from new domestic gadgets and labor-saving devices to televisions, radios, electrical generators, and simulated production lines. An enormous amusement zone had the usual concessions, variety shows, and mild burlesque extravaganzas. Among the most renowned spectacles in the official section were the behemoth Trylon and Perisphere (Wallace K. Harrison and J. André Fouilhoux), the fair's uplifting centerpiece and the focus of stunning light shows.

Leigh was bowled over by the fair and visited it at least ten times, noting carefully how he traveled—by boat, bus, subway, and car—and what he saw there. He was interested in everything: the pavilions, the decor, the films, the advertising, and all the new materials. Leigh was particularly struck by the many shows, especially those at the Fountain Lake and the Lagoon of Nations, where over a huge artificial lake the architect Jean Labatut (1899–1987) staged a nightly extravaganza combining powerful colored lights, fireworks, music, towering water jets, and boats mounted with projectors and water pumps. Leigh drew inspiration from these theatrical displays for the rest of his life.

As early as 1935–36, Leigh had imagined outsized urban and environmental spectacles and spectaculars. He wanted, for instance, to turn the Empire State Building into a giant cigarette, to make the Chrysler Building a lofty billboard with eighty-foot-tall brand names down its sides and a battery of searchlights projecting patterns in the skies, and to develop the Rock of Gibraltar into an island-sized sign. When Leigh visited the fair, he found that his own imaginary installations were strikingly similar to what he saw there, including the giant fountains and waterfalls bright with colored lights and the "symbolic" light projections on the Perisphere (orange for Halloween, green and red for Christmas, and so on). He was also taken by the enormous structure-as-product demonstration pavilions, for instance, the loaf-shaped Wonder Bread building and the giant cash register on the midway. The fair, giving form to his imaginary universe of electrical spectacle and giant advertisements, crystallized for Leigh what he had already dreamed and recorded. It all confirmed for him his own theatrical vision and inspired him to try out his ideas in Times Square and elsewhere.

Doug Leigh's inspiration, the World's Fair in Flushing: the Trylon and Perisphere, 1939–40.

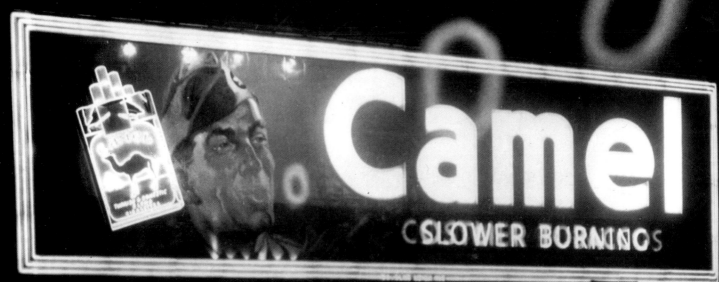

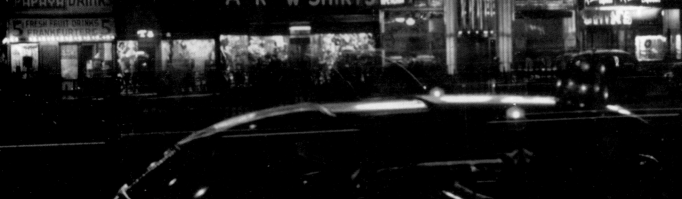

(Opposite) The smoking Camel man, unveiled in 1941 just months before the U.S. government ordered Times Square's signs dimmed in April 1942, became an international celebrity. In it, a soldier blew smoke rings that wafted out to the middle of Broadway, growing wider as they went. Leigh soon copied the trick in Camel ads for twenty-two other American cities.

(Left) Working with his chief engineer, Fred Kerwer, and Artkraft-Strauss, which built the Camel spectacular, Leigh developed a kind of giant bellows, seen here in miniature being demonstrated by him. The device took ordinary steam and blew it out as rings, with an occasional puff of plain smoke to vary the dramatization.

On December 12, 1941, five days after the December 7 attack on Pearl Harbor, Leigh unveiled his Camel cigarette sign—considered the most famous advertisement of all time. A horizontal board that was hung low on the facade of the Claridge Hotel at the southeast corner of Broadway and Forty-fourth Street, this addition to Times Square's signscape looked like a typical semispectacular. It had a painted soldier, a large brand name, a streamlined neon frame, and a multicolored cigarette package. The action was simple: the soldier blew smoke rings out over Broadway and occasionally puffed plain smoke to vary the action. People were transfixed.

The sign was quintessential Leigh, but not in the over-the-top vein of the Wilson whiskey sign. Although the conception was theatrical and outsized, it showed an everyday action whose visual impact was heightened by rendering it large and with real steam. Leigh claimed that the perfectly paced and carefully staged animation of a man blowing smoke rings came from a party trick of his brother's, in which smoke rings emanated from the cellophane wrapper of a cigarette pack punched with a hole; he may also have seen the artist Howard Chandler Christy's 1933 print ad and national outdoor poster campaign for Lucky Strike, which featured a man blowing smoke rings. As usual, Fred Kerwer designed the sign mechanism; it was built by the Artkraft-Strauss factory, which constructed many of Leigh's signs. Updated at regular intervals with new brands, the sign endured until 1966.

LIGHT UP AND LIGHTS OUT

The period just before the United States entered World War II was a high point for Times Square signs, one characterized by some of the most successful and well-remembered signs of the twentieth century. Douglas Leigh's creations for Ballantine, Four Roses, Gillette, Wilson, and Silex (another steam-and-neon example) brightened the east side and the head of the square, while GOA had the Wrigley's aquarium spectacular, a striking Sunkist sign, and both Chevy and Planters Peanuts signs. The square's infield was at its brightest in these years, thanks to several new and much lower buildings topped with enormous roof signs that dominated their blocks.

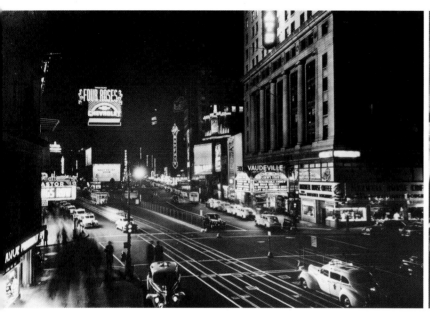

Before-and-after views of Times Square clearly show the effect of the 1942 wartime blackout, which obliterated all views of Thomas Lamb's Loew's State Theatre at Forty-fifth Street (the colonnaded building to the right), Leigh's Wilson whiskey Epok and Mayfair Theatre signs to the north, and the Chevrolet and Four Roses spectaculars at the middle of the square. People complained about the square's dismal, shadowy quality, but the ban did not seem to affect the crowds.

Outdoor advertising men had long been attuned to the power of dramatizations, which assumed that the buying public was as credulous as small children and could be tricked by overwhelming visual appeals that bypassed the conscious brain to make them go to the theater, take a vacation, have a cocktail, brush their teeth, or smoke a cigarette. Classic dramatizations—images of steaming cups, siphons filling glasses, bubbling drinks, or rolling wheels—had been common since the early part of the century. Electric spectaculars were perfectly suited to dramatization, as the best signs of Gude and Leigh so brilliantly demonstrated. The Camel sign, arguably the best product dramatization of all time, summed up the best qualities of the spectacular form. In a sense, too, it was Leigh's last classic Times Square sign.

The order to dim the lighted signs came in April 1942. In World War I, Broadway's lights had been cut back to save fuel. Now, to prevent reflected light from showing at sea and endangering American ships, war restrictions required exterior advertising signs as well as electric lights above the fifteenth floor to be turned off from sunset to sunrise; exceptions were allowed for signs where the light could be screened or made to shine downward. As in the previous war, the lights of Times Square were considered a symbol of normal life in America, something officials mentioned occasionally and the newsreels never tired of saying.

Display companies adapted quickly, trying to brighten their signs by using anything reflective or luminous. Some worked to create fluorescent or light-emitting paints. In 1942–43 Jake Starr at Artkraft-Strauss developed a reflective material made of small

chips of mirror glass that were colored as well as clear; during this period, his Astor Theatre fronts glimmered in the dark but were otherwise similar to 1930s spectacular signs and poster advertisements, with huge letters and perhaps a figure or two or a clever visual effect rendered across the facade. For attraction panels on marquees, instead of designing neon letters or outlining them with neon, sign makers used cutout letters lighted in silhouette. "Daytime effectiveness" became the mantra of the local sign men; fabricators made do with available materials: cloth, papier-mâché, reused letters, and plastics.

Not surprisingly, painted billboards made a big comeback. Roof spectaculars along Broadway and Seventh Avenue were replaced with pictorial signs, a trend that held strong during the dimout years and afterward. In September 1942 a painted sign for beer replaced GOA's Planters Peanuts sign at the north end of Times Square, just above a spectacular still under construction for a servicemen's club. On the north corner of Seventh Avenue and Forty-eighth Street, a painted canvas was put up at the Mayfair Theatre (1909, W. H. McElfatrick), a smaller movie house that changed hands in the 1930s from RKO to Loew's; in the thirties it had been the corner's neon-and-incandescent glory, but after the war the theater never used big electric signs again.

Movie-front publicity was affected by another influence: signs rendered in the style of documentary photographs then gaining wider exposure in the national magazines. The Rivoli Theatre on Broadway just above Forty-ninth Street in January 1942 used a stunning diorama painted on glass and backlighted across the entire facade to advertise John Ford's *How Green Was My Valley*. Grand Central Terminal's main room had patriotic dioramas in a similar style, including a big installation in late 1941 by the photographer Edwin Rosskam for the Office of War Information (the successor agency to the Farm Security Administration); in 1943 Douglas Leigh produced another monumental display there that featured smoke, a waving flag, and simulated cannon fire. This more illustrative vein carried over in many Times Square movie and advertising signs for the next several decades, diminishing the signscape's more striking and original qualities. As the signage grew increasingly prosaic, the trend toward more run-of-the-mill Times Square signs, especially in film and Broadway show advertising, became more or less permanent.

The dimout nonetheless had its bright spots. For example, in autumn 1942 Artkraft-Strauss was commissioned to build a big sign when Pepsi-Cola opened its servicemen's center in a low building fronting the square at Forty-seventh Street between Broadway and Seventh Avenue. The sign showed a huge Pepsi logo made from letters faced in colored glass wired with sensational fluorescent and incandescent lights that could be turned on whenever the wartime restrictions ended.

LIBERTY PORT

The cheap carnival ambience that had come to Times Square in the early 1930s with the influx of inexpensive popular amusements intensified during World War II, when Times Square was the most popular liberty port in the world. The capacity of New York Harbor was vast, the Brooklyn Navy Yard was the country's most important shipyard during the war, and numerous bases and training facilities were located throughout the Northeast. Before the war

ended in 1945, more than three million troops, their equipment, and sixty-three million tons of other war matériel were shipped from the city. Added to the normal Times Square influx of New Yorkers, tourists, and suburbanites were tens of thousands of servicemen a week, according to one 1943 survey.

The men on leave were both a boon and a strain. Their presence gave a sense of patriotic purpose to local businesses, but it also made the district more openly male oriented. Everybody struggled to find places for the men to sleep—in hotels, dormitories, clubs (for officers), and even schools. Yet servicemen made for Times Square in such numbers that, if they could not find a room, they often went to Central Park, sometimes with girlfriends or wives in tow, where MPs rounded them up and sent them back to base. Official centers opened for the troops, making Times Square a home away from home for the thousands of men who circulated there. A telephone center, the Pepsi-Cola Service Center, and the Stage Door Canteen under the Forty-fourth Street Theatre (where actors and actresses served, chatted, and performed) were all open until midnight or later. Men could drop in for a shower and a shave, to write letters, to read, to place telephone calls, to record talking messages, or to ask questions. Overall, in the area's 200 "service" centers, each week a half-million meals were served and approximately 93,700 servicemen and servicewomen were helped or entertained.

In 1943–44 the city's train stations were handling 50 percent more passengers than before the war, and by July 1944 the Defense Department was making noises about rationing travel and promoted a "stay-at-home" campaign on the radio. The Broadway Association, which represented business owners up and down the avenue, saw things differently. It ecstatically reported that the square was seeing the "greatest boom in history" because of the war. Each week, the newspapers reported, restaurants served five million meals; a quarter of a million patrons frequented the nightclubs (there were fifty-three at the time); almost two million people went to the movie theaters, many more than the legitimate houses, which tabulated only about 230,000; and radio theaters and churches welcomed a record attendance not seen in a generation.

People came as before for the mix of movies, dance halls, arcades, popular shows, "big garish places catering to the Broadway trade" (as the *New York Times* referred to local nightclubs), shooting galleries, and all-night restaurants. In the *Times*, the reporter Meyer Berger described a typical night in 1944, painting a scene that was similar to the one Charles Green Shaw had described in 1931—only with the addition of service personnel and without the vestiges Shaw saw of Times Square's more stylish days. According to Berger, by 10:00 p.m. the square got dimmer as businesses and spectaculars turned their lights off. The thousands of people who went to the movies and shows thinned out by midnight, when servicemen and their dates became the most noticeable group. As the dance halls closed at 1:00 a.m., the square was full of drunken, singing passersby on their way home, and courtships behind a famous statue of Father Duffy, the World War I fighting priest, in the middle of the square. Workers were everywhere, closing up and cleaning or installing theater decorations under the marquees. By 4:00 a.m. people could get their hometown newspapers at the giant Hotelings newsstand at the north end of the Times

Tower. By 5:00 a.m. civilians coming to work began to outnumber servicemen, who did not start to arrive again until around 7:00 p.m. Later in 1944, another piece by Berger struck a Runyonesque note when he profiled a group of marginal men who worked in the square—a gambler (who Berger claimed was the model for Runyon's Lemon Drop Kid), a beggar, and a grating angler (a man who spent his days pulling coins up from street drains). There was a strong police and military police presence. Runaways and rowdy teenagers were a problem, and a special Times Square police squad rounded them up every so often, tested them for syphilis and other sexually transmitted diseases, and, if possible, sent them home to their parents. The authorities called the girls "Victory chippies."

Prostitution, both heterosexual and gay, thrived. Times Square had an active, fairly open gay scene beginning in the 1920s, with periods of surveillance and crackdown. With the Depression in the 1930s came a noticeable increase in hustling and runaways. The trend intensified and grew more open during the war. Lots of gay men were already in the district, with its many rooming houses, short-let hotels, and late- or all-night businesses, including gay bars and other meeting places that moved frequently. Many more men came from the boroughs and from out of town. When Bryant Park at Fifth Avenue was closed in 1944, the all-night movie houses on Forty-second Street became more active cruising scenes, as did the arcade leading to the subway from the Rialto Theatre at Forty-second Street and Seventh Avenue.

Not surprisingly, the square's public functions assumed more importance for the duration of the war. As in World War I, war-bond drives, many of them now sponsored by the movie studios, kicked off there. A six-story-tall replica of the Statue of Liberty was lighted by FDR for the sixth war loan in 1944; at the center of the square, it sat on top of a huge cash register similar to the one on the midway of the 1939 world's fair, with a Motograph used to run the totals and donors' names along with a stage for daily pitches and morale-boosting entertainment. Other icons of wartime Times Square proclaimed the district's role as a national gathering place during the period: a fifty-foot-tall replica of the famous Iwo Jima photograph made in 1945 for the seventh war loan, a giant battleship, and two captured Japanese submarines. The government used radio heavily to promote the war effort from "the heart of Times Square," encouraging scrap drives, conservation campaigns, and Victory Gardens. Newsreel companies also continued to shoot weekly footage in the square, which had many recruiting stations: marine, army, WAC, coast guard. Military police shared the small police headquarters, which was open most of the night.

In the war's waning months, the *Times* Motograph ran news of the D Day invasion in France and the Pacific campaigns from 8:30 a.m. until midnight. However, the victory celebrations at the end of the war marked what turned out to be the square's last days of meaningful civic importance. Its decline as a public gathering place began in earnest during the late 1940s and the 1950s.

ALL THE CITY A STAGE

Douglas Leigh's booming sign business, which had made him millions by the mid-1930s, slowed during the war, but he kept busy. A fleet of delivery trucks proved extremely lucrative. For the duration, he

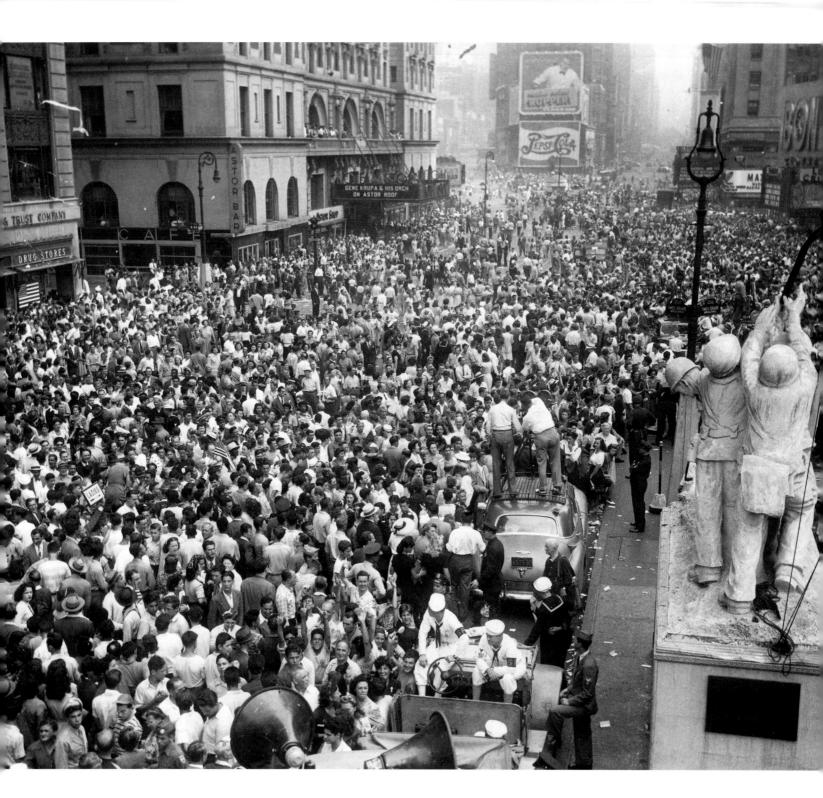

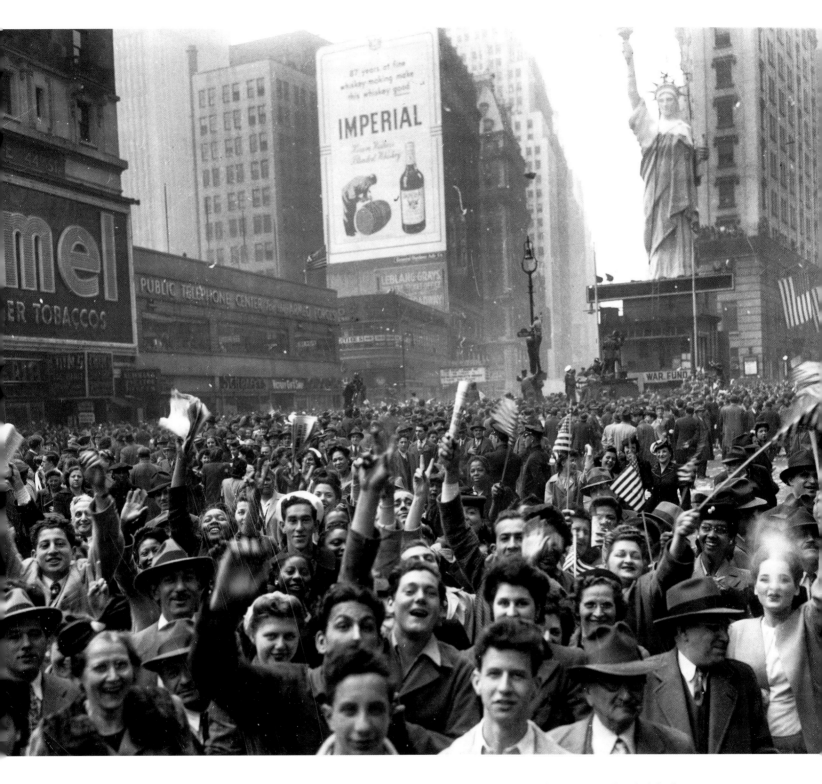

On August 14, 1945, nearly 750,000 New Yorkers gathered in Times Square to await the news of Japan's surrender, which finally came at 7:03 p.m. With Artkraft-Strauss's scaled-down Statue of Liberty looking over the crowd, poster and paint signage dominates the roof and facade spaces around the square.

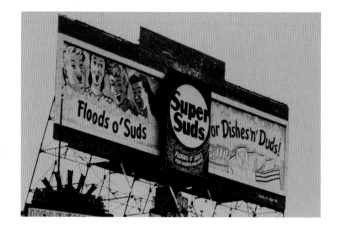

● ● ● **After the war** Leigh wanted to create a sign that shot novelty gifts and prizes to people in the street, but the closest he came to creating the effects he had recorded and talked about so enthusiastically in 1944–46 was a sign for SuperSuds detergent. Mounted on the top of the Strand Theatre on Broadway between Forty-seventh and Forty-eighth Streets, this 1946 spectacular burbled thousands of real soap bubbles up into the sky.

organized war-bond galas, poster campaigns, and the patriotic display in Grand Central Terminal. Stalled by circumstance and unable to build any light spectaculars, though, the energetic Leigh was forced back on his prewar habit of cataloging his unstoppable flow of ideas. Over several years he compiled his hundreds of ideas in a series of fascinating notebooks that give a clear sense of how Leigh's unique imagination worked and what kind of diverse sources he drew on.

Sometimes Leigh started with an image or an idea—smoke, or a giant man walking between roofs across a street, for example—and sometimes he was inspired by a particular part of New York or potential sign spaces. He envisioned simple gags and visual gimmicks, for instance, giant windmills, puppets, and enormous balloons. One idea for a series of signs incorporated real things, from animals to costumes, bubbles, smells, and an aquarium. Other ideas were more complicated: stages ("steps, steps, steps, à la Ziegfeld"), a glassblower behind a window over the street, a whole fairground in a sign, and an electrical stage set that changed throughout the day and night. Leigh derived especially beautiful visual and kinetic ideas from nature. He imagined a giant wheat field waving above Broadway; water, fire, smoke, wind, and the aurora borealis over the skies of New York; and rainbows that broadcast across the avenues.

Spurred by what he had seen at the 1939 New York World's Fair in Flushing Meadows, Leigh also dreamed of giant effects adapted for Times Square signs or playing above the streets in Manhattan's skies. His imagination moved beyond paint, incandescent bulbs, neon, and even his favorite special effect—smoke—and toward Brobdingnagian sculpture, stage effects, moving pictures, running water, and colored-light projections. Some of his ideas superimposed the giant figures and light-and-sound shows of the fair onto the narrower, taller space of Times Square, with its triangular shape and dynamic sight lines. He envisioned something beyond advertising signs, more like city galas or world's fair spectacles designed to exploit the city's street canyons, skyscrapers, vistas of rooflines, and stray aerial perspectives, near and distant. In one group of especially tantalizing ideas, Leigh took as his stage the whole island of Manhattan and its surrounding skies and rivers. For the Hudson River he designed a fountain with a giant colored jet of water—an idea straight out of the fair's Lagoon of Nations; a related vision would have sent a fleet of fireboats with multicolored searchlights to circle Manhattan, making a mobile, all-night spectacular.

Leigh's notes built on his work in the real world of Times Square signs, and in them he emerges as a visionary of commercial pageantry and light spectacle whose scope was much broader than his commercial

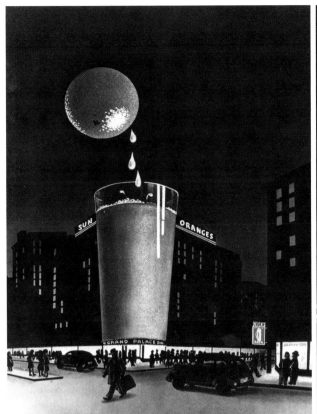
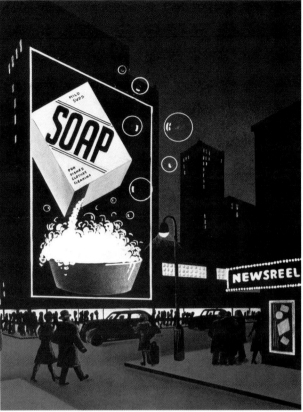

⊕ ⊕ ⊕ **Leigh's hoped-for** glass of orange juice, soap box, and perfume bottle (not illustrated) recalled old trade signs as well as 1920s vernacular roadside architecture—the giant ducks, milk bottles, beer kegs, and doughnuts built to attract drivers to stop and buy (now known colloquially as "ducks"). He had also admired the gigantic Wonder Bread Pavilion and the huge cash register at the 1939 New York World's Fair.

practice would ever suggest or allow. Leigh's visions show him to be a kind of environmental artist *avant la lettre*, seeing Manhattan as if from above as a site for superscaled works. His range of thought and view of the city were never equaled by any other sign man. The biggest, more abstract ideas had to wait, but just after World War II Leigh made notable attempts to realize grand, Flushing-style ideas in signs and other commercial promotions.

As the war wound down, Leigh courted publicity to drum up interest for a vision of postwar Times Square signs that went beyond the usual formulas. He appeared on a *Newsweek* cover, in *Life* and *Charm* ar-

ticles, and as the subject of a long Sunday *Times* magazine piece by Meyer Berger. With Berger Leigh talked about items many sign makers had experimented with during the wartime dimout—fluorescent paint and black lights, for instance—and hyperbolized about a more tasteful use of color inspired by Winslow Homer and James Tissot.

The *Times* article unveiled a set of drawings Leigh provided that showed Times Square completely reimagined in his post-Flushing style. In the images, the square's double triangles were shown not as a space surrounded with buildings of different styles and ages but as a unified urban campus ringed by skyscrapers

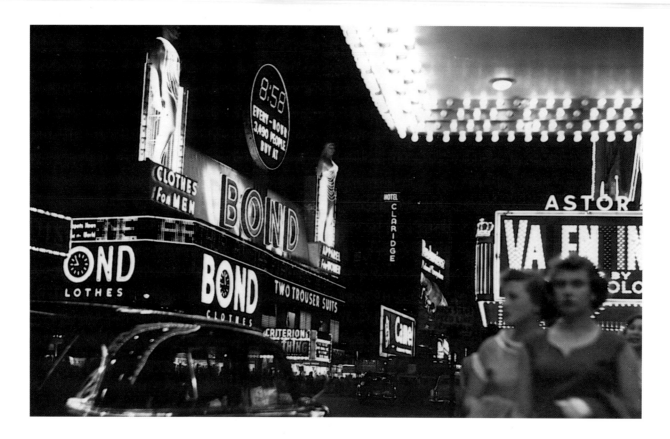

(Above) **The Bond Clothes sign,** displayed from 1948 to October 1954, epitomized Leigh's vision of a Times Square filled with larger-than-life figures and products like those he had seen at the 1939 world's fair. Even after neon draperies were added, the fifty-foot-tall nudes shocked some elderly visitors staying across the street at the Hotel Astor, but the spectacular became one of Leigh's most popular and famous signs.

(Opposite) **The first Lulu sign,** which was 180 feet wide and wrapped around the corner of Forty-third Street, stood more than seven feet tall on the low building that had replaced the Cadillac Hotel. A famously plucky cartoon character, Lulu faces off here against a building-wide bottle of Budweiser on the front of Toffenetti's; the bottle was circled by a model train (repainted each month to portray a different regional line), just visible on the bottom right.

turned into giant, three-dimensional building signs; at the heart of his plan, buildings imitated Leigh's favorite kind of oversized fair pavilions, scaled up and set down in the city's streets. Roofs, sections of building facades, and even whole buildings took the form of giant commercial products—a perfume bottle, a glass of orange juice, a glass of soda—or were mounted with screens or other attractions. In 1946 Leigh had the famous architectural renderer Hugh Ferriss (1889–1962) redraw his ideas. The new illustrations departed from the antic, comic-book tone of the first set, as Ferriss turned Leigh's group of cute

structures into hulking, grandiose street vistas. Ultimately neither vision would ever be realized, but that same year Leigh tried to inject something of his inspirations into new projects.

The most famous examples of Leigh's world's fair–influenced signs ended up right in the middle of Times Square, in the prime space above the Bond Clothes store between Forty-fourth and Forty-fifth Streets at Broadway, where the block-long Wrigley's aquarium spectacular had been. There in 1948 he erected his first memorable waterfall sign, which featured a 120-foot-wide cascade flanked by

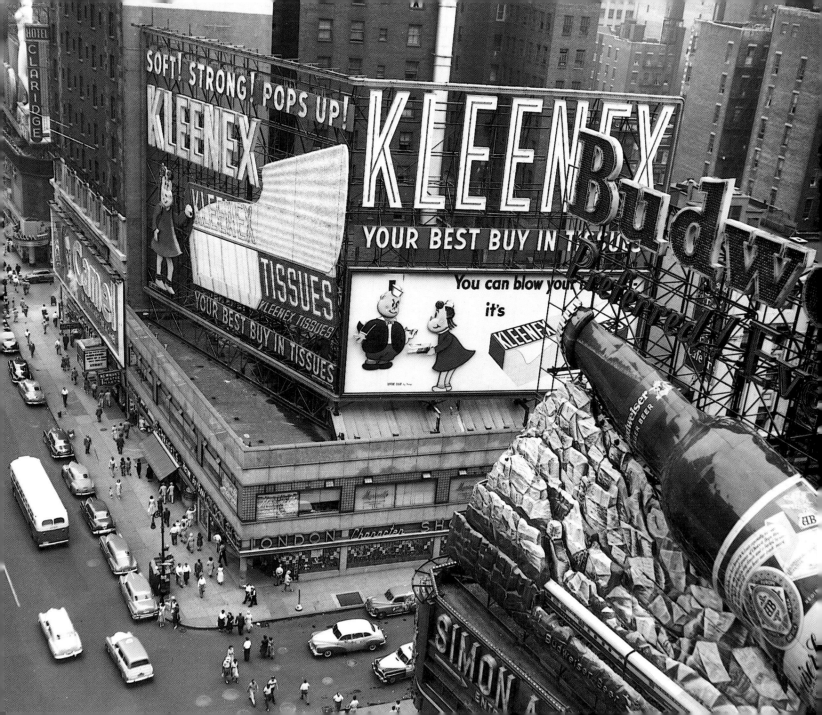

50-foot-tall male and female statues clothed in cling-ing neon drapery on either side of a giant clock; a news zip and kaleidoscope effects playing underneath the water added message and motion to the mix. The figures, for which he had originally wanted to hire Paul Manship (1885–1966), sculptor of the golden *Prometheus* (1934) at Rockefeller Center and notable figures at Flushing, dominated the ensemble—two sober nudes that seemed out of place amid the blare of Times Square's neon. The sign remained up for nearly six years, to October 1954, after which it was redesigned in early 1955 for a new client to include two 50-foot-tall Pepsi bottles sandwiching a giant bot-tle cap. Both incarnations of the sign blended sculp-ture, impressive scale, and special effects directly inspired by what Leigh had seen at the world's fair. Both were huge crowd pleasers, as his first works in Times Square had been.

THE PARTY ENDS

In 1960, when Leigh's audacious Pepsi sign came down, spectacular advertising was still highly prized by national advertisers. In the most elaborate signs—the big, bright, neon-and-mechanical show-pieces that sponsors paid him and Artkraft-Strauss to make—Times Square's light designs kept up the tradition of spectacularity, electrical excitement, and carnival hokum. Artkraft-Strauss made some of its most technically accomplished neon spectaculars during the 1950s, working in a number of styles that recalled the beginning of the Times Square spectacu-lar form. Two of the most famous were pictorial ani-mations that amazed people by the artistry of their neon overlays.

The first was the Budweiser spectacular of 1952,

located on the Brill Building roof at Forty-ninth Street and Broadway. The sign's animations reached the highest level of sign-making skill, giving a sense of real motion in two complex parts. The company's eagle, built from six overlays devised from watching a film of a flying eagle, flew over an unusually wide span across the building's roof. The sign captured six poses in neon tubes, each representing a moment in the bird's flight. Below the eagle, a team of eight Clydesdale horses, requiring six overlays for each horse, pulled a wagon with rolling wheels.

The second notable Artkraft-Strauss sign, the Little Lulu Kleenex spectacular of 1955, was adjacent to Douglas Leigh's Camel sign at Forty-fourth Street, in the middle of the square. Reminiscent of Gude's toothbrush imps and the Wrigley's soldiers, this masterful spectacular reached the pinnacle of funny-paper-style animations. Lulu, a famously spunky comic character of the 1930s, was shown swinging on a trapeze, turning somersaults, skipping across the sign, and then sliding down a giant tissue. A giant hand pulled colored tissues out of a giant box to end the animation sequence, all rendered in pastel neon. Lulu was amusing, nice to look at, and snappy in her pacing, but she was the last of her line to reach the highest level of spectacular art.

From 1955 to 1965, the block between Forty-fourth and Forty-fifth Streets boasted two perfect spectaculars, Lulu and Leigh's Camel sign, one a classic neon and the other a bold departure from it. During this period, a simpler form of spectacular advertising could also be found. It used names, logos, abstract insignia, geometric patterns, and elaborate decorative light effects and was somewhat less dependent on mechanical ingenuity and design than other large-scale pictorial neon signs. Two notable Artkraft-Strauss examples, occupying middle spots in the center of the square's north end, were the Admiral appliance and Canadian Club whiskey spectaculars of 1952. Using just the brand names and a couple of words in geometric arrangements of colored lights, both spectaculars were kinetic light paintings. Letters spelled out the words in different rhythms, borders chased, and words "breathed," giving the impression of growing bigger. Both signs, with their abstract neon-and-incandescent light effects of name-background-border arrangements, remained in place for many years.

Fashions in Times Square advertising started to become less imaginative in the late 1950s, creating a signscape that was less creatively dynamic than ever before. Gigantic spectacular signs remained popular, but the items advertised—cough syrup, jet travel, media conglomerates, foreign tourism, air conditioning, radio stations, health insurance, television—were harder to symbolize or dramatize effectively. Straight illustration became the norm. Sprightliness, cartoons, visual gags, beautiful neon animation, and appealing little animated shows declined. Postwar spectaculars were instead elaborate, grandiose machines that stayed up for years longer than had the signs before the war. By the mid-1960s, not only was the era of the greatest Times Square signs over, but so was the tradition of spectacular and electrical decoration throughout America. Downtowns all across the nation were becoming unfashionable and derelict. Times Square had hit its last, painful slide.

N THE TWO DECADES AFTER WORLD WAR II, TIMES SQUARE WAS STILL THE WORLD'S MOST FAMOUS DOWNTOWN, STILL THE CENTER OF BROADWAY (HOWEVER PAST ITS PRIME), STILL NEW YORK'S BIGGEST TRANSPORTATION HUB. DURING THE 1950S, THE BROADWAY ASSOCIATION REGULARLY COUNTED 1.5 MILLION PEOPLE A DAY IN TIMES SQUARE, A CROWD THAT REPRESENTED THE SAME MEDLEY OF NEW YORKERS AND TOURISTS WHO HAD ALWAYS BEEN DRAWN TO THE DISTRICT. NOW, HOWEVER, THEY CAME FOR THE BOOKSTORES, GRIND THEATERS, PENNY ARCADES, AND THE KITSCH STORES AS

much as for the theaters and first-run movie shows. The contrast between respectable (meaning tourism and upscale theater) and disreputable businesses in Times Square grew starker during these postwar years, when customers targeted by the area's popular entertainments began to dominate.

Urban amusement nationwide started to lose its popularity after the war. "Money, taxes, television" were a big part of the decline in city nightlife, asserted one *New York Times* reporter, together with the postwar spending boom for "washing machines . . . coffee-tables, and split-level houses." Although television certainly undermined Times Square's role as a town square and caused the dwindling numbers of New Yorkers who gathered there to see election results or baseball scores on the Motograph, the growing tawdriness and an escalation in crime were the most significant factors in the district's decline. Three or four big Manhattan nightclubs were still around in

the mid-1950s, but the only relic in Times Square was the Latin Quarter, which (quipped one critic) had "become as institutionalized as the New York Public Library." The clubs adapted to the times—by making themselves less interesting. Most canceled their late-night shows or, worse, gave in to "wan gentility," "rectitude, fashionable economy, and intellectual uplift." Tourists on package tours or parties of executives entertaining out-of-town clients who didn't know the difference were their best clients.

The carnival atmosphere that had been attacked by opponents of burlesque in the 1930s and tolerated during the war became a flash point again at midcentury. Local pastors, civic leaders, and merchants catering to the tourist trade spoke out vigorously against what the *Times* reported as "undesirables" of all kinds: peddlers, "mendicants, fake charity solicitors," and criminals of a kind that had been common in the neighborhood since the Great Depression.

Terror in Times Square, Pyramid Books cover, 1950.

Critics also deplored the proliferation of arcades and open-fronted stores selling cheap merchandise, their loudspeakers piping sales spiels into the street. Robberies were fairly regular at banks and theaters, and con men, pickpockets, and other criminals frequented the district, which still drew crowds that included families and teenagers.

Calls for a cleanup and stronger enforcement were slow to be answered. The Broadway Association agitated for zoning changes. Finally, in early 1954, the city banned new arcades and stores open to the sidewalk—"honky-tonk" businesses, as critics called them. A slight improvement in the area was noted in the *Times* in 1955, but enforcement continued to be lax. On the street, the more respectable amusements maintained an uneasy coexistence with the Coney Island–style barkers, arcades, dance halls, and "auctions" of fake jewelry. Prostitution and old-time sporting businesses (gyms, gambling dens, peep shows, and bars) became more visible. By the end of the decade, serious crimes like assault and rape were on the rise in the area, a disastrous trend that in the 1960s and 1970s spiraled into an epidemic of murders, stabbings, drug dealing, prostitution, and vagrancy.

"Modeling agencies," photographers of naked and nearly naked girls, makers of blue movies, and suppliers of pulp magazines—common in the neighborhood since the Depression—now increasingly operated in the open instead of being discreetly tucked away on upper floors or side streets. Novelty outlets and bookstores were conduits for under-the-counter novels and girlie and nudist magazines. General-interest bookstores, which increased after the 1954 ban, ramped up their trade in erotica around 1966. These stores, along with the continuous-show movie theaters on Forty-second Street (legitimate theaters that had converted to a grind format after the Depression), were a significant spur to Times Square's hard-core business after the mid-1960s.

In 1967 an enterprising jukebox owner named Marty Hodas installed peep shows in the back rooms of several area bookstores. The machines were just like the Edison kinetoscope cabinets of 1893 in which a film loop, advanced by a crank, could be watched through an opening at the top, but they ran pornographic filmstrips instead of comic or novelty material. Hodas's machines proved to be an enormous, lucrative draw. An explosion of sex marketing followed, most visibly in the form of pornographic movie programming at the Forty-second Street movie theaters. Lurid posters out front enraged critics, as risqué ones had in the 1890s. Lewd sound tracks broadcast loudly over the street were a harbinger of what was to come. Swarms of men passing through the area each day patronized the new peeps and movies, clearing the way for a much rougher, more criminal atmosphere in Times Square. About 1968 the Mafia entered the market in earnest, and a heavy influx of drugs, prostitution, hustlers, and runaways began to make the neighborhood dangerous, unpleasant, and frightening to tourists.

As sex shows, massage parlors, men's clubs, brothels, and porn marts overran the district during the 1970s and early 1980s, ineffectual attempts were made to control them; raids and temporary closings

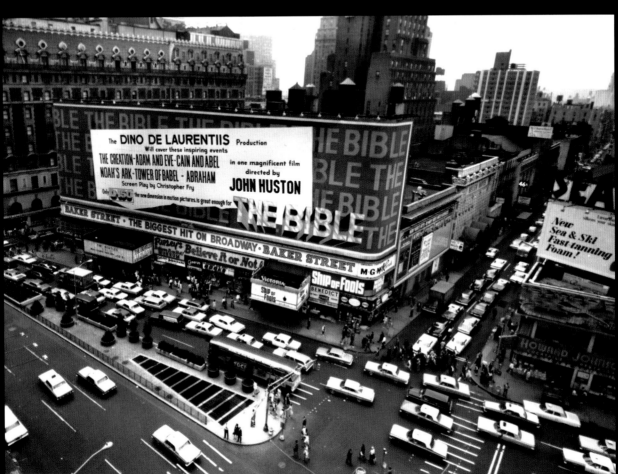

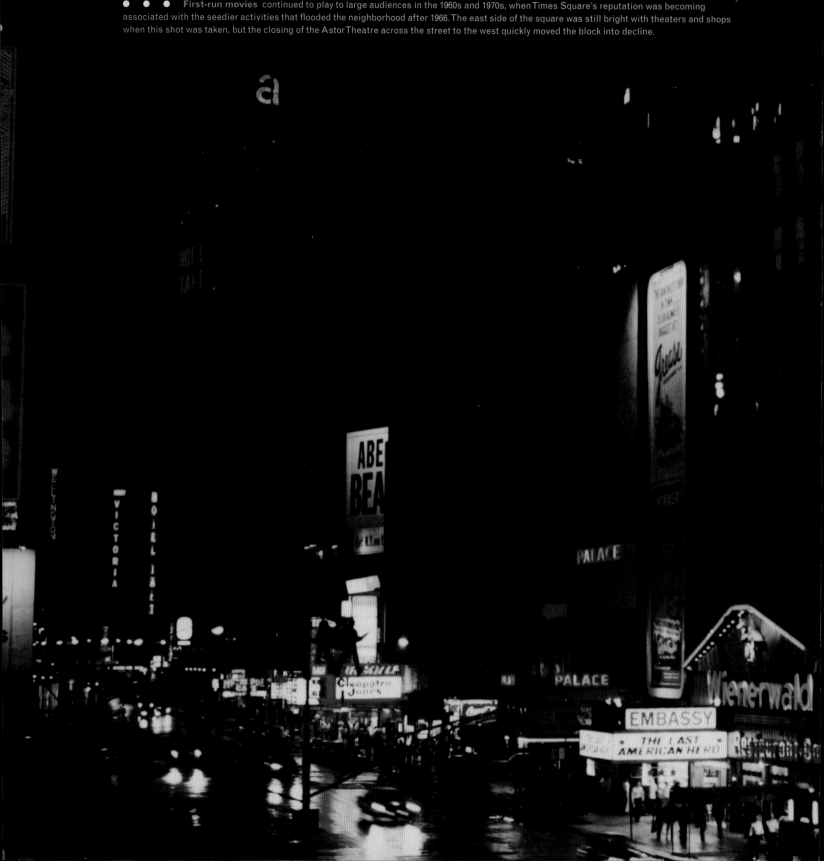

First-run movies continued to play to large audiences in the 1960s and 1970s, when Times Square's reputation was becoming associated with the seedier activities that flooded the neighborhood after 1966. The east side of the square was still bright with theaters and shops when this shot was taken, but the closing of the Astor Theatre across the street to the west quickly moved the block into decline.

Champale

DELIGHTFUL ANYTIME

ENJOY
LIKE CHAMPAGNE

8·26 39 8
Accutron
y Bulova

BEEFEATER
GIN

OKS

ELPIN

HOWARD J.
ICE CREAM
RESTAURANT

were followed by few convictions and small fines. The climate of tolerance for both pornography and the sex trade expanded as a result of important legal decisions that made the business even more difficult to control. A 1966 headline—"Lurid but Profitable Forty-second Street Hopes to Survive New Clean Up"—explains the difficulty faced by those calling for the area to be purged of smut. By the 1980s, Times Square's rampant Tenderloin-style entertainment and rough street life had become national symbols of urban decadence and decay.

The decline of Times Square's traditional street environment was linked to another important postwar trend: suburbanization. As the American metropolis ceded to the mushrooming suburbs and corporations and government officials took up European modernist architecture and planning ideas, the district's distinctive carnivalesque atmosphere was increasingly linked in the public mind with the low, criminal, and vulgar activities overrunning it. The

remaining neon spectaculars and tourist restaurants could not block out the growing welter of provisional and raunchy street displays. Facades along the garish and battered blocks teemed with unsightly advertisements, and store windows were full of cheap goods, weapons, and titillating signs.

As the decline accelerated after the late 1950s, tourist businesses and Times Square boosters were unable to paper over the seediness with glossy photographs or convincingly talk up the bright lights in columns and guidebooks. The need for improvement in the theater district had become clear by the early 1960s. Most people agreed on a simple prescription: get rid of the honky-tonk places and introduce more dignified, wholesome businesses to restore confidence and bring back solid investment. But as city officials and businesses struggled to come to terms with the area's growing problems, many debated the future of Times Square's unique identity. Would it remain a tourist and entertainment district, or would

(Opposite) In 1962 the local merchants' association commissioned the architect Richard Snibbe to design a new Deuce, the blocks of Forty-second Street between Seventh and Eighth Avenues. The plans called for restoration of live theater at some of the ten remaining theaters, glass-fronted retail all along the blocks, and pedestrian walkways above the street. A concrete divider in the middle was to be planted with seasonal landscaping.

(Left) In 1964 the Broadway Association presented a second major plan for redevelopment of Forty-second Street, proposing a massive new convention center. Included were exhibition galleries, promenades, a hotel, a high-rise office building, and an underpass down the middle of Forty-second Street. The plan's salient quality was its enormous scale, as seen in this photograph from the west looking east.

it become something else? The question took more than twenty-five years to answer.

The revival of Times Square was finally accomplished in a climate of renewed appreciation for cities and city life generally. Since the first calls for redevelopment in the early 1960s, at the height of antiurbanism in America, taste and sentiment had shifted. By the 1990s, advocates for the neighborhood's historic ambience hoped to retool rather than raze the devastated area. Celebration of the district's theaters and famous signscape along with commercially sustainable architectural preservation revived Times Square's international fame and reinvigorated the district as a center for entertainment, signs, retail, and office development.

REENTER DOUGLAS LEIGH

Public urban renewal, including condemnation of structures and wholesale destruction and rebuilding, was for a time the prevailing American model for tackling the kinds of unyielding urban problems besetting Times Square. Although this radical step of government intervention was mentioned as early as 1964 as a solution for the district's woes, most hopes for revival focused on large and small schemes initiated by private action. Such development proved hard to spark, and soon it looked unlikely that the incremental approach would kick off a Times Square revival. Larger trends worked against such initiatives, as the *Times* had noted in 1962, when it complained that the district was being bypassed in an ongoing citywide building boom. Rents were too high, and the large parcels necessary for the multistory office blocks and hotels that developers wanted to build were hard to put together. The area's bad reputation and seamy street atmosphere, increasingly played up by the national media, were additional liabilities.

Like many members of the local business community, Douglas Leigh, still active in the local sign

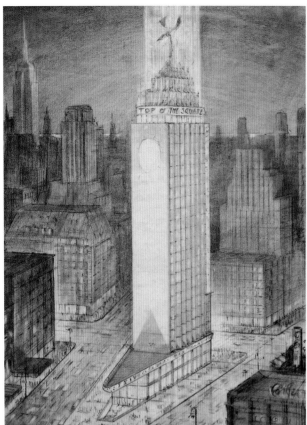 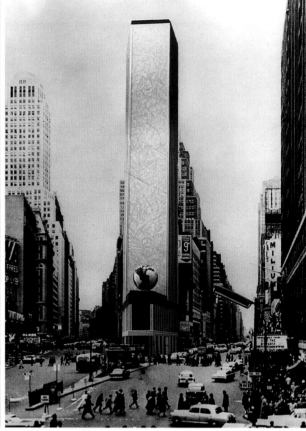

(Left) **In 1961 Douglas Leigh bought** the Times Tower and made plans to resell it. He hired Hugh Ferriss to prepare renderings for his pitch book. One of several versions Ferriss created, this version would have reclad the venerable landmark in ethereal glass while preserving the Motograph and capping the skyscraper with a fanciful sculpture and sign. The commission was the last job that Ferriss recorded in his workbook before his death in 1962.

(Right) **Douglas Leigh also commissioned** designs for the Times Tower that showcased commercial motifs typical of his earlier spectacular work, among them a globe (set against a facade of crackle Formica), clocks and thermometers, a giant Coke bottle, and various insignias.

business and deeply committed to Times Square, tried hard to initiate a turnaround—tabulating local crime, attempting to counter the area's sinking reputation, investing in real estate, giving money, and commissioning and promoting new plans. In November 1962 the Broadway Association, which had just elected Leigh its president, presented a plan for the restoration of Forty-second Street between Seventh and Eighth Avenues. Its architect, Richard Snibbe, recast the street as an arcaded two-level mall, with exhibition halls between refurbished theaters that would convert from increasingly raunchy second-run movies to legitimate shows (reflexively deemed more prestigious). Another association-sponsored plan unveiled in 1964 looked even less like the old Times Square. From Forty-first to Forty-third Streets between Seventh and Eighth Avenues, the association proposed what it called Exhibit City, a five-story, eighty-thousand-seat convention hall design projected to cost $80 million. At a time when much lip service was paid to Broadway's stature as the "showcase of our great city" and a "unique asset," the plan made

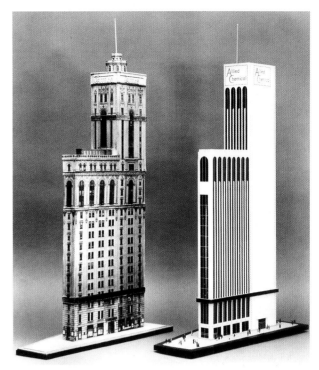

one mention of rehabilitated theaters on the lower floors; business use and tourism were the proposal's most prominent features.

How redevelopment on this scale was to be paid for remained unanswered. When the Broadway Association had advanced its first plan in 1962, it called for unspecified help from the city. When the second plan was announced with much fanfare at city hall in 1964, Leigh acknowledged to a reporter that the association itself would not finance it, but he confidently predicted that the money would not be "a major problem." A city official quoted in the same *Times* story was more cautious; the plan, he said, would indeed be a "gift from heaven for the city," provided that it did not cost it any money or require the use of eminent domain. That same week, the *Times* editorial page approved the new plan but tacitly acknowledged that it was highly unlikely to go forward.

In 1961, with spectaculars still playing from Times Square to Columbus Circle, Leigh had made a significant move when he bought the Times Tower (which had not been the newspaper's main headquarters since 1913) and announced that he was going to redesign it as an exhibition hall and office building. Leigh, who had started to design "tower identifications" and lighting schemes for national corporations in the 1950s, envisioned the 1904 landmark as a building-sized advertisement for whichever company might buy the structure. He moved quickly, commissioning models, montages, and renderings that he shopped around to many large national corporations. Designs in several styles were worked up. Hugh Ferriss, who had reinterpreted Leigh's plans for Times Square in 1946, developed designs that were soaring and transparent, with large areas of glass replacing the original building's terra-cotta skin. Other models and mock-ups showed product-oriented schemes that more closely resembled Leigh's Times Square spectacular mode. Still others featured safe, abstract corporate name signs, and it was this idea that Leigh finally sold, to Allied Chemical, in 1963.

Signing on to Leigh's vision of a building designed to raise Allied Chemical's public profile, the company refurbished the former Times Tower into a rental building with an exhibition space dedicated, in inimitable postwar style, to one of the company's important (but hard-to-dramatize) products—nylon. When the building reopened in late 1965, it was launched as a present to the city, literally tied up in a big red bow the size of the skyscraper. Its repackaging fell flat, however. Everybody seemed to hate it, a response that Leigh and Allied Chemical had not expected. The makeover was criticized for its blandness and "cheap" look. Despite broad public support for giving Times Square a face-lift, only after the tower's familiar aspect was erased did people take notice of

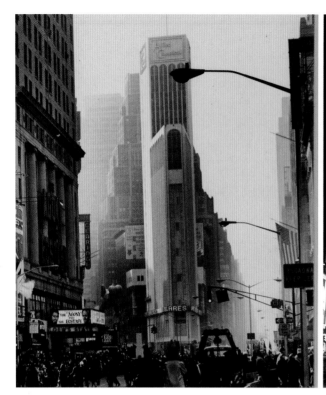

Even with a blue neon name sign at the top, a narrow sign strip down the north facade used for signs, a new Hotelings newsstand, and a fabulous new Motograph news zip run by *Life* magazine, the converted Allied Chemical Building never flourished. Leigh's idea of turning the Times Tower into a gigantic lighted advertisement was related to a new line of work—designing name identifications and exterior lighting schemes for corporate office buildings.

the original structure's symbolic importance to the district. "The distinctive character of the old building was replaced by the lowest common denominator of nondesign; if the remodeling had set out to be artless, banal and ordinary, it could not have done a better job," Ada Louise Huxtable, the *Times* architecture critic, later wrote in calling for "a coordinated city plan to revitalize Times Square."

The renovation had the extra misfortune to follow the 1963 destruction of McKim, Mead and White's magnificent Pennsylvania Station (1902–10), an act that spurred preservation sentiment nationwide and the passage of national and city legislation to protect historic buildings and districts. Allied Chemical sold its new tower at a loss in 1972. The entire effort had

been caught between the two competing ideas that framed the coming debate over Times Square: was the area to be improved by razing and rebuilding or by renovation and preservation?

Preservation was beginning to emerge as a public force at this time, one articulated in several important publications. Jane Jacobs's *The Death and Life of Great American Cities* (1961) was an extremely influential defense of cities against radical planning and wholesale destruction of buildings, streets, and neighborhoods in the name of abstract and inflexible ideas about modernization—an approach favored by Robert Moses (1889–1981), the city's planning czar. The architect Robert Venturi's *Complexity and Contradiction in Architecture* (1966) included enthusiastic appreciation

of the kind of vernacular streetscapes of which Times Square was the most famous example in America. The struggle over the square played out as these new urban-planning ideas started to come into wider currency. By the late 1970s and early 1980s, deep fault lines had opened among municipal and state governments, civic groups, local property owners, and developers, all of whom were ostensibly working toward the same goal—Times Square's revival.

BLIGHT OR HERITAGE?

Rebuilding remained the unquestioned model for Times Square past the 1960s. Apart from a number of projects on the district's margins started before the 1964 New York World's Fair, no major high-rise construction inside the square or on Forty-second Street had been completed since the Paramount Building opened in 1926. Most of the important commercial buildings dated from the area's glory days even earlier in the century. On Forty-second Street between Seventh and Eighth Avenues, the original center of Times Square, no large-scale buildings had gone up since the Candler Building in 1914.

The Broadway Association's revival plans and Douglas Leigh's own development activities stirred things up. In 1964 Leigh took on two more projects: he bought Daniel Burnham's 1909 Claridge Hotel, which he hoped to renovate, and he invested in the old

Heidelberg Building (run for years as a popular restaurant, the Crossroads Café), which he and his partners hoped to turn into a seven-story glass-fronted automobile showroom with "a huge oval revolving belt." Neither project succeeded.

By 1966 several more projects were announced for Times Square. The first to get off the ground was an office project on the west side of Broadway between Forty-fourth and Forty-fifth Streets, which required the demolition of the Hotel Astor, the first important hotel in the square. As the plan went forward, there was a cautious uptick in confidence, with the *Times* reporting that investors finally believed that the building boom might move to the West Side. A flurry of sales followed, with buildings around the square's infield and on side streets assembled into large parcels that could be used for high-rise office construction, the use that everybody projected for the area.

⊕ ⊕ ⊕ **In 1964 Douglas Leigh** and another local property owner bought the Crossroads Building (the old Heidelberg Building) and commissioned a new structure for the site. The plans, by William S. Shary, called for a seven-story automobile showroom with glass walls on three sides and revolving conveyor belts to show the newest models. Without a Big Three client, the dealership never went past the design stage.

Before proceeding with any of their plans, however, developers wanted to see what would happen with the office project on the Hotel Astor site, scheduled to begin in 1968.

Many of the only important remaining sign spaces were included in these putative projects: the Bond Building; the parcel next to the Claridge Hotel; and the whole block front on the square's west side between Forty-fifth and Forty-sixth Streets, which contained the block-long movie billboard above the Astor and Victoria Theatres, a site that had been a candidate to hold a different, never-built skyscraper proposed by its owners in 1964. (The Victoria, designed by Herts and Tallant, was named the Gaiety from 1908 to 1942.)

The *Times* declared that these projects, together with several other big developments in midtown, seemed at last to herald a Broadway that would be refurbished from the Thirties up to Lincoln Center (the recently finished redevelopment project at Sixty-sixth Street and Broadway masterminded by Robert Moses). Developers and city officials imagined that the new Times Square would be centered around business skyscrapers (instead of large theaters) set back from the street in spacious plazas, a type of design that might also garner developers some bonus space if these areas were devoted to public use. Gone would be the blocks of miscellaneous buildings from all eras, the spectacular signs, and the bright movie displays. The new towers would have pristine facades of marble or glass, fountains, and pedestrian malls to replace the jumble of the theater district's highly animated, varied commercial block fronts. Although there was some talk of protecting the district's entertainment and tourism, Times Square's classic ambi-

ence and look—irrevocably linked now to working-class taste and rising crime—were not considered an asset; most people favored new theater development instead of preservation.

With a construction boom looking likely by 1966–68, rather than seeking to preserve the old theater buildings themselves, the Lindsay administration (which took office in 1968) tried to offset the probable loss of legitimate theaters by encouraging developers to build them in their office or hotel projects. Envisioning a district of "sophisticated, very dense" high-rise construction with "luxurious, comfortable" new theaters, the city created what it called the Special Theater District in December 1967. Within a designated zoning area (from Fortieth to Fifty-seventh Streets between Sixth Avenue and just west of Eighth Avenue) where officials sought to maintain the district's concentration of theaters, developers could build up to 20 percent more rentable office space than existing laws allowed in return for including new theaters. Two plans around the square took advantage of these incentives: first the Astor project, completed in 1971, and then the Uris Building, which in 1968 replaced Thomas Lamb's 1919 Capitol Theatre at Fifty-first Street, the biggest American movie theater for many decades. Four new theaters, one a movie theater at the Minskoff Tower, were opened in these years, but Broadway professionals and critics hated the oversized and badly designed new spaces.

ROCK BOTTOM

The anticipated new construction in Times Square, which people hoped would kick-start a revival, was stopped completely in 1973–74. The cause was a city-wide glut in office space, some of it prompted by the

Curtains

As the struggle to preserve Times Square unfolded, few considered its old movie palaces. Because preservationists' intense focus at the time was on legitimate theaters, the area's picture palaces—America's most famous movie theaters for many decades—were taken for granted. Times Square started to lose its motion picture showcases, which in many ways were more architecturally distinct than the legitimate houses. (Regrets over the loss of Times Square's legitimate theaters have since been attributed by some to the fact that they served a largely white middle-class audience.)

The losses started in the early 1960s. The Roxy (1927) and the Paramount (1926) were the first palaces to go, the former demolished in 1961 and the latter gutted for offices in 1967. The Capitol followed in 1968. Other theaters survived but were partitioned. The historic Strand (1914) was divided into three theaters in 1968. The 3,500-seat Loew's State (1921), which received an updated front and a new lobby in 1959, was later subdivided into two auditoriums.

The movie theaters that remained intact stayed viable through the 1980s. A Municipal Art Society study found that Times Square's first-run houses sold more tickets than all the theaters in New York put together and that a large part of the enormous audience was drawn from working-class, black, and Latino New Yorkers living in neighborhoods where first-run theaters had closed. Like Times Square itself, by the 1970s and 1980s the movie theaters were strongly associated with cut-rate entertainment and pornography; developers for the government's Forty-second Street redevelopment plan insisted in the early 1980s that the theaters along the

Gloria Swanson in the ruins of the Roxy Theatre, 1960.

street not be used for movie programming. It was an attitude that prevailed for a long time. As late as the 1990s, Rudolph Giuliani's administration adamantly opposed having the multiplex company AMC Entertainment as a tenant on the Deuce.

Today no vestige of the important movie fronts—Lamb's giant orders, the Astor Theatre signs, the Rialto spectacular, the three Warner marquees—remains in the square. The Paramount's arched entrance and marquee have been re-created, and Lamb's Hollywood Theatre, minus any Broadway entrance, has become a church. The building at the corner of Forty-seventh Street and Seventh Avenue that once housed the 1909 Mayfair Theatre still exists, but the theater closed as a triplex in 1998; now its facade is used for a wraparound canvas billboard, usually advertising Broadway shows playing elsewhere—a distant reminder of the ravishing, roof-high neon fronts displayed by the movie house in the 1930s.

steep increase in rental footage when Minoru Yamasaki's World Trade Center was completed in 1973. With no economic incentive, the district continued to slide into lawlessness, and the question of what was to be done to rescue Times Square became academic. Developers disassembled their large parcels inside the square and put their plans on hold. Businesses that had been open since the 1920s contended with a rapidly deteriorating street environment. Some tourist and retail businesses stuck it out in the late 1960s, among them Toffenetti's large tourist restaurant, Woolworth, a Ripley's Believe It or Not, and Bond Clothes (for many years among the country's biggest makers of off-the-rack clothes). Most, however, were gone by the mid-1970s. The stretch of Forty-second Street that held New York's most famous theaters was by then a marketplace for hard-core movies, peeps, and stores selling pornography and sex paraphernalia. Nighttime customers avoided theaters, bars, restaurants, and other businesses on the side streets. Danger, coupled with a national recession, caused tourism in the city to drop 40 percent between 1969 and 1971.

The blocks on Broadway and Seventh Avenue between Forty-fifth and Forty-sixth Streets entered a limbo with no clear future. Owners hastened the area's decline by renting to short-term tenants, many of them fly-by-night businesses and sex marketers willing to pay above-market rents from month to month. Except for a few important rooftop sign spaces, by 1976 these blocks were nearly derelict. On the west side of the square between Forty-fifth and Forty-sixth Streets, one legitimate-turned-movie theater, the Astor, which had been open since 1905, went dark in 1972. The new owner, Peter Sharp, refused to pay for renovations needed to keep the movie theater open; for some time afterward, the space, which had been stylishly renovated in the 1950s, housed a flea market with porn shows in the basement. The flea market eventually moved across the street into an empty Woolworth store (the chain closed there in 1975) on the Bond block, and by the end of 1976 no big tenants or investors were interested in the properties. The same attitude prevailed elsewhere in the district. Announcing in 1974 that the historic Franklin Savings Bank (1899, York and Sawyer) at the southeast corner of Forty-second Street and Eighth Avenue was a "dump the city would be better off without," bank officials declared their intention to demolish it. In 1975 the owners of the Knickerbocker Hotel, a consortium that included Harry Helmsley, defaulted, and the mortgage holder gave "serious consideration" to tearing down the historic property. Besides speeding the area's decline, the symbolism of these losses was devastating.

Media images portraying Times Square as a symbol of the evils and the decline of cities had wide appeal in the 1970s, when the square was often the butt of jokes by late-night television comedians and show-business personalities. Horrified boosters countered with PR offensives and tourist propaganda, to no avail. Photographs of the fallen Times Square were broadcast or published widely, just as the brilliant images of the 1930s and 1940s had been. For New York City, itself in the throes of a severe fiscal crisis and near bankruptcy, the publicity was disastrous.

The sign market limped along. Some billboards, movie posters, and big spectaculars held on as faint reminders of the stylish streetscape established in the 1910s, but many sign spaces were vacant. From 1972 to

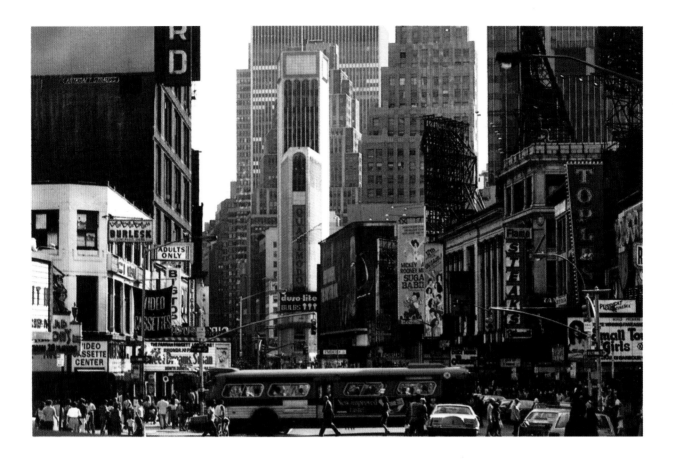

By the late 1970s, pornographic movies, peep shows, adult bookstores, live sex shows, brothels, massage parlors, streetwalkers, pimps, and drug dealers made sidewalks and the mazelike subway stop unpleasant and dangerous even during the day. At night remaining restaurants and legitimate theaters, many of them clustered on side streets to the west of Broadway, were often deserted.

1977, the Bond Building roof at Forty-fifth Street had a giant Douglas Leigh semispectacular billboard featuring a Gordon's Gin bottle, flanked on either side by two smoke-ring signs for Winston. The news zip on the Times Tower was still in operation, at the expense of its new owner. In 1976 a large computer-operated screen, called the Spectacolor sign, went up on the north end of the Times building, a harbinger of the huge television screens in Times Square today. By 1979 Douglas Leigh, nearing eighty, sold his dozen or so sites to a new sign company named Van Wagner.

Business signs now bore little resemblance to the expensive neon fronts framed in enamel and chrome of the 1930s–50s. Instead, the street level had a patched, piebald quality, with handpainted signs, banners, and windows cluttered with the cheapest goods. In the 1950s these handmade signs had flogged odd lots, knockoffs, and souvenirs, but now the crude paintings advertised "models," "wild sex," and "Psychedelic Burlesk."

In John Schlesinger's 1969 Oscar-winning film *Midnight Cowboy*, the street scenes document the area's decline. In them the remaining spectacular signs, partially visible and seldom seen straight on or in long shots, are joyless and tawdry. At the center of attention are the peeling arcades, second-run movie

Taking the World Stage

As Times Square deteriorated in the early 1970s, American advertisers deserted it, many of them after decades. Eager to break into the American market, Japanese companies began taking over spectacular spaces and steadfastly hung on while the theater district degenerated. The new advertisers were great admirers of Times Square, particularly of its neon, which they considered an important vernacular art form. "Times Square had begun to go dark by the time I was sent . . . in 1969," Sam Kusumoto, the head of Minolta's USA subsidiary, said in the *New York Times* in 1991. "Indeed, at the time, the night sky over Tokyo was brighter than New York." The new sponsors also shared what Kusumoto called "a nostalgia for Manhattan," and they "struck a gentlemen's agreement to relight Times Square."

The new sponsors mixed their aesthetic reverence with real-world business judgment, believing that to advertise in Times Square was to announce their arrival in the American market—indeed on the world stage. To the Japanese, the commercial signs in the district had lost nothing of their prestige or glamour. Many of their Times Square signs were placed by the successor of Douglas Leigh's firm, Van Wagner, which maintained high standards of neon spectacularity.

The Japanese companies are now widely credited with keeping the Times Square spectacular market alive during the area's decades of decline, at a time when foreign investment in the United States was unpopular. Their deeply felt appreciation for the streetscape was in stark contrast to the attitude of American businesspeople, who for years had disdained Times Square's neon as honky-tonk. The Japanese enthusiasm for the lights was carried back to Asia, where it has been developed in Hong Kong, Singapore, and, most famously, Tokyo's Ginza district.

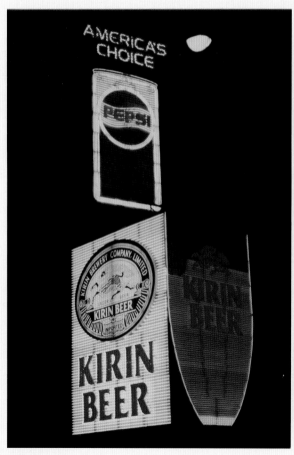 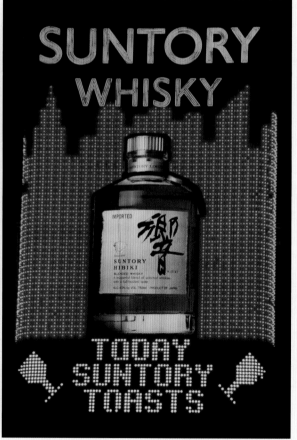

Japanese spectaculars in Times Square, 1980s.

houses, and all-night restaurants, with their casts of hustlers, marks, and crazies. The energy and excitement of the signs and the square's bright atmosphere of light and beautiful moving surfaces, which had been vividly framed in William Klein's documentary film *Broadway by Light* in 1958, were only a memory.

LEARNING FROM TIMES SQUARE

Proposals designed to improve Times Square continued through the Lindsay and Abraham Beame administrations (1966–73 and 1974–77, respectively). Several were similar to the plans of 1962 and 1964, envisioning Times Square and Forty-second Street as pedestrian malls with glassed-in concourses, raised pathways, and streets closed to cars and trucks at least part of the day. Businessmen, officials, and even architecture critics considered the area a possible site for a large new convention center that city authorities wanted to build; others imagined the garment district extending north to include structures for showrooms and trade exhibits. A group of actors called for a dedicated red-light district like Amsterdam's. The coming bicentennial in 1976 caused a flurry of hope, with ideas floated for tourist booths and hospitality stations. In spite of continuing investigations, studies, and police and legal initiatives, however, none of the plans gained much traction.

By the second half of the 1970s, desperation had set in. The mood had changed from the early 1960s, when the city had cheered the Broadway Association's 1964 Exhibit City plan but insisted that private development was the only way to build it. To make Times Square once again safe for citizens and profitable for legitimate business, public sentiment wanted it to be returned to good use (as planners put it). The subway station—a maze of tracks, grade changes, and dangerous, deserted mezzanines—had to be modernized, cleaned up, and made secure. But the same questions remained. Which kinds of business should be encouraged to move in? High-rise offices or entertainment? How was it all to be paid for, and by whom? Should the process include demolition, renovation, or both? How would the city, emerging from its fiscal crisis with a lowered bond rating and state financial oversight, fit into the plan?

In the early 1980s, when the city and the state finally undertook a major redevelopment project for the worst section of the neighborhood—Forty-second Street between Seventh and Eighth Avenues—the financial model used was innovative but carried a price: private developers would pay for the needed subway renovations and new business buildings in return for deferred taxes and extra rentable floors. To carry out the desperately needed project, a city-state coalition would use its considerable powers to execute the complex operation of condemnation, acquisition, and resale of the land.

The eventual city-state plan for Forty-second Street was based closely on a nonprofit effort, funded by the Ford Foundation and other local donors and launched in 1979. Called by sponsors the City at 42nd Street, it proposed, as had the Broadway Association's 1964 convention center plan, both rebuilding and new construction in the oldest, most devastated part of the theater district: the thirteen-acre area from Forty-first to Forty-third Streets between Seventh and Eighth Avenues, with Forty-second Street at its center. At first the plan was to buy up properties and renovate them one by one, using as a model Theater Row, which was a group of off-Broadway theaters that

Frederic S. Papert, the head of the City at 42nd Street group, had successfully redeveloped west of Eighth Avenue. However, it became clear that this approach was unlikely to succeed when the owner of the New Amsterdam Theater (1903, Herts and Tallant), which was appraised at $700,000, asked for $8 million. The group then brought in business advisers who put the project's financing, initially based on tourist income, on a more realistic footing.

The redone City at 42nd Street plan tried to balance theater and entertainment with commercial development. Its projected costs came in at around $600 million, most of which was to be financed by the developers of the business buildings. The program allowed for five of the former legitimate houses on Forty-second Street to be renovated, three more to keep their facades, and a five-hundred-thousand-square-foot center combining exhibits (dispensing information about the city) and entertainment (including a Ferris wheel). There were to be three forty-two-story office blocks at the crossing of Broadway and Seventh Avenue at Forty-second Street, a merchandise mart at Eighth Avenue, and retail and restaurant development in a mall-like space across Eighth Avenue from the Port Authority Bus Terminal. The subway station was to be renovated when the offices went up. The plan's dependence on private developers for financing ensured the central place—financial and architectural—of enormous office towers.

The organizers needed the city to sign on to the plan for two reasons: to help with land acquisition, including designation of urban renewal status to allow condemnation; and to gain zoning exceptions, principally transfers of all the theaters' air rights (development potential) to pave the way for the big office buildings at the project's east end. With renderings in hand and two major developers lined up, backers consulted staff and officials at the City Planning Commission, the Office of Midtown Planning, and other city agencies and sent copies to Mayor Edward Koch's deputy for economic development, Peter J. Solomon.

Koch rejected the proposal in June 1980, calling it "Disneyland at Forty-second Street." He criticized not only the plan's theme park–world's fair conception but also its lack of competitive bidding and its likely destruction of the Times Tower. By the fall Koch had mounted a scheme of his own, the Forty-second Street Development Project, which came directly out of the City at 42nd Street plan. The ingeniously crafted new proposal, like the old one, ensured that the redevelopment of Forty-second Street from Broadway to Eighth Avenue, including a renovated subway and theaters, would cost the city nothing. Its financing plan similarly traded tax abatements and zoning exceptions to developers in return for public improvements. At least on paper, the city was trying to balance renovation and condemnation as well as live entertainment (in renovated historic theaters) and business development to pay the bills. The mayor quickly decided to bring in the state of New York's Urban Development Corporation, which had experience with big renewal projects and the right to condemn property without having to clear the many local reviews a city-only plan would require. In June 1981, Koch issued a set of detailed, mandatory design guidelines prepared by Cooper Eckstut Associates, a firm of planner-architects who had worked on the master plan for Battery Park City, and began discussions with developers.

The design guidelines were reassuringly true to Times Square's traditional look and atmosphere. They emphasized the idea that the square was a public space with singular visual qualities—dense moving crowds and the sense of an outdoor room decorated with animated, dazzling signs and marquees. The rules set maximum heights for the street "walls," required stepped setbacks from the street line to reduce skyscrapers' bulk and let in light, and specified electric signs, reflective materials such as metal and glass, and specific kinds of lighting for all new construction.

Chosen developers were designated in 1982, with the lead position taken by George Klein's Park Tower Realty, which in 1986 signed on with Prudential to become Times Square Center Associates. City-state plans were first presented to the public in late 1983 by Klein's architects, Philip Johnson (1906–2005) and John Burgee (b. 1933). For the central intersection of Forty-second Street, Broadway, and Seventh Avenue, they proposed four tall office buildings ringing a plaza on the site of the Times Tower—whose preservation in fact had been one of Koch's reasons for rejecting the City at 42nd Street proposal. The designs ignored the prescribed guidelines in several ways, most noticeably in their materials—there was virtually no reflective glass or metal—and, more ominous, by omitting signs and architectural setbacks. Most astonishing, however, was their size: at twenty-nine, thirty-seven, forty-nine, and fifty-six stories, they were unthinkably large for their sites. They would completely transform the neighborhood, dwarfing the theaters in the square and on Forty-second Street and eliminating electric signs. As well as destroying the historic Times Tower, the plaza ensemble—which sought to create an identity for the district similar to Rockefeller Center's—would do away with the square's familiar triangular space and dynamic sight lines. By eliminating the district's scale, shape, distinct visual qualities, and sense of a teeming street life, Times Square would no longer be Times Square.

Opposition was galvanized. Civic groups, including the Municipal Art Society and the local chapter of the American Institute of Architects, as well as property owners, neighborhood associations, and architecture and cultural critics lined up against the plan. They were shocked that the design guidelines had been ignored. The proposed destruction of the Times Tower—the neighborhood's central symbol—rallied people even more. In 1984 the Municipal Art Society and the National Endowment for the Arts sponsored a design competition for the tower's renovation. The response was huge, and the entries were exhibited and widely discussed.

The city and state continued to methodically pursue the project, which took the next eight years to fail in the face of lawsuits, another market downturn, preemption of their efforts by private office development in Times Square proper, rising land values and changing market cycles, and aesthetic criticism of the plan. As public criticism of the redevelopment scheme escalated, new Johnson and Burgee plans were made public in 1989. They too were met with disfavor, given that the proposed buildings were just as enormous as the earlier ones, with tacked-on electric lights, colors, and signs.

Even though the project's practical aim was clear—to clean up the underused but extremely valuable land at the center of Manhattan—and had

In 1984, rebuffed by negative reaction to the first Johnson and Burgee plan, the redevelopment plan's lead developer commissioned a new design from Venturi, Rauch, and Scott Brown. The resulting giant apple, ninety feet around, sought to establish a new icon in the tower's place, one that could compete as a symbol of New York. The "Big Apple" tourism campaigns were well known by this time, but the developer none the less rejected the plan.

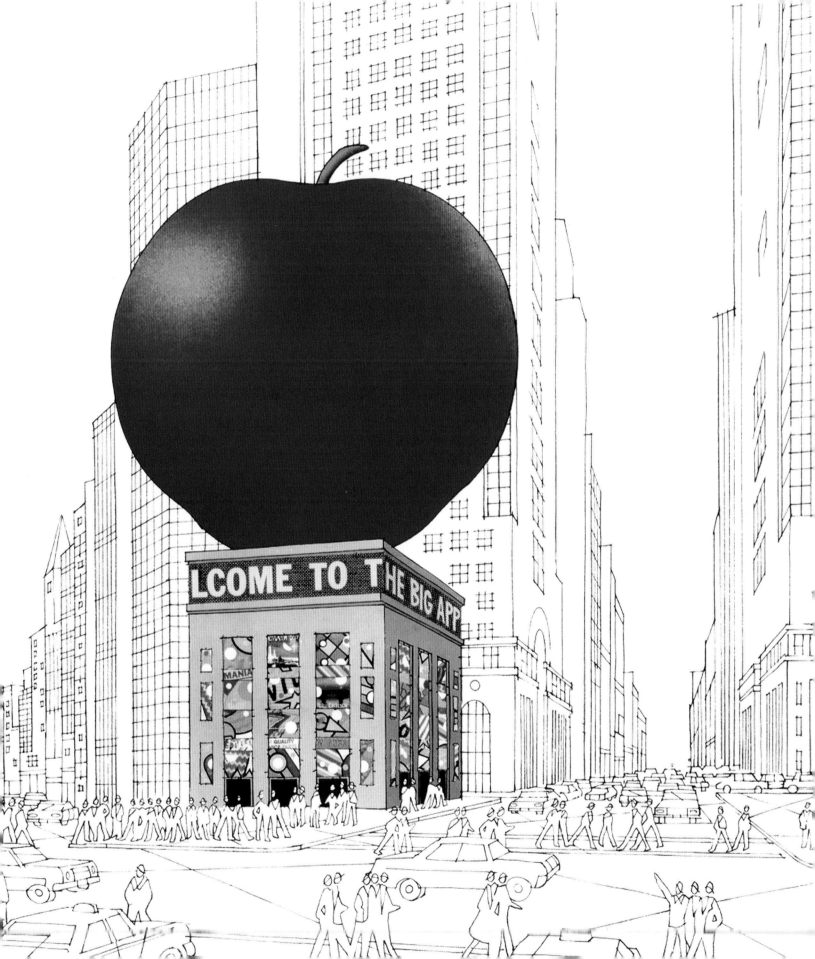

broad public support around 1980, hindsight suggests that the city-state plan was out of step almost from the minute it was proposed. By the mid-1980s, consensus seemed difficult to find. Freedom-of-expression advocates, notably the American Civil Liberties Union, and proponents of sexual freedom defended the sex shops, while feminists spoke out against the pervasive merchandising of sex. Area residents, feeling threatened by displacement and price rises that would come from gentrification, claimed class bias and discrimination in favor of business interests. The immensely powerful developers, the favored agents of economic growth and city improvement after the financial disasters of the 1970s, arrogantly flouted controls placed on them. Until as late as 1986, scant attention was paid to how the theaters were going to be restored and what would happen to them afterward. By 1992, when the Koch plan was foundering, one *Times* critic, Herbert Muschamp, remarked on its authoritarian tone and execution.

As Lynne Sagalyn notes in her book on the redevelopment of Times Square, because the project's financing was so complicated, it tended to be underreported. This threw greater media attention on the more easily understood part of the plan—its looks—at a time when the new ideas about preservation, cities, and commercial environments continued to find wider acceptance. Toward the end of a period of cultural and aesthetic ferment that had begun in the late 1960s, architecture and planning were shifting away from International Style modernism and the large-scale redevelopment plans of the postwar years. Showing the influence of Jane Jacobs, the growing preservation movement, and architects such as Robert Venturi, Denise Scott Brown, Steven Izenour, and Rem Koolhaas, appreciation was growing for what had previously been scorned—vernacular building types, commercial decoration, and the traditional scale and visual qualities of city neighborhoods and street fronts. In New York and elsewhere, the shift opposed inward-looking towers in plazas favored by local developers and embraced more humanly scaled, traditional block fronts, materials, and colors. As America's most famous downtown, Times Square—where the vivid Main Street aesthetic had been so memorably built up—made a fitting test case.

LET THERE BE LIGHT

The outcome of the Forty-second Street plan became more closely tied in the 1980s to other private development efforts inside the square, which took off following a separate city zoning push. After the first Johnson-Burgee plans were presented to the public in 1983, the Municipal Art Society worried that the Koch redevelopment plan might become a model for the whole of Times Square. Skyscraper development in the square proper was almost inevitable after the passage in 1982 of the Midtown Zoning Resolution, a city initiative seeking to encourage private development by including incentives allowing extra rentable floors (and thus taller office towers) for projects whose foundations were completed by May 1988.

Although the Municipal Art Society had supported the construction incentives, by 1984 it saw the zoning law as a threat to Times Square's look, atmosphere, and traditional businesses. The group undertook a study of its own and also tried to push the Landmarks Preservation Commission to grant landmark status to forty-four of the area's historic theaters, which were in danger of being demolished.

Using its opposition to the Koch plan for Forty-second Street as a starting point—the Johnson-Burgee models made it crystal clear what was at stake—the Municipal Art Society and its allies waged an extended and effective public relations campaign to promote the preservation of Times Square's distinctive visual qualities and traditional uses. The organization wanted the planning commission to reexamine zoning guidelines in the theater district in order to protect the "bowl of light" and the streetscape that had developed since 1904.

As Midtown West (the planners' name for the larger neighborhood including Times Square) was developed on the basis of the 1982 zoning resolution, the Municipal Art Society argued that preservation of Times Square's distinctive environment and status as a theater-entertainment district was crucial. In a number of highly theatrical publicity events, the opponents of Koch's scheme demonstrated vividly how the plan would permanently change the district. They twice blacked out all of Times Square's spectaculars—the instantly recognizable symbol of the entire theater district. An effective presentation using sixteen-foot architectural models of the street and a film narrated by Jason Robards Jr. and the cast of *Big River* showed how the scale and the monolithic look of the Burgee-Johnson buildings (whose designs Johnson later disavowed) would alter the street from a pedestrian's point of view. To keep their positions before the public, the Municipal Art Society–led group used celebrities, press conferences, sign launches, op-ed pieces, the 1984 Times Tower design competition, and public ceremonies.

After ordering a study of the area's zoning regulations, in early 1986 the planning commission proposed a zoning amendment mandating that all new buildings in the so-called Bow-Tie zone (the blocks running from Forty-third Street to Fiftieth Street between Seventh Avenue and Broadway) carry animated electric signs. All buildings there would be required to reserve a certain amount of space for entertainment and to display electric signs. The design rules, formulated after intensive study of Times Square's signscape and streetscape by city planners and consultants, mandated ratios of signs to facades, street heights, light levels, and placement of signs. When developers seemed ready to flout the guidelines in the year after the commission's recommendation, the Municipal Art Society called for a moratorium on building in the area. During hearings many developers spoke out, and Morgan Stanley, in negotiations for one of the giant new buildings going up in the square, threatened to pull out. Nonetheless the guidelines were adopted in February 1987 by the Board of Estimate, the city agency whose approval was necessary to enact the zoning changes.

FAST, PRACTICAL, AND INEXPENSIVE: 42ND STREET NOW!

By 1990 Times Square's fortunes were affected by the second downturn in demand for office space to hit New York in twenty years. When Midtown West's vacancy rate reached 33 percent that year, a debilitating glut took hold. Two years later, the floundering Koch plan for Forty-second Street was finished off. First, the four large towers planned for the corners of Forty-second Street, Broadway, and Seventh Avenue were preempted by projects inside Times Square that had taken advantage of Midtown Zoning Resolution bonuses, which expired in mid-1988. When in 1992

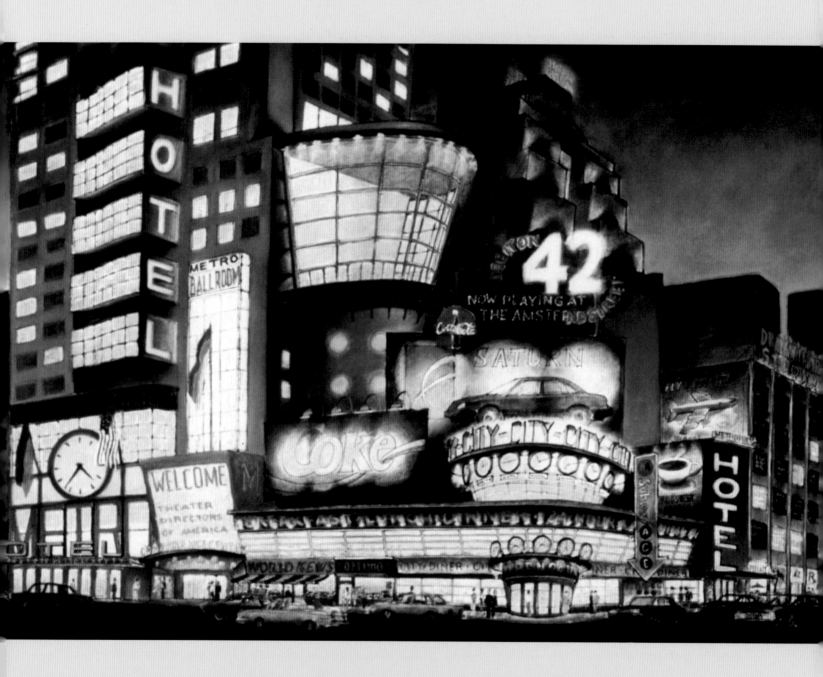

and 1993 two major companies—Morgan Stanley and the media conglomerate Bertelsmann—took over two new buildings inside the square on good terms, accepting tax abatements offered to lure corporations to the city, a psychological barrier was crossed. Prices rose, and a flood of new businesses opened buildings or rented space in Times Square offices.

The problem of Forty-second Street, however, remained extremely pressing. Since 1990, the Urban Development Corporation, the state partner in the Forty-second Street Development Project, had started taking over parcels on the Deuce to make way for redevelopment. With the street growing darker and more deserted as condemnation progressed, the project renegotiated its deal with Times Square Center Associates, the developer of the four stalled office buildings. To try to bring some activity back to the street and to honor the developer's commitment to help with theater renovation, the partners were required to fund temporary retail and entertainment development at the corners of Forty-second Street, Seventh Avenue, and Broadway; in return the company was allowed to postpone construction and received extended tax breaks and some money back.

The Forty-second Street Development Project then commissioned a well-received interim plan to enliven the corners around the Times Tower and the darkened, condemned stretch between Seventh and Eighth Avenues. The mostly private plan, entitled 42nd Street Now!, was presented publicly in 1993. While Times Square Center Associates waited out the downturn, the plan's authors, the architect Robert A. M. Stern and the designer Tibor Kalman, created a flexible model they called a "matrix" to be used for

five to ten years. To restore the traditional mix of businesses in the theater district, the plan sought big and small stores, restaurants, bars, clubs, hotels, and large retail and theatrical businesses. It proposed a general framework of renovated and new buildings to the west, restored theaters in the middle of the blocks, and some kind of big tourist or amusement center at the Eighth Avenue end of the site.

Stern and Kalman explicitly rejected the idealized "radiant-city" image so beloved by postwar planners and architects or any imposed, unified design for the whole street. Using images of archaeological strata and collage, simple design guidelines called for new street decoration to be added to the old. With signs, layered surfaces, glass storefronts, and bright electric lights everywhere, Stern and Kalman's plan called for visual surprise and excitement of the kind that had been typical of Times Square streets in the area's heyday. The designers did not want a streetscape that was totally random, however, and called for eye-catching architecture and businesses as anchors at Seventh and Eighth Avenues. The Forty-second Street Development Project and its theater arm, the New Forty-second Street, moved quickly to line up tenants for key sites on the Deuce.

With several national retailers already taking space on the blocks surrounding the Times Tower, the Walt Disney Company was persuaded by late 1993 to renovate and run the New Amsterdam Theatre at Forty-second Street just west of Seventh Avenue. Disney demanded that all remaining porn businesses on Forty-second Street be condemned and closed and that two other large entertainment companies sign on, which AMC Entertainment and Madame

Tussaud's did in 1995. The nonprofit New Victory Theatre opened that year in the renovated Republic Theatre (1900, Albert Westover), and the dark blocks on the street soon began to revive.

By 2005 office buildings were finished on all four corners around the Times Tower. Corporate development inevitably reshaped the district into one of bigger buildings and business headquarters, but what emerged was a revived entertainment and office district, not a new Rockefeller Center. Offices and hotels form the core, surrounded by a concentration of media headquarters, corporate-run entertainment, and retail giants. Just as swank, commercial Broadway theaters in an earlier era had attracted hotels, roof gardens, and restaurants, and just as movie companies had taken over Broadway theaters and remade the district, these new entertainment businesses and electronic media have reinvigorated the area. Inevitably there were trade-offs—the new upzoned buildings changed the scale of Times Square forever, and many early Broadway buildings have been torn down or covered up.

Now sometimes criticized as ersatz, bland, and gentrified, the highly commercial tourist square that developed after 1993 is perfectly in line with Times Square's past. With many porn outlets pushed to the avenues and side streets to the west, retailers, restaurants, and tourist businesses are now thriving and the sidewalks are again crammed with New Yorkers, suburbanites, tourists, caricaturists, and vendors. The media-savvy Naked Cowboy is typical of the new Times Square: a buff, telegenic eccentric who is a million miles from Runyon's preachers, Meyer Berger's disabled beggars, or Jon Voight's vulnerable hustler.

SPECTACULAR RETURN

With Times Square the hottest real estate market in New York after the mid-1990s, and its fame as a national marketplace renewed, sign revenues began to break records. American advertisers had started coming back earlier that decade, joining the Japanese companies that had stuck it out through the decline of the 1970s and 1980s. In 1980 approximately two dozen spectaculars were mounted in the square, but by 1995 a news report cited sixty of them, with annual rentals ranging from $180,000 to $1.2 million.

The sign landscape has changed noticeably, as new advertising forms and strict design regulations have affected the look and placement of signs in Times Square. Prominent today are architectural signage (spectaculars incorporated into large parts of building facades), enormous multistory vertical identification signs, huge video screens, Flex-front (sculpted plastic) signs, and acres of computer-printed billboards that are essentially print ads blown up several stories high. Giant television and video screens have become a mainstay, some of them carrying product advertisements and others running news and other streaming video. On-air exposure promotes the signscape, as newspaper supplements did earlier in the last century: many of the cable news networks include footage of the square day and night in credit sequences, and dozens of televisions shows and movies use pictures of the square as establishing shots.

At close range, the textures of the new electronic Times Square streetscape are different from those of earlier eras. Computerized and plastic surfaces have replaced the handwrought miracles of neon bending, clever smoke-emitting mechanisms, and the

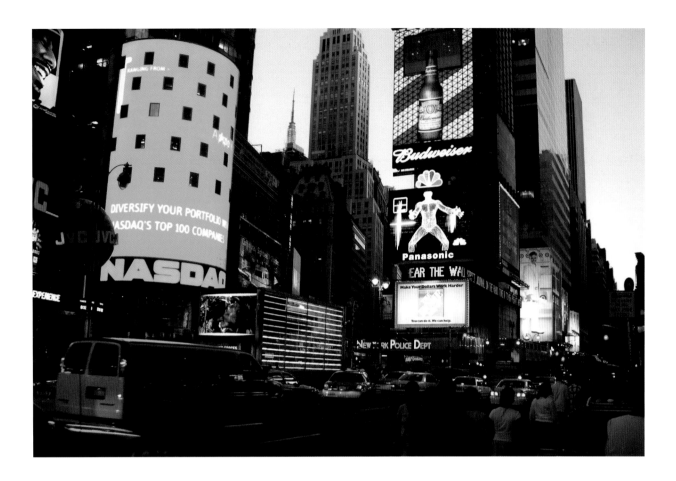

tinseled, overdecorated lobby installations that sign shops painstakingly created. Canvas or plastic signs hide the few old facades, for example the I. Miller Building and the Mayfair Theatre, that linger on Seventh Avenue.

Oscar Gude, Mortimer Norden, General Outdoor Advertising, Douglas Leigh, Artkraft-Strauss, and many of the hundreds of sign producers working in Times Square made free outdoor programs that were carefully timed, often playing at a snappy, cartoony pace pitched to the average passerby. By contrast, today's signs are a blend of product, retail, and increasingly sensational corporate information and identification signs that scroll by in a hypnotic stream of color and video images.

In the dark or at a distance, the signscape is mag-ical. Among the most beautiful developments are the LED (light-emitting diode) displays, a relatively new light form in which a computer-controlled semiconductor diode gives off light when charged with electricity; as the colors, resolution, and design advance, they have been capable of thrilling and mysterious effects (though like the video feeds, their programming is sometimes meager). Even if the modern signs lack the antiquarian interest of their forebears, Times Square's new, endlessly photogenic signscape conjures up all the visual excitement and energy of the earlier incandescent and neon spectaculars. Through them Times Square has become a center in which buildings have become signs, and news, live sports events, and advertisements are broadcast night and day, as Douglas Leigh imagined sixty years ago.

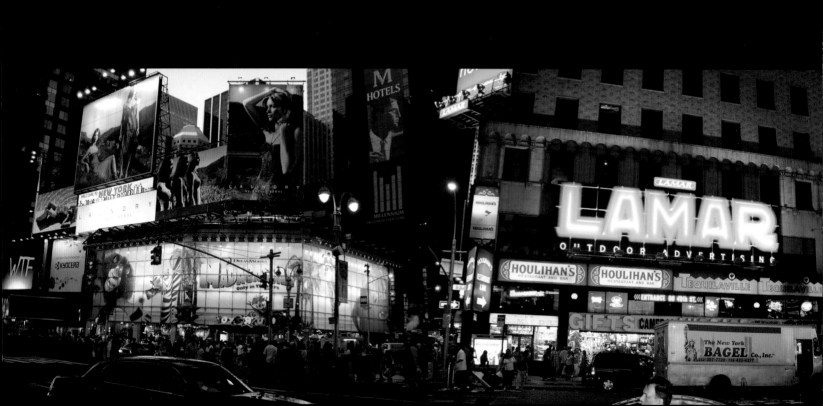

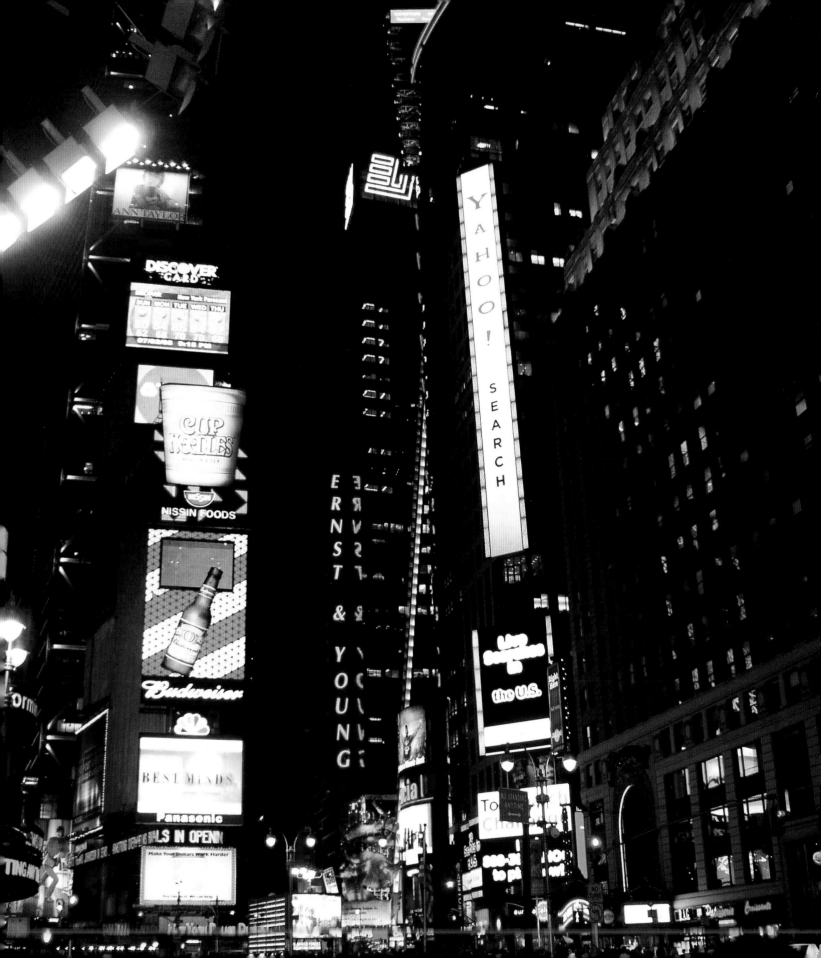

DOUGLAS LEIGH'S GRAND PLANS FOR TIMES SQUARE FROM 1944 ANTICIPATED MANY OR ALL OF THE NEW EFFECTS AND TREATMENTS SEEN IN TIMES SQUARE TODAY: GIANT TELEVISIONS, SIGNS THAT MAKE UP ENTIRE WALLS OR RUN THE FULL FACADES OF BUILDINGS, STREAMING VIDEO, PHOTOGRAPHS THE SIZE OF MOVIE SCREENS, SKYSCRAPERS MADE INTO SIGNBOARDS. LEIGH LIVED THROUGH THE LONG STRUGGLE OVER THE SQUARE (HE DIED IN 1999), BUT AFTER 1979 HE PLAYED NO CENTRAL PART IN THE AREA'S REVIVAL. HE HAD MOVED ON.

After the war, Leigh was restless for fresh creative and business opportunities and turned his energies to a number of new projects. He had always dreamed of working in the enormous scale that he had never been able to realize fully in his commercial sign work. Now his imagination focused more and more on New York's largest and most famous spaces and on its skies and rivers. It took twenty-five years for him to find the right outlet, but he never abandoned his goal to work large.

Since the 1930s skyscrapers had appeared repeatedly in the thousands of ideas Leigh recorded for signs and other urban spectacles. Now in one way or another they occupied him more closely. As a sideline in the 1950s and early 1960s, Leigh designed exterior lighting schemes for new corporate office buildings, including headquarters for *Newsweek*, *Time* and *Life*, and several regional corporations. This phase came to an end with the badly received transformation of the Times Tower into the Allied Chemical headquarters in 1963. The various schemes he presented before he resold the tower show Leigh searching unsuccessfully for a balance between the commercial mainstream and his less salable impulses to make flashy world's fair–style spectacles. Another project gave Leigh a stimulating problem to work out, but it was not a direction he could parlay into real-world practice—yet. For the 350th anniversary of Henry Hudson's discovery of Manhattan, in 1959 Leigh made Manhattan Island into a giant temporary spectacular by asking all skyscraper owners to keep their lights on for an entire night. Despite the spectacle's great success, it was more than a decade before Leigh was able to build on the experience.

In 1976, when Times Square was approaching its nadir, and Leigh still held some fourteen important sign leases there, he was approached for a job he had dreamed of since the early 1930s. Harry Helmsley,

Tribute in Light and the Empire State Building, New York City, 2002.

(Above, Left to Right) **Declaring his desire to deliver** "pure light to glorify beautiful buildings," Leigh installed dramatic architectural lighting on structures all over New York. For the Citicorp Center (1978, Hugh Stubbins and Associates), Leigh installed three systems, lighting the crown from outside. His designs for the Crown Building at Fifth Avenue and Fifty-seventh Street (1921, Warren and Wetmore) called for the regilding of the cupola, which was originally green, and the restoration of its statues. New lamps highlighted the gold ceramic crown of Cass Gilbert's 1928 New York Life Building for the company's 140th anniversary.

(Opposite) **Leigh's six-thousand-light snowflake** at Fifth Avenue and Fifty-seventh Street became an almost instant icon of the city in 1984. Leigh's memorable wintertime symbol, sponsored by Tiffany and other local businesses, supersized a typical downtown decoration for one of New York's most famous corners. The decoration has been used ever since its debut despite initial reservations voiced by Paul Goldberger, architecture critic for the *Times*, who lamented the original's execution and Main Street origins.

the new owner of the Empire State Building (1931, Shreve, Lamb and Harmon) at Fifth Avenue and Thirty-fourth Street, asked him to light the skyscraper for the nation's bicentennial. Leigh proposed not a giant cigarette or a soda bottle but striking red-white-and-blue lights for the building's crown. His design, attaining the "memory value" of many catchy Leigh works of the past, instantly became an enormously popular, constantly photographed symbol of the city. The scheme was a typical Leigh idea, a design the size of a city skyscraper—in fact, the most famous sky-scraper in the world. Its supersized, abstracted Main Street lighting idea (the use of symbolic colors) was perfect for a city anxious to renew the fame and popularity it had slowly lost in the decades after World War II. In one important design, Leigh did a great deal to help restore the city's damaged image and wounded ego. The sign maker's lighting of the Empire State Building, which the owners allowed him to expand into a permanent program, is still used today to mark special occasions and holidays with varied color schemes.

Over the next two decades, Leigh went on to revive another of New York's most important icons: its skyline. In these years he was commissioned to design lighting schemes for more than a dozen important historic and new skyscrapers in New York, among them the New York Central Building (1929, Warren and Wetmore), the Waldorf-Astoria (1931, Schultze and Weaver), the Citicorp Center (1978, Hugh Stubbins and Associates), and the New York Life Building (1928, Cass Gilbert). Leigh lovingly brought out the buildings' architectural details and decorative elements—their crowns, sculpture, cupolas, turrets, crockets, and arches—with cleaning, regilding, and lights that helped viewers see them afresh. In his new career, Leigh's imagination was given all of Manhattan to work with. Each restoration and relighting was conceived to be seen from a variety of distances and to look good in news photographs. "I'm trying to pattern this to get an effect . . . that's . . . not a hodge-podge," Leigh told the *Wall Street Journal*. "I want some buildings visible for drivers approaching Manhattan from the east and west as well as those jets that are coming in." His work, featured on a *New Yorker* cover and in many newspaper and magazine articles, was so effective that it kicked off an undeclared race among building owners, who rushed to give their buildings the same nighttime drama Leigh gave his designs. With Leigh at the forefront, New York's skyline began to regain its currency and power as a national symbol. Finding himself at the forefront of his field, he expanded his practice, which had grown to include decorations and lighting for municipal celebrations, to cities across the country.

Leigh's view of New York City, expressed in the original but usually unbuilt ideas that preoccupied him over his long career, was outsized and forward looking. With its roots in the electrical decorations of American downtowns, Leigh's late work was solidly in the Beaux-Arts tradition of electrified urban decoration and pageants, among them Stanford White's gala opening of Madison Square Garden, the electrical designs of the world's fairs, and Luna Park and Dreamland in Coney Island. Like these spectacles, Leigh's civic programs and skyscraper work made New York's dramatic geography and distinctive built environment central. Leigh had spent his career trying to thrill and divert people with improbable effects created with electric light and color, and now he finally realized something of his bigger vision of the city as a kind of giant fairground or an amazing panoramic sculpture.

Leigh was one of the most inventive designers of the electrical era. His many creations brilliantly reworked the visual traditions that defined the light spectacles of his time, extending from dime museums to carnivals to vaudeville theaters, nickelodeons, world's fairs, and movie palaces. Leigh's role in the visual history of the city is extremely important, not only because his work helped determine how Times Square, its most famous district, looked and was portrayed in the age of mass media. From the steaming A&P coffee cup of 1933 to the Camel and Bond signs, from the Empire State Building to the skyline of the 1980s and 1990s and the gigantic twinkling snowflake he raised over Fifth Avenue in 1984, Leigh's most memorable light designs, with unmatched staying power, have helped define how the city is remembered.

Although Leigh's views on the reborn Times Square are not recorded, he must have been pleased

with how it turned out. When he died in 1999, the square was again essentially the same fantastic advertising carnival it had been before its decline—a mediagenic, illuminated blur of people, cars, lights, and moving electric surfaces. Finishing his career as he began it, Leigh's lighting designs helped revive the sublime skyline as a thrilling symbol of New York and as an object of fascination and admiration all over the world.

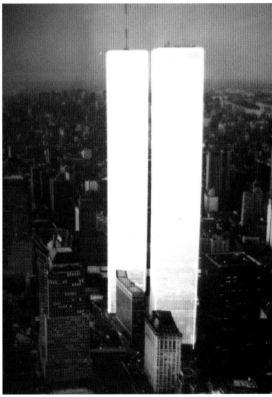

✦ ✦ ✦ *(Above)* Leigh was hired in 1985 to study lighting at the World Trade Center. Several concepts returned to his early ideas of clocks, weather devices, and rainbows. More memorable were Leigh's photocomposites envisioning the Twin Towers as two enormous shafts of light. None of the proposals was adopted.

(Following pages) Douglas Leigh, thriving in his new career as a designer of skyscraper lighting schemes, never offered any extended comment on the renewed Times Square, but he did give a hint here and there. In 1995, queried by a reporter about the rebounding signscape, Leigh called the JumboTron—the giant television screen that dominated the square and established a new fashion for video screens—"a great technology," but confessed that he found it a bit commonplace. He was not particularly nostalgic, however. Admitting that he missed the mechanical signs of old, his final judgment on their replacements was low-key: "That's the electronic age, pal," he told the *Times*.

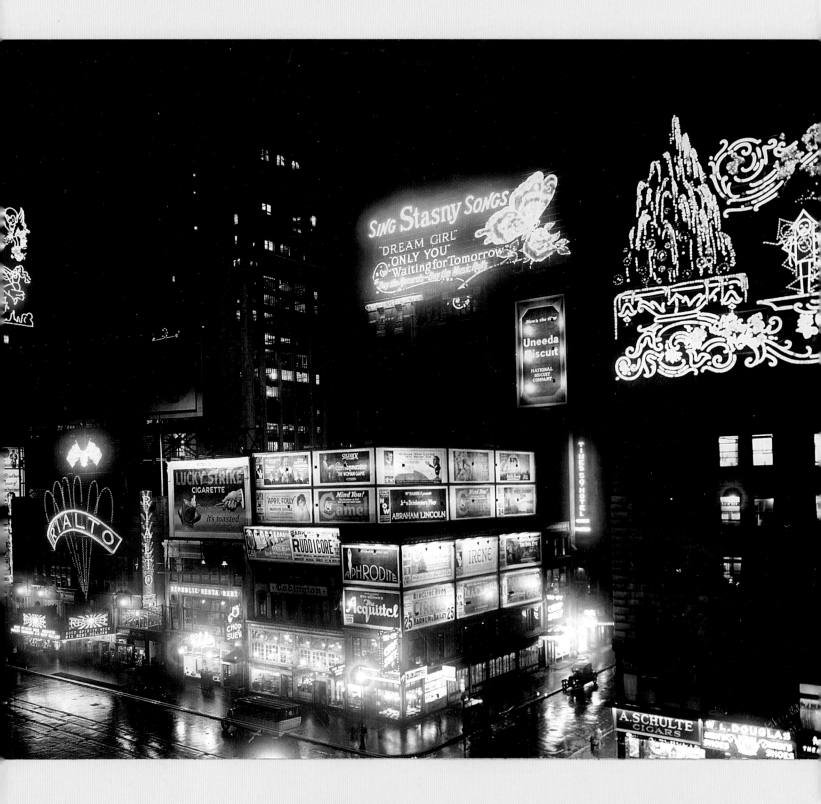

1860s Retail development moves north up Broadway and Sixth Avenue. The entertainment industry follows suit, and Union Square at Fourteenth Street and Broadway becomes the city's principal theater district.

1880 Electric streetlights are installed on Broadway between Fourteenth and Twenty-third Streets.

1882 The New York Casino, noted for its beautiful electric decorations, opens at Broadway and Thirty-ninth Street as a club and theater for a group of elite New Yorkers.

1883 The Metropolitan Opera debuts on the west side of Broadway directly opposite the Casino.

1888-93 The Broadway and Empire Theaters open on Broadway between Fortieth and Forty-first Streets, followed by cafés, retail shops, and restaurants. The American Theatre is built at a still-remote location at Forty-second Street and Eighth Avenue.

1893 The World's Columbian Exposition in Chicago spurs intense nationwide interest in electrification.

1895 The impresario Oscar Hammerstein launches his Olympia Theatre complex inside Long Acre Square north of Forty-second Street.

1899 Rector's Restaurant opens in Long Acre Square, beginning New York's lobster-palace craze.

1900 Oscar J. Gude's first giant electric sign, advertising Heinz pickles, is installed on the wall of a building at Broadway and Twenty-third Street, facing Madison Square. A Philadelphia newspaper calls Broadway the "Great White Way."

1904 Gude lights his first billboard spectacular in Long Acre Square,

Four-Decker lighted billboards and O. J. Gude spectaculars, 1923.

which is officially renamed in April when Mayor George McClellan dubs the area Times Square in honor of the *New York Times* building under construction at Broadway and Forty-second Street. The Hotel Astor opens in September, followed the next month by the IRT subway line's Times Square station. A high-powered electric beacon broadcasts election results from the top of the new Times Tower in November.

1905 Before beginning daily publication from its new building, the *Times* sponsors its first New Year's Eve celebration with a light show and fireworks. Times Square Station becomes the city's busiest subway stop.

1906 The Knickerbocker Hotel opens at Broadway and Forty-second Street. Led by Gude, advertisers start to erect electric spectaculars on Broadway rooftops from Thirty-fourth to Fifty-ninth Streets, creating a visual spectacle that becomes world famous.

1907 After safety concerns lead to a citywide ban on fireworks, the New Year's Eve ball drop is introduced at the Times Tower.

1909-10 Office buildings and other "high-class" real estate development, aggressively promoted by the *Times*, enter the square.

1913 The *Times* moves its headquarters from the Times Tower to Forty-third Street.

1914 The Strand Theatre becomes Times Square's first movie palace. Under the management of Samuel Rothapfel (the legendary "Roxy"), it establishes the new low-price, high-volume format that dominates film exhibition for nearly two decades. Mortimer Norden introduces a fashion for enormous electrical displays mounted over a theater's permanent marquee.

1916-21 Five new Times Square movie palaces draw a night-and-day crush of patrons and gawkers. Daily pedestrian traffic in the neighborhood is estimated to be in the hundreds of thousands. Technological improvements, reduced electricity costs, and publicity encourage local business owners and advertisers to install signs of unprecedented size and wattage.

1917-18 Late in World War I, Broadway's lights are dimmed several nights a week to save fuel.

1920	Prohibition (1920–33) radically changes Times Square's nightlife, closing cabarets that had served liquor. Illegal speakeasies, nightspots, and gambling houses thrive in the area.
1928	In November the *Times* debuts its Motograph news ticker on election night.
1929	The stock market crashes on October 24.
1930s	A new lighting medium, neon tubing, becomes popular and increasingly supplants the incandescent bulb in outdoor advertising, theater signs, and storefronts.
1931-37	Burlesque shows begin at the Republic Theatre; as Times Square's entertainment industry reels from the Depression, many legitimate theaters on Forty-second Street are forced to convert to a second-run movie, "grind," format. Critics deplore the district's growing carnival atmosphere, and the city bans burlesque in 1937. Broadcasters and publishers expand coverage of Broadway's electrified glitz.
1933	The advertising genius Douglas Leigh supervises construction of his first Times Square spectacular, featuring a steaming cup of A&P coffee.
1937	Leigh brings animated-cartoon advertisements to Times Square with his first Epok sign.
1939	The New York World's Fair in Flushing Meadows inspires Leigh to reimagine urban spectacular advertising in Times Square; he unveils his designs in the *Times* in 1944.
1942	In April, Times Square goes dark each night during a "dimout" to protect the city from enemy air raids. Leigh's legendary Camel smoke-ring sign becomes the era's most famous sign.
1942-45	Service personnel flood into Times Square during World War II, helping fill its restaurants and theaters. News bulletins of the D Day invasion and VJ Day are announced by the famous Motograph news zip.
1954	To eliminate "honky-tonk" businesses in Times Square, New York City outlaws new arcades and stores open to the sidewalk. The area's decline is speeded by postwar suburbanization and television's growing dominance of American entertainment.

1961	The Roxy, followed by the Paramount in 1967, becomes the first of Times Square's grand picture palaces to be demolished or gutted.
1962	The Broadway Association releases a plan to restore Forty-second Street as a two-level mall with exhibition halls; it fails to garner necessary private support, as does a similarly sweeping proposal two years later.
1963	The Times Tower is sold by Douglas Leigh to Allied Chemical for use as a flagship advertisement for the corporation.
1966-68	Pornographic film-loop machines take over the backroom areas of Times Square bookstores. Many movie houses and former theater stages introduce full-time erotic programming. Crime rates soar, and the Mafia enters the market.
1967	A Special Theater District allows Times Square developers to build more office space in return for including new theaters in their plans.
1976	Douglas Leigh is commissioned to light the exterior of the Empire State Building for the U.S. bicentennial. His designs are a rousing success, and he lights other city skyscrapers in coming years.
1976-80	Japanese corporations increasingly take over Times Square billboard and spectacular spaces abandoned by American advertisers, as middle-class customers avoid the now-dangerous neighborhood.
1980-86	Mayor Edward I. Koch rejects a private proposal for redevelopment of Times Square and initiates his own effort in conjunction with the state government. Preservationists and local constituencies oppose the Koch plan, which includes designs for postmodern towers presented in 1983 by Philip Johnson and John Burgee; the proposals are called a threat to the district's signature signs and streetscape.
1987	New Times Square zoning regulations win final approval, permanently mandating the incorporation of electric signs into local building-front designs.

1992 42nd Street Now!, conceived by Robert A. M. Stern and Tibor Kalman, is announced as an interim plan to reanimate the famous block between Seventh and Eighth Avenues, which had been darkened by city and state efforts to shutter the district's sex businesses and dilapidated theaters.

1994 The Walt Disney Company agrees to help revive Forty-second Street by renovating the New Amsterdam Theater.

1995-PRESENT Advertising spectaculars, business development, and tourism return to Times Square, whose lights are seen by millions of television viewers each night.

This book is based on contemporary items about Times Square's history and development published in the *New York Times*, including news coverage; articles on real estate, the theater, architecture, and advertising; obituaries; the society pages; and feature stories. The *Washington Post* also reported regularly on the Broadway scene in the early years of Times Square's history. Library and archival collections in the Library of Congress, the Smithsonian Institution's Archives Center at the National Museum of American History, and the New York Public Library provided illustrations and important information on Times Square history and the history of electric signs. The chapters on Douglas Leigh draw on news clippings and other materials in Leigh's papers, which are preserved in the Smithsonian Institution's Archives of American Art, the American Sign Museum in Cincinnati, and a private collection.

The following selected secondary references, organized by subject, also provided invaluable information and ideas:

GENERAL HISTORY OF NEW YORK CITY, LONG ACRE SQUARE, AND TIMES SQUARE:
Anthony Bianco, *Ghosts of 42nd Street: A History of America's Most Infamous Block* (New York: William Morrow, 2004); Edwin G. Burrows and Mike Wallace, *Gotham: A History of New York City to 1898* (New York: Oxford University Press, 1999); Marc Eliot, *Down 42nd Street: Sex, Money, Culture, and Politics at the Crossroads of the World* (New York: Warner Books, 2001); Kenneth R. Jackson, ed., *The Encyclopedia of New York City* (New Haven, Conn.: Yale University Press, 1995); William R. Taylor, ed., *Inventing Times Square: Commerce and Culture at the Crossroads of the World* (Baltimore: Johns Hopkins University Press, 1991).

ELECTRICITY AND ELECTRIC SIGNS:

Dietrich Neumann, *Architecture of the Night: The Illuminated Building* (Munich: Prestel, 2002); David Nye, *Electrifying America: Social Meanings of a New Technology, 1880–1940* (Cambridge, Mass.: MIT Press, 1990); *Signs of the Times* magazine, 1906 to the present; Tama Starr and Edward Hayman, *Signs and Wonders: The Spectacular Marketing of America* (New York: Currency Doubleday, 1998).

BROADWAY AND NEW YORK NIGHTLIFE:

Lewis A. Erenberg, *Steppin' Out: New York Nightlife and the Transformation of American Culture, 1890–1930* (Westport, Conn.: Greenwood Press, 1984); Mary C. Henderson, *The City and the Theatre* (Clifton, N.J.: James T. White, 1973); Stephen Burge Johnson, *The Roof Gardens of Broadway Theatres, 1883–1942* (Ann Arbor, Mich.: UMI Research Press, 1985); Margaret M. Knapp, "A Historical Study of the Legitimate Playhouses on West Forty-second Street Between Seventh and Eighth Avenues in New York City" (Ph.D. dissertation, City University of New York, 1982).

THE WALTER WINCHELL ERA:

Neal Gabler, *Winchell: Gossip, Power, and the Culture of Celebrity* (New York: Knopf, 1994).

THE SEX TRADE:

Timothy J. Gilfoyle, *City of Eros: New York City, Prostitution, and the Commercialization of Sex, 1790–1920* (New York: W. W. Norton, 1992).

MOVIES AND MOVIE PALACE ARCHITECTURE:

Eileen Bowser, *The Transformation of Cinema, 1907–1914* (Berkeley: University of California Press, 1994); Ben M. Hall, *The Golden Age of the Movie Palace: The Best Remaining Seats* (New York: Clarkson Potter, 1975); *Marquee: The Journal of the Theatre Historical Society*, 1969 to the present; Ross Melnick and Andreas Fuchs, *Cinema Treasures: A New Look at Classic Movie Theaters* (St. Paul, Minn.: MBI, 2004); Charles Musser, *Edison Motion Pictures, 1890–1900: An Annotated Filmography* (Gemona, Italy: Giornate del cinema muto; Washington, D.C.: Smithsonian Institution Press, 1997); David Robinson, *From Peep Show to Palace: The Birth of American Film* (New York: Columbia University Press, with the Library of Congress, Washington, D.C., 1996).

THEATER ARCHITECTURE:

A. Craig Morrison, *Theatres* (New York: W. W. Norton, 2006); Nicholas Van Hoogstraten, *Lost Broadway Theatres* (New York: Princeton Architectural Press, 1997).

ARCHITECTURE AND PRESERVATION IN NEW YORK CITY:

Robert A. M. Stern, Gregory Gilmartin, and John Montague Massengale, *New York 1900: Metropolitan Architecture and Urbanism, 1890–1915* (New York: Rizzoli, 1983); Robert A. M. Stern, Gregory Gilmartin, and Thomas Mellins, *New York 1930: Architecture and Urbanism Between the Two World Wars* (New York: Rizzoli, 1987); Robert A. M. Stern, Thomas Mellins, and David Fishman, *New York 1960: Architecture and Urbanism Between the Second World War and the Bicentennial* (New York: Monacelli Press, 1995); Norval White and Elliot Willensky, *The AIA Guide to New York City: The Classic Guide to New York's Architecture*, 4th ed. (New York: Three Rivers Press, 2000).

REDEVELOPMENT:

Gregory F. Gilmartin, *Shaping the City: New York and the Municipal Art Society* (New York: Clarkson Potter, 1995); Lynne B. Sagalyn, *Times Square Roulette: Remaking the City Icon* (Cambridge, Mass.: MIT Press, 2001).

ACKNOWLEDGMENTS

More thanks than words can adequately express go to Vicky Raab, Gwen Wells, Mary Panzer, David Ward, Martha Kaplan, Alison Lurie, Carole and Martin Woodle, Tod Swormstedt, Ilaria Borghese, Steven Winn, Elsie Leigh-Baker, Alfred A. Reiss, and John and Diane Murray.

I would also like to thank the following people for their help throughout this project. Diane Maddex provided editorial expertise and a keen eye. Others variously provided photographs, information, reference tips, moral support, and many, many invaluable ideas: Wendy Hurlock Baker, Elizabeth Botten, Lois and Michael Brooks, Carol Butler, Constance Carter, Maryann Chach, Cecelia Chin, Alice Clarke, Hans Crome, Bob Dickson, Peter Morris Dixon (Robert A. M. Stern Architects), Lee Ewing, Raymond Fielding, Jean Fitzgerald, Reagan Fletcher, Mia Glover, Nancy Groce, Neil Harris, Marv Hoffmeier, Chris Hunter, John Izenour (Venturi, Scott Brown and Associates, Inc.), Cathy Keen, Ted F. Leigh, Bob and Sandy London, Pat Lynagh, Bruce Martin, Rick Mastroianni, Linda McCurdy, Ross Melnick, Eleanor A. Mills, Dietrich Neumann, Janet Parks, Kay Peterson, Ned Rifkin, Lynne B. Sagalyn, Tama Starr, Robert A. M. Stern, Susan Strange, Lauren Paige Zabelsky, and Walter Zvonchenko. And, as always, love and thanks to David, Eva, Nick, Richard, and Ollie.

ENDPAPER AND FRONTISPIECE ART

Endpaper: Map of Long Acre Square from G. W. Bromley & Co., *Atlas of the Borough of Manhattan: Pocket and Desk Edition*, 1912 (private collection). Page i: Douglas Leigh, Kool Cigarette sign, Broadway at Forty-third Street, 1934 (Douglas Leigh Papers, Archives of American Art, Smithsonian Institution). Page iii: (Detail) Irving Browning, montage, 1931–1932 (Collection of the New-York Historical Society). Page vi: Times Square looking north: 1920s–1930s (private collection).

INTRODUCTION

Page x: Map of Long Acre Square from G. W. Bromley & Co., *Atlas of the Borough of Manhattan: Pocket and Desk Edition*, 1912 (private collection). Pages xii-xiii: The north end of Times Square, ca. 1905 (Brown Brothers, Sterling, PA).

CHAPTER 1

Page xiv: J. Hoyt Toler, "Up Broadway," 1900, sheet music, published in New York City (Duke University Rare Book, Manuscript, and Special Collections Library). Page 2: Upper Long Acre Square, ca. 1890s (private collection). Page 3: Long Acre Square looking south from Forty-fifth Street, ca. 1898–1899 (Brown Brothers, Sterling, PA). Page 4: (Left) Forty-Second Street at the southern boundary of Long Acre Square, ca. 1893 (Brown Brothers, Sterling, PA); (right) the east side of Long Acre Square looking south from Forty-seventh Street (Brown Brothers, Sterling, PA). Page 5: (Right, top) The New York Casino, Kimball & Wisedell, architects, 1882 (Brown Brothers, Sterling, PA); (right, bottom) program for the Roof Garden at the New York Casino (private collection), 1891. Page 7: The Olympia Theatre complex, John B. McElfatrick, architect, 1895 (Brown Brothers, Sterling, PA). Pages 8–9: The subway tunnels under construction in Long Acre Square (Brown Brothers, Sterling, PA). Page 10: The Upper West Thirties, turn of the century (Schenectady Museum & Suits-Bueche Planetarium). Page 11: Times Square as the new center of New York (graphic, private collection.). Page 12: (Left, top) the "head" of Times Square, ca. 1908 (private collection); (left, bottom) Times Square looking south, before 1910 (private collection) and (right) the Times Tower before 1910 (private collection). Page 13 (Top) Lillian Russell (Warshaw Collection of Business Americana, Archives Center, National Museum of American History, Smithsonian Institution); (below) Anna Held (Warshaw Collection of Business Americana, Archives Center, National Museum of American History, Smithsonian Institution). Page 14: Cover for *Everybody's Magazine*, May 1910 (private collection). Page 15: The original Rector's Restaurant, Broadway between Forty-third and Forty-fourth Streets, 1908–1909 (Brown Brothers, Sterling, PA). Page 16: "Oh! You Girl from Rector's," 1909 (postcard, private collection). Page 18: (Left) The Hotel Astor, Broadway between West Forty-fourth and Forty-fifth Streets, Clinton & Russell, architects, 1900–1909 (private collection); (above) menu for the Belvedere Roof Garden at the Hotel Astor (private collection). Page 19: The Grand Ballroom at the Hotel Astor, Unitt & Wickes, decorators, 1909 (private collection). Page 20: The Knickerbocker Hotel, Trowbridge & Livingston, architects, 1906 (Detroit Publishing Company postcards. Photography Collection, Miriam and Ira D. Wallach Division of Art, Prints and Photographs, The New York Public Library, Astor, Lenox and Tilden Foundations). Page 21: The Times Tower on Election Night with beacon, ca. 1904 (hand-colored lantern slide, print by Lee Ewing; copyright, Brown Brothers, Sterling, PA). Page 23: The Times Tower and Hotel Astor decorated for the Paris-New York auto race, 1908 (Brown Brothers, Sterling, PA).

CHAPTER 2

Page 24: Scott Joplin, "Searchlight Rag," 1900, sheet music published in New York City (Duke University Rare Book, Manuscript, and Special Collections Library). Page 26: Lower Broadway, ca. turn of the century (Brown Brothers, Sterling, PA). Page 27: Sun towers in Madison Square, December 1881 (Warshaw Collection of Business Americana, Archives Center, National Museum of American History, Smithsonian Institution). Page 28: The west side of Times Square looking toward Forty-sixth Street (Brown Brothers, Sterling, PA). Page 29: Electric sign at the Casino, 1908 (scan courtesy of Lee Ewing; *Signs of the Times; the National Journal of Advertising Displays*, February 1908). Page 31: "It Made One Long to Go": Ocean Breezes sign, 1892, Broadway's first spectacular (Brown Brothers, Sterling, PA). Page 32: New Court of Honor and Grand Basin, World's Columbian Exposition, Chicago, 1893 (Kenneth M. Swezey Papers, Archives Center, National Museum of American History, Smithsonian Institution). Page 33: Three views of the Louisiana Purchase International Exposition at night, Saint Louis, Missouri, 1904 (Larry Zim World's Fair Collection, Archives Center, National Museum of American History, Smithsonian Institution). Page 34: (Above) The Hotel Astor decorated for the Hudson-Fulton celebration, 1909 (Larry Zim World's Fair Collection, Archives Center, National Museum of American History, Smithsonian Institution); (right) architecture of light: Times Square on a holiday ca. 1907 (scan courtesy of Lee Ewing; copyright, Brown Brothers, Sterling, PA). Page 35: William J. Hammer, "Edison," the first spectacular sign, 1882 (Schenectady Museum & Suits-Bueche Planetarium). Page 36: (Left) the Putnam Building, Broadway and Forty-third Street, 1908 (Brown Brothers, Sterling, PA); (right) high-class Times Square finished, 1911 (Brown Brothers, Sterling, PA). Page 37: Blue chip construction in Times Square, 1909 (Brown Brothers, Sterling, PA). Page 38: The Regal Shoes spectacular at the corner of 42nd and Seventh Avenue, before 1910 (Brown Brothers, Sterling, PA). Page 39: The Trimble Whiskey spectacular, 1904-1905 (Brown Brothers, Sterling, PA). Page 42: Coney Island at night (colored postcard, private collection). Page 43: The Heinz pickle sign, late 1890s (Library and Archives Division, Historical Society of Western Pennsylvania, Pittsburgh, PA). Page 45: The Bright Light District: the west side of Times Square looking north, ca. 1914 (Schenectady Museum & Suits-Bueche Planetarium). Page 46: The Canadian Club Ginger Ale sign, 1909 (Brown Brothers, Sterling, PA). Page 47: Print advertisement for Phoenix Silk Hose, 1910 (Picture Collection, Branch Libraries, The New York Public Library, Astor, Lenox and Tilden Foundations). Pages 48-49: (Page 48, left) the C/B Corset sign at night, 1910 (*Signs of the Times; the National Journal of Advertising Displays*, August 1910); (page 48, above) the Second Heatherbloom sign, 1909–1912 (Brown Brothers, Sterling, PA); (across pages 48–49 and page 49, below) the Egyptienne Straights spectacular, 1912 (*Signs of the Times; the National Journal of Advertising Displays*, October 1912). Page 50: Spectaculars and semispectaculars in upper Times Square, seen from Forty-sixth Street, 1920s (Brown Brothers, Sterling, PA). Page 51: O. J. Gude's Great White Way, 1914 (Brown Brothers, Sterling, PA). Page 52: O. J. Gude, 1920s (*Signs of the Times; the National Journal of Advertising Displays*, September 1925). Page 53: Print advertisements for spectacular signs, 1913 (both, *Signs of the Times; the National Journal of Advertising Displays*, July 1913). Page 54: The Heidelberg Electric Building, ca. 1910 (Brown Brothers, Sterling, PA). Pages 56–57: Night view with second Corticelli Silk sign, Broadway at Forty-second Street, ca. June 1913 (Schenectady Museum & Suits-Bueche Planetarium). Page 59: The White Rock spectacular, ca. 1910 (Brown Brothers, Sterling, PA).

CHAPTER 3

Page 60: Harry von Tilzer, "I'm a Little Bit Afraid of You, Broadway," 1913, sheet music from *The Passing Show of 1913* (private collection). Page 62: Song hits of the Ziegfeld Follies: "Borrow From Me," 1912 (Music Division, The New York Public Library for the Performing Arts, Astor, Lenox and Tilden Foundations). Page 64: Churchill's Cabaret, ca. 1911–1913 (private collection). Page 65: Cabaret performers at Murray's Roman Gardens, 1911–1914 (Brown Brothers, Sterling, PA). Page 67: "The Castle Walk," 1915 (Music Division, The New York Public Library for the Performing Arts, Astor, Lenox and Tilden Foundations). Page 68: (Left) Strand Theatre, Thomas Lamb, architect, 1914 (Underwood & Underwood, Billy Rose Theatre Division, The New York Public Library for the Performing Arts, Astor, Lenox and Tilden Foundations); (right) the Rivoli Theatre, ca. 1917 (B'hend and Kaufmann Collection, courtesy of the Academy of Motion Picture Arts and Sciences). Page 69: Program for the Roxy Theatre, 1928 (private collection). Page 70: Movie premiere, Strand Theatre, Broadway at Forty-Seventh Street, 1920 (Brown Brothers, Sterling, PA). Page 72: The Rialto Theatre, after 1916 (Brown Brothers, Sterling, PA). Page 73: (Left, top) nightscape, 1919 (private collection); (right, top) Times Square at Forty-third Street, ca. 1920 (Warshaw Collection of Business Americana, Archives Center, National Museum of American History, Smithsonian Institution); (right, bottom) *The Golddiggers of Broadway* at the Winter Garden Theatre, 1929 (Courtesy Shubert Archive); (left, bottom) the Paramount marquee and GOA Cadillac sign (Brown Brothers, Sterling, PA). Page 74: The Hollywood Revue sign, 1929 (Ben Hall Collection, Theatre Historical Society of

America, Elmhurst, Illinois; www.historictheatres.org). Page 75: O. J. Gude Company, Wrigley's Spearmen spectacular, and Mortimer Norden, the *Ten Commandments* sign, 1924 (Brown Brothers, Sterling, PA). Pages 76–77: Irving Browning, photograph of O. J. Gude's Clicquot Club Ginger Ale sign, 1924 (Collection of the New-York Historical Society). Page 78: Times Square looking north from Forty-fifth Street: *The Student Prince*, 1927 (Schenectady Museum & Suits-Bueche Planetarium).

CHAPTER 4

Page 80: Harry Ruby, "What'll We Do on a Saturday Night (When the Town Goes Dry)," 1919, sheet music, published in New York City (Duke University Rare Book, Manuscript, and Special Collections Library). Page 82: (Left) daytime view of the Paramount Building, 1926 (B'hend and Kaufmann Collection, courtesy of the Academy of Motion Picture Arts and Sciences); (right) the Paramount Building at night (private collection). Page 83: Paramount Theatre program, 1928 (private collection). Page 84: Thomas Lamb, project for a New Palace Theatre, 1920s (Drawings and Archives Department, Avery Architectural and Fine Arts Library, Columbia University). Page 85: The Hollywood Cabaret sign, Forty-ninth Street and Broadway, October 1933 (*Signs of the Times; the National Journal of Advertising Displays*, October 1933). Page 86: Paradise Cabaret Restaurant, 1930s (photo mount cover, private collection). Page 87: The Republic Theatre became Minsky's Burlesque in 1932–1942 (both, B'hend and Kaufmann Collection, courtesy of the Academy of Motion Picture Arts and Sciences). Page 88: Cover for *New York Behind the Scenes, Uncensored!*, 1939 (private collection); "Betty of West Forty-second Street and Broadway," 1940s (private collection). Page 89: Cover of *Broadway Nights* magazine, 1930 (private collection). Page 90: *Palmy Days* front, the Rialto Theatre, Forty-second and Broadway, 1931 (Marc Wanamaker/Bison Archives, Los Angeles; (print) B'hend and Kaufmann Collection, courtesy of the Academy of Motion Picture Arts and Sciences). Page 91: Lunch Wagon in Times Square across from the Palace Theatre, Seventh Avenue above Forty-sixth Street, 1931 (Brown Brothers, Sterling, PA). Page 93: *The Great White Way, It's the Life!*, movie program cover, 1925 (private collection). Page 94: Irving Browning, commercial montage, 1931–1932 (Collection of the New-York Historical Society). Page 95: (Detail) Irving Browning, montage, 1931–1932 (Collection of the New-York Historical Society). page 97: Douglas Leigh, the second Bond Store, 1941 (Douglas Leigh Papers, Archives of American Art, Smithsonian Institution). Page 98: The Schenley Tower Building, Broadway and Forty-second Street, Rosario Candela, architect, 1936 (Schenectady Museum & Suits-Bueche Planetarium). Page 99: The Chevrolet and Squibb spectaculars, 1933 (Schenectady Museum & Suits-Bueche Planetarium). Page 101: The Pepsodent spectacular, 1932 (Brown Brothers, Sterling, PA).

CHAPTER 5

Page 102: Hugh Ferriss, Times Square, 1944 (private collection). Page 104: (Left) Douglas Leigh, semispectacular for A & P at the southeast corner of Forty-seventh Street and Seventh Avenue, 1933 (Douglas Leigh Papers, Archives of American Art, Smithsonian Institution); (right) Douglas Leigh, Kool Cigarette sign, Broadway at Forty-third Street, 1934 (Douglas Leigh Papers, Archives of American Art, Smithsonian Institution). Page 106: Douglas Leigh, Ballantine spectacular, Broadway at Forty-eighth Street, 1936 (Douglas Leigh Papers, Archives of American Art, Smithsonian Institution). Page 107: Ballantine animation sequence, point-of-purchase display, 1936 (private collection). Page 108: *Above the Crowd*, ca. 1935 (cartoon, Douglas Leigh Papers, Archives of American Art, Smithsonian Institution). Page 109: (Left and right) Douglas Leigh, Epok animation sign for Old Gold Cigarettes, Broadway between Forty-third and Forty-fourth Street, 1938 (Douglas Leigh Papers, Archives of American Art, Smithsonian Institution). Pages 110–11: (Page 110, top) Douglas Leigh and Mickey Rooney, mid-1930s (private collection); (across pages 110–11, left to right) four drawings for Epok animations and (page 111, below) one frame of a projected Epok cartoon, 1930s (private collection). Page 112: (Left) the Gillette, Silex, and Bond signs (all by Douglas Leigh except the Bond store display), Seventh Avenue between Forty-sixth and Forty-seventh Street, ca. 1940 (private collection); (right) the Wondersign animation at the Palace Theatre on Seventh Avenue near Forty-seventh Street, 1946 (B'hend and Kaufmann Collection, courtesy of the Academy of Motion Picture Arts and Sciences). Page 113: (Above) Douglas Leigh, the Four Roses spectacular, Forty-eighth Street between Broadway and Seventh Avenue, 1938 (Douglas Leigh Papers, Archives of American Art, Smithsonian Institution); (below) workmen on the Four Roses sign (Douglas Leigh Papers, Archives of American Art, Smithsonian Institution). Page 114: (Left) study for the Wilson whiskey spectacular, 1939 (private collection); (right) the Wilson spectacular at night (Douglas Leigh Papers, Archives of American Art, Smithsonian Institution). Page 116: (Above) Dorothy Shepard's Wrigley aquarium spectacular, Broadway above Forty-fourth Street, 1936 (private collection); (below) two fishes from the Wrigley spectacular (public domain, image courtesy of the American Sign

Museum, Cincinnati). Page 117: The Trylon and Perisphere at night, New York World's Fair, Flushing, 1939–1940 (Larry Zim World's Fair Collection, Archives Center, National Museum of American History, Smithsonian Institution). Page 118: The Camel sign, east side of Broadway at Forty-fourth Street, ca. 1942 (private collection). Page 119: Douglas Leigh demonstrating a small version of the mechanism that produced the smoke rings for the Camel sign, 1942 (private collection). Page 120: Time Square before (left) and after (right) the Dimout, 1942 (Douglas Leigh Papers, Archives of American Art, Smithsonian Institution). Pages 124-25: Two views of Times Square on VJ Day, August 14, 1945 (Brown Brothers, Sterling, PA). Page 126: Douglas Leigh, the Supersuds spectacular (Douglas Leigh Papers, Archives of American Art, Smithsonian Institution). Page 127: Two renderings of Douglas Leigh's skyscraper-spectaculars, 1944 (private collection). Page 128: The Bond sign at night, 1948 (Courtesy National Archives Still Photo Unit). Page 129: The Little Lulu and Budweiser spectaculars, Broadway at Forty-third Street, ca. 1947–1955 (Courtesy National Archives Still Photo Unit). Page 130: (Above) Douglas Leigh's Braniff Sign under construction at the head of the square, 1964 (photomontage, Douglas Leigh Papers, Archives of American Art, Smithsonian Institution); (below) Douglas Leigh's Epok spectacular for the Philco Company, Seventh Avenue at Forty-sixth Street, 1950s (Douglas Leigh Papers, Archives of American Art, Smithsonian Institution).

CHAPTER 6

Page 132: *Terror in Times Square*, Pyramid Books cover, 1950 (private collection). Page 135: (Top) Design for a sign space that spanned the facades of the Astor and Victoria Theatres, Broadway between Forty-fifth and Forty-sixth Street, 1954 (Douglas Leigh Papers, Archives of American Art, Smithsonian Institution); (below) the Astor-Victoria billboard, Broadway between Forty-fifth and Forty-sixth Street, 1966 (Douglas Leigh Papers, Archives of American Art, Smithsonian Institution). Pages 136–37: First-run movies in Times Square, Broadway Seventh Avenue looking north from the middle of the square above Forty-fifth Street, 1973 (Douglas Leigh Papers, Archives of American Art, Smithsonian Institution). Page 138: Broadway Association plan, November 1962 (Douglas Leigh Papers, Archives of American Art, Smithsonian Institution). Page 139: Rendering of the Broadway Association's Exhibit City design (photomontage, private collection). Page 140: (Left) Hugh Ferriss, design for Douglas Leigh's recently purchased Times Building, 1961 (Drawings and Archives Department, Avery Architectural and Fine Arts Library, Columbia University); (right) photomontage of a new design for the Times Building, Forty-second Street between Broadway and Seventh Avenue, 1962 (private collection). Page 141: The Times Tower, before and after, 1963 (models, photograph in the Douglas Leigh Papers, Archives of American Art, Smithsonian Institution). Page 142: (Left) Times Square with redone Times Tower, ca. 1963 (Douglas Leigh Papers, Archives of American Art, Smithsonian Institution); (right) the new Times Tower at night, ca. 1963 (private collection). Page 143: Project for the Crossroads Building, Forty-second Street between Broadway and Seventh Avenue, 1964 (Douglas Leigh Papers, Archives of American Art, Smithsonian Institution). Page 145: Gloria Swanson lamenting the demolition of the Roxy Theatre, 1960 (Eliot Elisofon, photographer, Time & Life Pictures/Getty Images). Page 147: The south end of Times Square, ca. 1979 (private collection). Pages 148–49: Neon spectaculars commissioned by Japanese companies, 1980s (private collection). Page 152: Philip Johnson and John Burgee with a model of their design for Forty-second Street at the corners of Broadway and Seventh Avenue, 1983 (photograph by Ted Thai, Time & Life/Getty Images). Pages 154–55: Venturi, Rauch, Scott Brown, Inc., *A Big Apple for Times Square*, Broadway and Seventh Avenue between Forty-second and Forty-third Street, 1984 (Architectural Archives, University of Pennsylvania, by gift of Robert Venturi and Denise Scott Brown). Page 158: 42nd Street Now!, rendering, Chris Scarpati for Robert A. M. Stern Architects, 1992 (image courtesy of Robert A. M. Stern Architects). Page 161: Spectacular signs, Times Square, 2005 (photographs by D. Tell). Pages 162–63: Views around Times Square, 2005 (photographs by D. Tell).

AFTERWORD

Page 164: *Tribute in Light:* The World Trade Center Memorial in New York City, 2002, with the lighted Empire State Building in the foreground (Reuters/Peter Morgan, photographer, © Reuters/Corbis). Page 166: (Left to right) Douglas Leigh, three lighting installations for New York skyscraper crowns, late 1970s (private collection). Page 167: Douglas Leigh, Snowflake, Fifth Avenue at Fifty-seventh Street, December 1984 (private collection). Page 169: Douglas Leigh Organization, three lighting designs for the World Trade Center, 1985–86 (photo renderings; Douglas Leigh Papers, American Sign Museum, Cincinnati). Pages 170–71: Times Square looking south from Seventh Avenue, 2005 (photograph, D. Tell). Page 172: Lighted Billboards and O. J. Gude Spectaculars, 1923 (Brown Brothers, Sterling, PA).

Page numbers in *italics* indicate illustrations.

A

A&P coffee spectacular, 103, 104, *104*, 113, 168, 175
Abbey's (theater), 4
"Above the Crowd" (cartoon), *108*
Academy of Music, 4
actualities, 46
Admiral sign, *130*, 131
Ahlschlager, W. W., *69*, *83*
Allen, Fred, 105
Allied Chemical, 141–42, *141*, *142*, 165, 176
AMC Entertainment, 145, 159–60
American Civil Liberties Union, 156
American Institute of Architects, 153
American Theatre, 6, 173
amusement parks, 20, 31, 42, 168
Anheuser-Busch, 101
animations, 35, *38*, 40, 41, 44–51, *45*, 46, 72, 79, 97–101, 105–6, *106*, *107*, 109, *109*, 112–15, *112*, 119, 130–31, 175
architectural lighting, 33, *33*, 40, *166*, 168
arc lights, 25, *27*
Aronson, Rudolph, 4–5, *5*
Artkraft-Strauss Company, 101, 106, 109, *112*, 119, *119*, 120–21, *125*, 130–31, *130*, 161
Associated Architects, 98
Astaire, Fred and Adele, 115
Astor, John Jacob, IV, 17, 18, 19
Astor, William B., 3
Astor, William Waldorf, 17
Astor Hotel. *See* Hotel Astor
Astoria (hotel), 17
Astor Theatre, 74, *78*, *99*, 100, 109, 115, 121, *135*, *136–37*, 144, 145, 146
Automat, the, 61, 81

B

Balaban and Katz, *83*
Ballantine beer sign, 105–6, *106*, *107*, 119
Battery Park City, 151
Beame, Abraham, 150
Beaux-Arts lighting, 33, 34, 58, 168
Belasco, David, 13, *87*
Berger, Meyer, 99, 122–23, 127, 160
Bertelsmann, 159
Betts and Betts, *54*
Betty of Forty-Second and Broadway (hand card), *88*
Big River (musical), 157
billboards, *4*, 29, 52, 75, 79, 98, 121, 146, *172*
computer-printed, 160
opposition to, 55, 58
black lights, 127
Board of Estimate, 157
Bond Clothes sign, *97*, *112*, 128, *128*, 130, 144, 146, 147, 168
bookstores, 133, 134, 176
bootleggers, 81
"Borrow from Me" (sheet music), *62*
Brady, Diamond Jim, 17
Braniff Airlines sign, *130*
Brewster Company, *2*
Brill Building, 131
Broadway (street), ix, x, *xi*, *4*, *8–9*, *10*, 96
as code word, 88
electric lights of, x, *10*, 25–31, *26*, *27*, 34, *34*, 36–41, 173
history of, 1–6, 10
See also theater district
Broadway Association, 122, 133, 134, *139*, 140–41, 143, 150, 176
Broadway by Light (documentary), 150
Broadway Nights (magazine), *89*
Broadway revues, 61–63, 87, 88

Broadway Theatre, 4, 173
Bromo-Seltzer sign, 113
Brooklyn Navy Yard, 121
brothels, 10, 134, 138
Browning, Irving, *94*, *95*
brownstones, 3, 87
Brush Electric Company, 25, 31
Bryant Park, 123
Budweiser beer sign, *129*, 130–31
Buffalo World's Fair (1901), 33, 42
Bull Durham sign, 40
Burgee, John, *152*, *153*, 156, *157*, 176
Burnham, Daniel H., *37*, 51, 143
burlesque, xi, 13, *87*, 90, 175
Bustanoby brothers, 64
Bustanoby's (restaurant), 81

C

cabaret, 63–66, *67*, 81, 87, 175
cab joints, 87
Cadillac Hotel, *129*
Cadillac-LaSalle sign, *73*, 101
Café Society, 85–87
Camel smoke-ring sign, *118*, 119, *119*, 120, 131, 168, 175
Canadian Club spectacular, 46, *130*, 131
Candela, Rosario, *98*
Candler Building, 143
Cantor, Eddie, *90*, 115
Capitol Theatre, 68, 70, 71, 144, 145
Carlu, Jean, 109
cartoons, 106, 109–12, *112*, 114, 175
Casa Mañana (nightclub), 87
Casino de Paree (nightclub), 87
Casino Theatre. *See* New York Casino
Castle, Vernon and Irene, 65, 67
"Castle Walk, The" (sheet music), *67*
C/B Corsets sign, *48*

Central Park, 3, 40, 122
Century of Progress exposition (Chicago, 1933–34), 98
Charm (magazine), 127
Cheney Johnston, Alfred, 88
Chevrolet signs, *99*, 119, *120*
Childs (restaurant), 61, 81
chorus shows, 63
Christy, Howard Chandler, 119
Chrysler Building, 117
Churchill, James, 64, *64*
Churchill's (restaurant), *28, 64*, 81
Citicorp Center, *166*, 168
City at 42nd Street plan, 150–51, 153
City Beautiful movement, 51
City Hall Park, *1*, 12, 22, 23
City of Contrasts (documentary), 95
City Planning Commission, 151, 157
"city symphony" films, 95
Claridge Hotel, 112, 119, 143, 144
Claude, Georges, 97
Clinton and Russell, 17
Clicquot Club Ginger Ale sign, *76–77*, 79
Cobb, Henry Ives, 55
Cohan Theatre, *37*, 75
Columbus Circle, 6, 105
Complexity and Contradiction in Architecture (Venturi), 142–43
concert gardens, *5*, *5*
concert saloons, 10
Coney Island, 30, 42, *42*, 92, 168
Cooper Eckstut Associates, 151, 153
Corticelli kitten sign, *54, 56–57*
Cotton Club (Broadway nightclub), 87
Crawford, Joan, 115
crime, 81, 133–34, 138, 146, 176
Criterion (movie theater), 74, 100
Crossroads Building, *143*
Crossroads Café, *143*
Crown Building, *166*
Crystal Palace Electrical Exposition (London, 1882), 35
Cumberland Hotel, 30, *31*, 41, *43*
Cusack, Thomas, 101
cutouts, 91

D

dance halls, 10
dancing, 64, 65, 67
Davis, Richard Harding, 96
daytime development, 37, 79

D Day, 123, 175
Death and Life of Great American Cities, The (Jacobs), 142
Delmonico's (restaurant), 15
Depression (1930s), xi, 85, *87*, 90, *91*, 92, 96, 98, 104, 123, 175
Dewey, Admiral George, 22
dioramas, 121
dramatizations, 103, 120
Dreamland amusement park, 20, 42, 168
Dreiser, Theodore, 30
Duffy, Father, 122
Dundee, Elmer, 42

E

"Edison" (spectacular), *35*
Edison, Thomas A., 25, 31, 35
Edison Electric Company, *31*
Egyptienne Straights (cigarette sign), *49, 50*
Eidlitz, Cyrus L. W., 11
electric companies, 31
electric lights, 5, *10*, 25–59, *95*, 97, 173
 color photographs of, 96
 decorative styles of, 33–34, 58, 98, 168
 dimouts and, 22, 120–21, 174, 175
 evocative appeal of, ix
 exterior use of, 165–69
 first showcase for, 32, *32*
 New York Casino and, 5
 as visual medium, 25, *26*, 42
 See also neon tubing
electric signs, 30–59
 as defining Times Square, ix–x, xi
 first in Times Square, *6, 7*
 first on Broadway, 30, *31*, 41, 173
 Japanese companies and, 148, *148, 149*, 160
 LED displays and, 161, *161*
 makers of, 101, 161
 neon and (*see* neon tubing)
 opposition to, 51, 55, 58–59
 Times Square decline and, 146–47
 Times Square redevelopment and, 153, 157, 159, 160–61, *161, 162–63*, 176
 World War II effects on, 120–21, *120*
 See also animations; semispectaculars; special effects; spectaculars
El Morocco (nightclub), 87
El Patio (nightclub), 87
Empire State Building, 117, *164*, 166, 168, 176
Empire Theatre, 4, 173
Epok. *See* Leigh-Epok technology

Evans, Walker, *95*
Exhibit City, 140, 150

F

Famous Players-Lasky, *68*
Fanchon and Marco, 105
Ferriss, Hugh, *102*, 128, *140*, 141
Fifth Avenue, 4, 11, 17, 30, 36, 40, 58, *166, 167*, 168
Fifth Avenue Association, 58
Fitzgerald Building, *37*
flagship system, 71
flashers, 30, 35, *45*, 46
Flatiron Building, 11
flex-front signs, 160
floor shows, 87
fluorescent lights, 121
fluorescent paints, 120, 127
Ford, John, 121
Ford Foundation, 150
Fortune (magazine), 105
42nd Street Now!, 159, 177
Forty-fourth Street Theatre, 122
Forty-second Street Development Project, 151–59
Fouilhoux, J. André, 117
Four Roses whiskey spectacular, 113, *113*, 114, 119, *120*
Franco-American sign, 40
Franklin Savings Bank, 146
French, Daniel Chester, *32*

G

Gaiety Building and Theater, *28, 78*, 100, *135*, 144
gambling, 81, 123, 175
gangsters, 81
Garbo, Greta, 99
gay men, 123
General Electric, 31, 107
General Outdoor Advertising Company, *73*, 74, *99*, 101, 103, 105, 115, *116*, 119, 121, 161
Gilbert, Cass, *166*, 168
Gillette signs, *112*, 113, 119
Ginza district (Tokyo), 148
girl shows, 63
Giuliani, Rudolph, 145
GOA. *See* General Outdoor Advertising Company
Goldberger, Paul, *167*
Gold Diggers of Broadway, The (movie), *73*
Golden Horseshoe (nightclub), 87
Gordon's Gin sign, 147
Grand Central Terminal, 121, 126
Granlund, Nils T., 87

Great White Way, 3, 44, 97, 99, 173
Great White Way, The (movie), *93*
Greeley Square, 1
"grind" theaters, 90, 133, 134, 175
Gude, Oscar, *39*, 41, 43–58, *52*, *56–57*, 61, 71, 75–79, *75*, *76–77*, 97, 99, 101, 103, *104*, 105, 108, 120, 131, 161, *172*, 173–74
 animations and, *38*, 40, 44–51, 79
 background and career of, 52
 first spectacular of, 30, *31*, 41, 173
 sign network of, 44
guides, after-dark, 88, *88*, *89*
Guys and Dolls (musical), 96

H

Hammer, William J., 35
Hammerstein, Oscar, *3*, 6, *7*, *8*, 13, 17, 22, 52, 74, 101, *116*, 173
Hammerstein, Willie, 52
hand cards, *88*, 91
Harrison, Wallace K., 117
Haussmann, Baron, 55
Hearst Building, 105
Heatherbloom, *48*, 50
Heidelberg Electric Building, *54*, 55, *56–57*, 58, 143, *143*
Heinz sign, 40, 41, *43*
Held, Anna, *13*, 50
Helmsley, Harry, 146, 165–66
Henry, O., 92
Herald Square, 1, 23
Herts and Tallant, *28*, 144, 151
High, Wide, and Handsome (movie), 106
high-class development, 6, 36–37, 55, 61, 66, 81, 174
Hodas, Marty, 134
Hollywood (nightclub), *85*, *86*, 87
Hollywood Revue sign, 74, *74*, 115
Hollywood Theatre, 145
Homer, Winslow, 127
Hong Kong, 148
Horse Exchange, *2*
Hotel Astor, *12*, 17–18, *18*, *19*, 34, 36, *73*, 82, 84, *135*, *141*, 143–44, 174
Hotelings newsstand, 122–23, *142*
Hotel Rector, *36*
hotels, 17–20, 37, 55, 84, 160. *See also specific hotels*
How Green Was My Valley (movie), 121
Hubert's dime museum, 84, 92
Hudson, Henry, 165
Hudson-Fulton celebration (1909), *34*
Hudson River, 2, 3, 126

Hugh Stubbins and Associates, *166*, 168
Huxtable, Ada Louise, 142

I

Ihnen, George, 79
illuminated show windows, 40
"I'm a Little Bit Afraid of You, Broadway" (sheet music), *60*
I. Miller Building, *110*, 161
incandescent lights, 25, *32*, 97, 101, *113*, 121, 175
international expositions. *See* world's fairs
Izenour, Steven, 156

J

Jack Dempsey's restaurant, 81
Jacobs, Jane, 142, 156
Japanese companies, 148, *148*, *149*, 160, 176
Johnson, Philip, *152*, 153, 156, 157, 176
Jolson, Al, 115

K

Kalman, Tibor, *158*, 159, 177
Katz, Sam, *83*
Keith vaudeville circuit, 69
Kellogg's spectacular, 46, *50*
Kerwer, Fred, 106, 107, 119, *119*
Kilgallen, Dorothy, 96
Kimball and Wisedell, *4*
kinetic light paintings, 131
Kirchoff and Rose, 103, *112*
Kleenex spectacular, *129*, 131
Klein, George, 153
Klein, William, 150
Knickerbocker, Cholly, 87
Knickerbocker Grill, 85
Knickerbocker Hotel, 18–20, *20*, 34, *37*, 84, 146, 174
Koch, Edward, 151, 153, 156–57, 176
Koolhas, Rem, 156
Kool cigarettes semispectacular, *104*
Kusumoto, Sam, 148

L

Labatut, Jean, 117
Ladies Mile, 1
Lady Olga (professional freak), 92
Lahr, Bert, 115
Lamb, Thomas W., 66, 68, *68*, 69, *84*, 120, 144, 145
Landmarks Preservation Commission, 156–57
Lang, Fritz, 95
Latin Quarter (nightclub), 133
LED displays, 161, *161*

Leigh, Douglas, 103–21, *108*, *110*, 119, 123, 126–31, *135*, 147, 161, 175, 176
 background and work method of, 108
 exterior lighting schemes and, 165–69
 Times Square redevelopment and, 139–43, *140*, *141*, *142*, *143*
 Times Square's image and, xi
Leigh-Epok technology, 106, *109*, *110*, *111*, 112–15, 175
Life (magazine), 127, *142*, 165
light-emitting paints, 120
light extravaganzas, 22, 32, 33, *59*
lights. *See* electric lights; neon tubing
light shows, 33–34, 174
Lincoln Center, 144
Lindsay, John, 144, 150
Lindy's (restaurant), 81
Little Lulu Kleenex spectacular, *129*, 131
lobby displays, 91–92
lobster palaces, *14*, 15–17, *15*, *36*, 40, 61, 63–64, 65, 173
 Prohibition's closure of, 81
Loew's State Theatre, 68, 79, *120*, 121, 145
Longacre Building, *37*, 81
Long Acre Square, xi, 2–6, *2*, *4*, *7*, 10, *15*, 173–74
 See also Times Square
Long Island Rail Road, *31*
Louisiana Purchase Exposition. *See* St. Louis World's Fair
Louisville electrical fair (1883), 31
Lucky Strike poster campaign, 119
Luna Park, 42, 168
Lyons, Leonard, 96
Lyric Theatre, 74, 101

M

Macfadden, Bernarr, 96
Madame Tussaud's, 159–60
Madison Square, 1, 11, 12, 22, 23, *27*, 30, 41, 173
Madison Square Garden, 6, *7*, 20, 168
Mafia, 134, 176
Manhatta (movie), *95*
Manship, Paul, 130
Marbury, Elizabeth, 67
marquees, 40, 41
 Leigh-Epok technology and, 106, 109
 of movie theaters, 71–72, *73*, 74, 90, 91, 92, 145, 174
 neon and, 98, 99–100, 101
 World War II dimout and, 121
Martin's (restaurant), 81
massage parlors, 134, 138

mass media, 92, 96, 146, 160, 175
Maxwell House coffee sign, 101
Mayfair Theatre, *120*, 121, 145, 161
McClellan, George, 6, 174
McElfatrick, John B., 6, 121
McKim, Mead and White, 142
meatpacking district, 3
men's clubs, 134, 138
Merman, Ethel, 115
Messmer, Otto, 109, *109*, *111*
Metro-Goldwyn-Mayer, 71
Metropolitan Opera, 4, 44, 52, 173
Midnight Cowboy (movie), 147, 150
Midtown West, 157
Midtown Zoning Resolution (1982), 156, 157
midway lighting style, 34
Midway Plaisance (World's Columbian Exposi-
 tion), 34
Miller, Ann, 115
Minskoff Tower, 144
Minsky brothers, *87*
Mitchell, Joseph, 92
modeling agencies, 134
moral reformers, 16, 61
Morgan, J. P., 31
Morgan Stanley, 157, 159
Moses, Robert, 142, 144
Moss, Joe, 87
Motograph, 100, 109, 123, 133, *140*, *142*, 175
movies, xi, *95*
 Broadway themes of, 96
 as Gude influence, 46, 50
 pornographic film-loop machines, 134, 146,
 176
movie theaters, 61, 65, 66, 68–75, 79, *82*, *83*, 85, 90,
 133, *136–37*, 174
 closures of, 146, 176
 crime and, 81
 facade advertising of, *75*, *90*, 99–100, 121
 as grind houses, 90, 133, 134
 lobby displays of, 91–92
 marquees of, 71–72, *73*, 74, 90, 91, 92, 145, 174
 neon tubes and, 99–100, 101
 sex and, 123, 176
 Times Square redevelopment and, 144, 145
 as Times Square staple, 66, 68–71, 81, 84
 See also specific theaters
moving light displays. *See* animations
Municipal Art Society, 55, 58, 145, 153, 156–57
Muray, Nikolas, 88
Murray, John, 64
Murray's Roman Gardens (restaurant), *65*, 81, 84

Muschamp, Herbert, 156
Muschenheim, William, *18*

N

Naked Cowboy (Times Square personality), 160
name signs, 40, 71
National Endowment for the Arts, 153
NBC, *112*
neon tubing, 101, 161, 175
 Japanese companies and, 148
 spectaculars and, 97–101, *98*, *99*, *101*, 105–6,
 112, *113*, *113*, 114, 130–31
New Amsterdam Theater, 151, 159, 177
New Forty-second Street, 159
Newport Casino, *5*
newsreels, 96, 123
Newsweek (magazine), 105, 106, 127, 165
New Victory Theatre, 160
New Year's Eve event, 22–23, 34, 101, 174
New York Athletic Club, 52
New York Behind the Scenes, Uncensored! (guide), *88*
New York Casino, 4–5, *5*, 20, *29*, 44, 173
New York Central Building, 168
New York Central railroad terminal, 1–2
New York City
 light show, 33–34
 photomontage of, *94*, *95*
 See also specific landmarks
New Yorker (magazine), 92, *104*, 105, 107, 168
New York Evening Graphic (newspaper), 96
New York Life Building, *166*, 168
New York Motor Club, 52
New York Times (newspaper), 15, 17, 34, 43, 65, *82*, *84*
 daytime development support by, 37, 79
 first electric sign for, 30, 41
 Heidelberg project opposition to, 58
 high-class development and, 36–37, *36*, 55,
 61, 81
 on Leigh, 127
 Motograph sign and, 100, 109, 123, 133, *140*
 on postwar Times Square, 133, 134, 139, 141,
 142, 143, 144
 society reporter for, 87
 on World War II, 122–23
 See also Times Tower
New York World's Fair (1939–40), 117, *117*, 126, *127*,
 130, 175
nickelodeons, 66, 91
nightclubs, 85–90, 133
nightlife, ix–xi, 10, 15–16, 37, 61–66
 cabarets and, 63–66, 67, 81, 87
 Prohibition effects on, 81, 175

See also lobster palaces; nightclubs; theaters
Norden, Mortimer, 71–75, *78*, 100, 101, 103, 105, 115,
 161, 174

O

Ocean Breezes sign, *31*, 41
office buildings, 55, 81, 143–44, 151–60, 176
Office of Midtown Planning, 151
Office of War Information, 121
O. J. Gude Company, *36*, 40, 52, *73*, 75, 79, 101. *See
 also* Gude, Oscar
Old Gold cigarettes spectacular, 109, *109*, 112, 114
Olympia Theatre, *3*, 6, *6*, *7*, *12*, 17, 22, 74, *116*, 173
Omaha World's Fair (1898), 33

P

Packard neon sign, 97
Palace Theatre, *73*, *84*, 103, 109, 112, *112*
Panama-Pacific Exposition (1915), 31–32
Papert, Frederic S., 151
Paradise (nightclub), *86*, 87
Paramount Building, *76–77*, *82*, 84, 143
Paramount-Famous Lasky Corporation, *83*
Paramount studio, 71, 106
Paramount Theatre, *68*, *73*, 74, 79, *82*, *83*, 145, 175
Paris Exposition (1889), 35
Paris Exposition (1900), 32–33
Parker, Alton B., 20
Park Row Building, 12
Park Tower Realty, 153
Parrish, Maxfield, 19
peep shows, 134, 146
Pennsylvania Station, 142
penny arcades, 66, 133, 134, 175
Pepsi-Cola Service Center, 121, 122
Pepsi-Cola sign, 121, 130
Pepsodent spectacular, 101, *101*
Perrier sign, 58
Philco sign, *130*, *131*
pickpockets, 81
Planters Peanuts sign, 119, 121
pornography, 134, 138, 146, 176
Port Authority Bus Terminal, 151
Porter, Cole, 92
Porter, Edwin S., 50
posters, 91–92, 134, 146
preservationists, 142–43, 153, 156–57, 176
Prohibition, xi, 79, 81, 84–85, 87, 175
Prometheus (Manship), 130
promotional cards, 91–92
prostitution, 10, 63, 123, 134, 138, 146, *147*, 156, 159
Prudential (company), 153

Publix Theatres, *83*
pulp magazines, 88, *89*
Putnam Building, *36, 73*, 75, *76–77*, 79, 81, *82*

Q
Quaker sign, 40

R
radio, 105, 123
Radio City Music Hall, 74, 98, 101
Radio-Keith-Orpheum Building, *84*
Rainbow Room, 87
Rapp and Rapp, 74, *82*
Raye, Martha, 115
RCA, 74
Realart Pictures, 101
Rector, Charles, 15
Rector, George, 15, *37*, 64, 65
Rector Hotel. *See* Hotel Rector
Rector's Restaurant, 15, *15*, 16, *16*, 22, *34*, *37*, 64, 81, 85, 173
reflective materials, 120–21, 153
Regal Shoes spectacular, *38*
Regan, James B., 18–19
Regent (movie theater), 69
Republic Theatre, *87*, 160, 175
restaurants, ix, xi, *6*, 37, 55
 unpretentious, 81, 84
 See also lobster palaces
revues, 61–63, 87, 88
rheostats, 33, 35
Rialto Theatre, 68, 70, 71, 72, *72*, *90*, 123, 145
Riis, Jacob, 23
Ripley's Believe It or Not (store), 146
Rivoli Theatre, 68, *68*, 70, 121
RKO, 112, *112*, 121
Robards, Jason, Jr., 157
Robinson, Bill, 115
Rockefeller Center, 130, 153, 160
Rock of Gibraltar, 117
roof gardens, 4–5, *5*, 6, *6*, *7*, *18*, 20, 63, 84
roof spectaculars, 121
Rooney, Mickey, *110*
Roosevelt, Franklin Delano, 123
Roosevelt, Theodore, 20, 33
Rosenberg, Kurt, 106
Rosskam, Edwin, 121
Rothapfel, Samuel ("Roxy"), 68–71, *72*, 92, 174
Roxy Theatre, *69*, *83*, 145, *145*, 175
Runkel Cocoa sign, *104*
running signs, 100. *See also* Motograph
Runyon, Damon, 81, 92, *93*, 96, 123, 160

Russell, Lillian, *13*, 17
Rustin, Henry, *33*
Ryan, Walter D'Arcy, *34*

S
Sagalyn, Lynne, 156
St. Louis World's Fair (1904), 33, *33*
saloons, 10
sans-serif lettering, 98
Saturday Evening Post (magazine), 105
Schenley Tower whiskey sign, *98*, 99
Schenley whiskey spectacular, 105
Schlesinger, John, 147
Schultze and Weaver, 168
"Scintillator, The" (searchlights), *34*
Scott Brown, Denise, 156
"Searchlight Rag" (sheet music), *24*
searchlights, 20–22, *21*, *34*
Selznick Pictures, *73*
semispectaculars, 75, *104*, 119, 147
servicemen, 121–23, 175
Seventh Avenue, ix, x, *xi*, 1, 3, *4*, *8–9*, 11, 121, 146
sex trade. *See* pornography; prostitution
Shanley brothers, 64
Shanley's (restaurant), *36*, 81
Sharp, Peter, 146
Shary, William S., *143*
Shaw, Charles Green, 85, *86*, 87, 90, 122
Sheeler, Charles, *95*
Shepard, Dorothy, 115
Sherry's (restaurant), 15
showgirls, 87, 88, *88*, *89*, 90
Shreve, Lamb and Harmon, 166
sign makers, 101, 161. *See also specific names*
signs. *See* billboards; electric signs; spectaculars
Signs of the Times (magazine), 97
Silex sign, *112*, 113, 119
Singapore, 148
Sixth Avenue, 1, 2, 10
sky signs. *See* spectaculars
Smart Set (magazine), 65
Snibbe, Richard, *138*, 140
snowflake (twinkling icon), *166*, *167*, 168
Sobel, Louis, 96
Soglow, Otto, *109*
Solomon, Peter J., 151
speakeasies, 81, 87, 175
special effects, 103, 104, *104*, *112*, *118*, 119, 126, *126*, 130
Special Theater District, 144, 176
Spectacolor sign, 147
spectaculars, 36, 40–58, *73*, *75*, *78*, 79, *85*, 101, 115, *116*, 119, 127–31, 161, *172*

aesthetic reformers and, 51
Artkraft-Strauss and, 130–31
dramatizations and, 103, 120
first in Times Square, 34, *39*, 40, 43
first on Broadway, 30, *31*, 41
Gude and, *38*, *39*, 40, 41, 43–58, 75–79, 120, 173–74
Japanese companies and, 148, *148*, *149*, 160
kinetic light paintings as, 131
Leigh and, 103, 104–9, 112–15, 117–20, 126, 130
movie theaters and, 68, *76*
neon tubing and, 97–101, *98*, *99*, *101*, 105–6, *112*, 113, *113*, *114*, 130–31
sign makers of, 101, 161
sky signs as, 30, 40, *46*, 75, 99
special effects and, 103, 104, *104*, *112*, *118*, 119, 126, *126*, 130
Times Square decline and, 146
Times Square redevelopment and, 160–61, 177
Sphinx (club), 52
sporting businesses, 134
Squibb sign, *99*, 101
Stage Door Canteen, 122
Starr, Jake, 101, 120
Statue of Liberty, 40, 123, *125*
Statue of the Republic (French), *32*
stereopticons, 72
Stern, Robert A. M., *158*, 159, 177
Stewart's department store, 1
Stieringer, Luther, *32*
stock market crash (1929), 85, 90, 175
Stork Club, 87
Strand, Mark, *95*
Strand Theatre, 66, 68, *68*, 69, 70, *70*, 71, 72, *72*, 74, *126*, 145, 174
Straus and Adler, *48*
Strauss, Benjamin, 101
Strauss and Company, 101
streaming video, 160, 165
streamlined design style, 98
street barkers, 90
Studebaker Building, *12*, 44, 46, *113*, *130*
suburbanization, 138, 175
subway, *8–9*, 11, *11*, 20, 150, 151
 opening of, ix, 6, 174
Sullivan, Ed, 96, 105
Sunkist sign, 119
sun towers, *27*
SuperSuds detergent spectacular, *126*
Swanson, Gloria, *145*

T

talking signs, 30, 100, 105
Tammany Hall, 18
television, 133, 160, 165, 175, 177
Ten Commandments (movie), 75
Tenderloin (vice district), 10
Terror in Times Square (Pyramid Books cover), *132*
theater circuits, 13, 71
theater district, ix, xi, 1, *3*, 4–6, 10, 37, 41, 55, 61, 71, 81, 96, 133
 Broadway revues and, 61–63, 87, 88
 Depression and, 85, *87*, 90
 "direct from New York" billing and, 13
 Times Square redevelopment and, 144, 145, 150–51, 153, 156–60
Theater Row, 150–51
Theatrical Syndicate, 13
Thompson, Frederick, 42
Tiffany snowflake symbol, *166*, 167
Time (magazine), 105, 165
Times Square, *vi*, ix–xi, 2–6, *12*, 23
 carnival ambience of, xi, 91, 92, 121–23, 175
 chronology, 173–77
 as "Crossroads of the World," ix
 decline and revitalization of, xi, 133–63, 175–76
 early (1905) photograph of, xi, *xii–xiii*
 electric signscape of, ix–x, xi, 25–59
 imagery of, ix, xi
 Leigh's reimagining of, *102*, 127–28
 map (1911) of, *x*
 naming of, 6, 174
 as national gathering place, 12, 123
 New Year's Eve event in, 22–23, 34, 101, 174
 nightlife and, ix–xi, 15–16, 37, 61–66, 85–90
 as subway hub, *11*, *11*, 174
 World War II and, 22, 120–23, *120*, *124–25*, 175
Times Square (Broadway Composition) (photograph), *95*
Times Square Center Associates, 153, 159
Times Tower, *xi*, *4*, 6, *8*, 11–12, *12*, 19–23, 20–23, *21*, *34*, 41, 55, 68, *82*, 174
 Leigh's redesigns for, *140*, 141–42, *141*, *142*, 165
 Motograph news ticker, 100, 109, 123, 133, *140*, *142*, 175
 Spectacolor sign, 147
 Times Square redevelopment and, 151, 153, 157, 159, 160, *161*, 176

Tissot, James, 127
Toffenetti's (restaurant), *129*, 146
tourism, xi, 37, 40, 81, 84, 87, 88, 100, 133, 138, 146, 160, 177
town-house establishments, 81
Tribute in Light (light display), *164*
Trimble Whiskey sign, 34, 36, *39*, 40, 43, 44, 52, *59*
Trinity Church, 12, 22
Trowbridge and Livingston, 19
Trylon and Perisphere, 117, *117*
21 (nightclub), 87

U

Uneeda sign, 40
Union Square, 1, 22, 23, 173
Unitt and Wickes, *19*
"Up Broadway" (sheet music), *xiv*, *xv*
Upper West Side, 2–3
Urban, Joseph, 63
Urban Development Corporation, 151, 159
urban renewal, 139
Uris Building, 144

V

Vallee, Rudy, 105
Vanderbilt, William, *2*
Vanity Fair (magazine), 85, *86*
Van Wagner, 147, 148
vaudeville, 5, *8*, 13
Venturi, Robert, 142–43, 156
Venturi, Rauch, and Scott Brown, *154–55*
vertical identification signs, 160
vice district. *See* prostitution
Victoria Theatre, 6, *8*, *135*, 144
video screens, 160, *161*
Vitagraph Theatre, 101
Voight, Jon, 160
Volstead Act, 79

W

Waldorf-Astoria Hotel, 168
Waldorf Hotel, 17
Walt Disney Company, 159, 177
war-bond drives, 123
Warner Brothers, *73*, 145
Warren and Wetmore, *166*, 168
waterfall signs, 128, 130

Western Electric, 31
Western Union Building, 22
Westinghouse, 31
Westover, Albert, *87*, 160
What Happened on Twenty-third Street, New York City (movie), 50
"What We'll Do on a Saturday Night (When the Town Goes Dry)" (sheet music), *80*
White, Stanford, 5, *5*, 6, 20, 168
White Rock ginger ale spectacular, 58, *59*
Willys-Overland sign, 101
Wilson whiskey sign, 113–15, *114*, 119, *120*
Winchell, Walter, 96, 104–5
window advertisements, 91
Winston smoke-rings sign, 147
Winter Garden (theater), *73*
Wolfe, Elsie de, 67
Wonder Bread Pavillion, 117, *127*
Wondersign, 109, 112, *112*
Woolworth's (store), 146
World of Tomorrow. *See* New York World's Fair
World's Columbian Exposition (Chicago, 1893), 32, *32*, 33, 34, 51, 63, 173
world's fairs, 31–34, *32*, *33*, 35, 42, 98, 168
 New York, 117, *117*, 126, *127*, 130
World Trade Center, 146, *169*
World War I, 120, 174
World War II, 22, 120–23, *120*, *124–25*, 175
Wrigley's gum spectaculars, 50, 131
 aquarium, 115, *116*, 119, 128
 Spearmen, *73*, *75*, 79

Y

Yamasaki, Minoru, 146
York and Sawyer, 146

Z

Ziegfeld, Florenz, *62*, 63, 87, 90
Ziegfeld Follies, 63, 88
Ziegfeld's Midnight Frolics, 63, 85
zoning, 151, 156, 157, 176
Zorina, Vera, 115
Zukor, Adolph, *68*, *83*

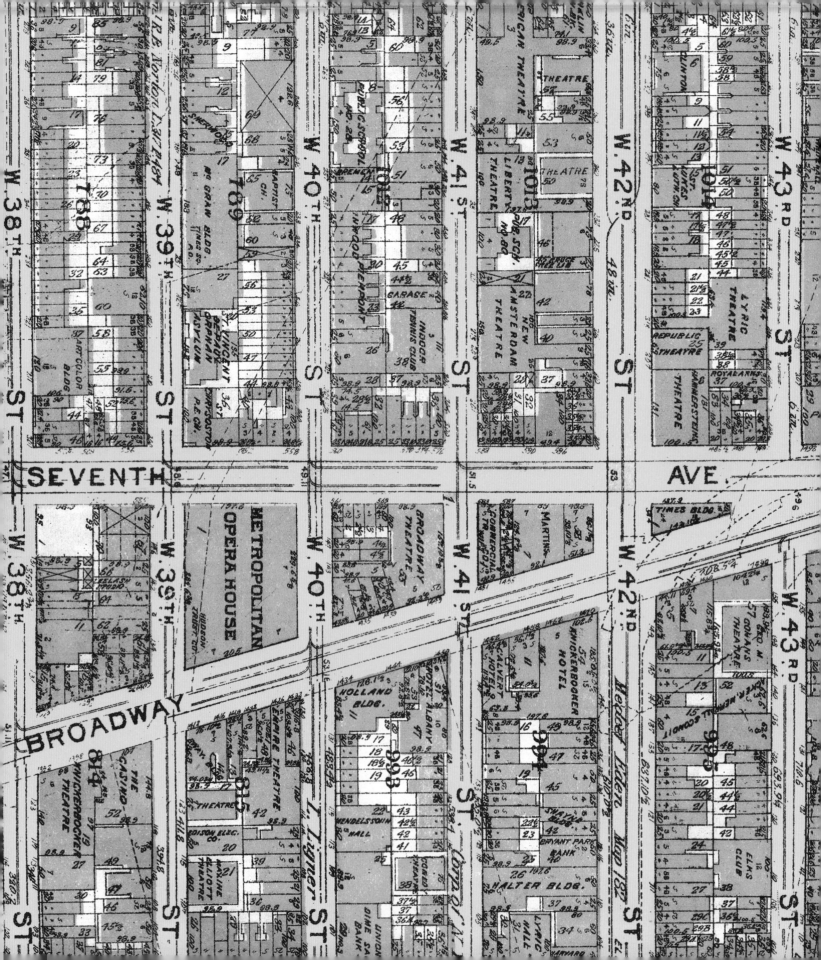